Symbols of the
CELTS

About this book:
This book, *Symbols of the Celts*, gives an insight into the colorful life of the Celts and their worldview, which is so different from ours today, as recorded in their abstract signs, artistic patterns, astonishing pictures, and literature. Their wanderings, customs, languages, and sects are illustrated in a striking manner through symbols, which have been handed down and some of which have become widespread, and through examples from Celtic literature. You will first be introduced to each motif, then get an entertaining history, and finally a brief outlook on modern times. You will rapidly discover many extremely fascinating or strange things in everyday life. For those with special interests, important sources are given in an appendix.

About the author:
Sabine Heinz, who was born in December 1963 in Berlin, has remained true to her home city by working there today as a scientific associate at the Humboldt University, where she is head in the field of Celtology. It all started with a course on the subject of English Celtology, which she completed as a thesis. Then she continued with research in Berlin, accompanied by a fellowship to the University of Freiburg in the field of Celtology in which she received a degree. Several visits to Wales, including such places as the Coleg y Brifsgol Cymru in Llandbedr Pont Steffan, helped complete the picture. However, instead of being able to work as a recognized scientific instructor in the field of the Celtic legacy, she had to struggle to obtain a teaching position in her field, which until recently was taught in Berlin as full Celtology.

Symbols
of the
CELTS

SABINE HEINZ

Sterling Publishing Co., Inc.
New York

Cover art: Klaus Holitzka
Illustrations: Tanja Al Hariri-Wendel

Library of Congress Cataloging-in-Publication Data

Heinz, Sabine.
 [Symbole der Kelten. English]
 Symbols of the Celts / by Sabine Heinz.
 p. cm.
 Includes bibliographical references and index.
 ISBN 0-8069-8634-4
 1. Mythology, Celtic. 2. Celts—Religion. 3. Symbolism—Europe. I.
Title.
 BL900.H39513 1999
 302.2'223'089916—dc21 99-30111
 CIP

10 9 8 7 6 5 4 3 2 1

Published by Sterling Publishing Company, Inc.
387 Park Avenue South, New York, N.Y. 10016
Originally published in Germany by Schirner Verlag, Darmstadt under
the title *Symbole der Kelten*
© 1997 by Schirner Verlag, Darmstadt
English translation © 1999 Sterling Publishing Co., Inc.
Distributed in Canada by Sterling Publishing
%o Canadian Manda Group, One Atlantic Avenue, Suite 105
Toronto, Ontario, Canada M6K 3E7
Distributed in Great Britain and Europe by Cassell PLC
Wellington House, 125 Strand, London WC2R 0BB, England
Distributed in Australia by Capricorn Link (Australia) Pty Ltd.
P.O. Box 6651, Baulkham Hills, Business Centre, NSW 2153, Australia
Manufactured in the United States of America

Sterling ISBN 0-8069-8634-4

CONTENTS

Acknowledgement .7
Preface .9
Abbreviations .10
Introduction .13
Fascination with Animals17
Snake .23
Dragon .31
Horse .37
Deer .47
Steer/Bull .53
Ox .59
Cow .61
Boar/Pig .63
Dog .71
Lion .75
Rabbit .79
Birds .83
 Owl .87
 Rooster .93
 Peacock (swallow, gull, songbirds)95
 Blackbird .97
 Dove .99
Birds of Prey: Eagle .103
 Hawk, Falcon, etc. .107
Water Birds .111
 Swan .113
 Goose .119
 Crane .123
Crow and Its Relatives125
Fish: Salmon .131
 Trout .137
Trees .139
 Tree of Life .144

Oak146
Mistletoe149
Yew151
Ash152
Apple tree154
Linden157
Lyre/Harp159
Cauldron163
Basket171
Barrel172
Horn175
Torque179
Cart183
Sword187
Stones195
Cross201
The Number One: Egg205
The Number Two: Eye and Moon209
The Numbers Three and Four: Sun221
 Triangle227
 Triads231
 Trinity233
 Triskele235
The Number Five237
The Number Seven241
Fertility Magic: Women247
Fertility Magic: Men251
Transformation and Transmigration of Souls ...257
Water Cult265
Head Cult269
The Otherworld277
The Year Circle: Samhain/Halloween, Beltene ..285
Appendix295
Index302

ACKNOWLEDGEMENT

I would like to thank my husband, who read my manuscript patiently, and my children, who let me work even though they would have preferred that I were with them. André has even contributed some lines of his own to this book.

I would also like to sincerely thank my teacher, honorary professor Martin Rockel, Dr.sc., for his advice and his books; my colleagues Prof. Tristram, Prof. Márín Ní Dhonnchadha, Prof. Poppe, Prof. Birkhan, and Dr. G. Isaac; as well as the Celtology students at the Humboldt University, Berlin: Alexander Marx, Ute Fickelscherer, Ulrike Schmidt, Karsten Braun, Ina Pflügler, Judith Schachtmann, and Belinda Albrecht, for their stimulating discussions and valuable advice.

PREFACE

The reader should know that the stories retold in this book sometimes represent only a part of a much greater story, and are chosen especially to document one symbol or another. Likewise, the selected stories hardly reflect all of the literary material available for a particular motif. Many readers will note that they know certain stories in another form of telling. This is because of the various versions that have served the individual book publishers as models. (Thurneyesen represents the problems with old manuscripts especially well.)

The selected motifs are not authentic, but artistic approximations that, so far as they exist, are based on historic models. In addition, the concept "symbol" is handled here quite freely.

Lastly, it should be indicated that it may happen in references in this book that known names appear in another form. This is almost unavoidable, since heroes in the literature of various countries are often represented at different times in differing spellings. The names may have been translated from Welsh to Irish, for instance, or vice versa, and it is well known that not every language has the same sound and possibilities of expression, which is the reason for different letters being chosen. Time also plays a role, since languages change constantly (just try to read Old English). In many materials, a span of 1000 years and more can be assumed, which necessarily entails changes. It should be added that the manuscripts that have been passed on were done by various scribes who had different knowledge and experience—another reason for variations. I have therefore given the names according to the sources used and sometimes added an alternative that is more common.

In general, the subject of Celtic symbolism is a difficult field. There is only little knowledge that can be applied with certainty. Though the world of the epics is diverse, it includes concepts from many

hundred years; therefore, a space-time organization is practically impossible. Nevertheless, I think that I have been able in this book to shed a little light on the vivid magical world view of our Celtic forefathers.

ABBREVIATIONS

Bret. Breton
Corn. Cornish
Eng. English
Gaul. Gaulish
Ger. German
Ir. Irish
Old Ir. Old Irish
Scot. Scottish (Gaelic)

I'M HANWYLYD

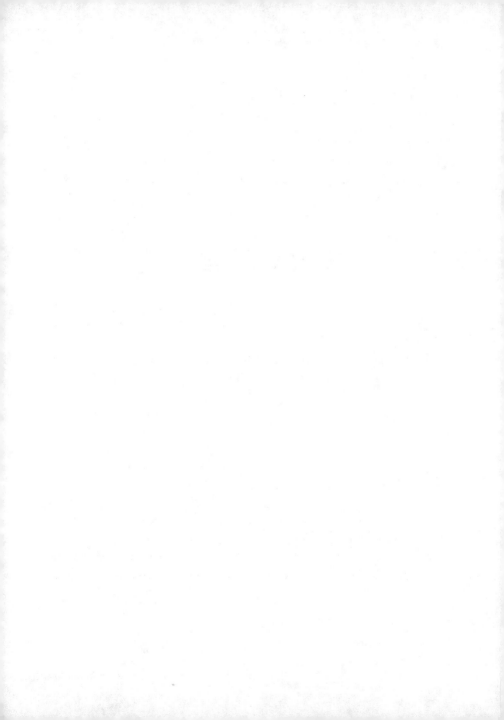

INTRODUCTION

Some of the first symbols of the Celts, such as the dragon, are still in use today. They are pictorial representations of customs, usages, and concepts of the Celts from about 800 B.C. The first archaeological evidence of the Celts around this time can be found. Since fundamental findings go back to Hallstatt (Gaul. *halen*, Ger. *Salz*, Eng. *salt*) in the Austrian salt-mining region, the early periods of the Celts around 800 B.C. are called the Hallstatt culture. According to present knowledge, the original regions of the Celts were along the Upper Rhine and near the upper Danube.[1] The spread of the Celts, from about the 5th century B.C., reached its peak in the 4th and 3rd centuries. They later settled in regions as far as the Black and Aegean Seas, part of the Near East, to the Mediterranean Sea and parts of Spain, Portugal, and the British Isles. Celtic branches also reached the British Isles and Ireland already before their extensive penetration through the Romans and expanding Germans.

The earliest art that can be identified as Celtic, from the Hallstatt period, is characterized essentially by a geometric style in which ornamental strips, zigzags, triangles, rectangles, rhombuses, checks, circles, angles, stars, etc., determine the pattern. In drawings, paintings, and sculptures, a divided structure of motifs predominates, as with Greek and Roman art. Celtic ceramic decor is diverse: graphite painting, flat color painting in white and red, inlay work, stamping, metal plating, and reliefs permit light and shadow to appear on the surface. One of the most important sources for clarifying Celtic religion is the Gundestrup Cauldron,[2] a ceremonial vessel that showed

[1] Eastern France, Alpine Switzerland, Southwest Germany.
[2] Cf. Birkhan 1997, pp. 378ff.

the already pronounced relationships between cultures. Caution is advised in reading Roman and Greek gods into the Celtic world view!

The spread of Christianity and its written language, Latin, led to previously primarily oral literatures, like that of the Celts, being recorded in writing. As a result, the Celtic culture in the insular style came to blossom again and significantly influenced Middle Age art and literature, such as in the epics of Arthur. Of the most important works of art from this time was the *Book of Kells*. It is one of the most richly decorated manuscripts of the four Gospels, and it probably derives from the Irish-Scottish mission (6th–7th century) during which Britain and part of the continent were converted to Christianity. The illustrations in it show a combination of old pagan and new Christian concepts and ways of life, and transmits the Celtic tradition of ornamentation in a new version tied to Christianity. The decorative metal and leather work probably go back to pre-Christian continental times and incorporate Byzantine, Italian, and other influences. The *Book of Kells* shows all the main components of Celtic manuscript design, such as branched and interlocking spirals, margin decorations with 45° angles, and three-dimensional woven torques.[3] People and/or animals sometimes form the letters in the text. Symbols of pagan origin play a large role in the Church of the early period and the Middle Ages.

Without exception, symbolism in Celtic art is more important than the representation of events, which is different from neighboring cultures such as the Etruscans or Greeks. The Celts seem to prefer the boundlessness of the imagination to the order of reality. The spread of art and symbolism, starting at the latest with Latin times

[3] See chapter "Torque."

(5th century B.C. to Caesar), showed that the various Celtic peoples must have been aware of their common origin.

Modern interpretations of the Celtic world of images have been made with a background of dominant Christian, non-religious, or other ways of thinking. They are therefore more or less distorted and reflect only pieces of pagan thought. In addition, the motifs could have had multiple symbolic forces that have been expressed differently depending on place and time, have changed by connections with one another, or have undergone historic changes.

I hope you have a lot of fun as you enter the world of Celtic symbols!

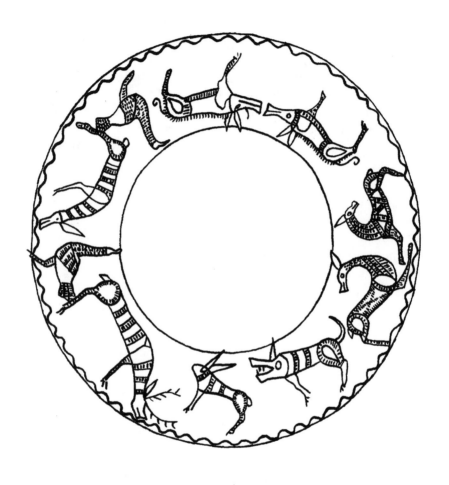

Animal frieze

FASCINATION WITH ANIMALS

Animals have characteristics and abilities that were once considered strange yet desired by people. They include types of movement, such as flying, diving and swimming long distances, jumping far and high, and running fast. They also include fine hearing and sharp vision, the ability to metamorphose, great strength, and many others. These abilities of animals were for people not just an introduction to behavior and knowledge of nature. For example, watching an animal fly both frightened and amazed people. It also to some extent explained a connection with the Otherworld, since some animals were considered to be messengers of the gods. Many of the animals' behaviors showed people how to understand or use nature, such as by pointing out useful plants and experiencing natural cycles. Tamed or domesticated animals[4] are, in contrast, not only useful but also evidence of the power of the trainers. Certain external characteristics, such as horns and fangs, were frightening. Others, such as large eyes, were regarded as being for protection, observing, or even classified as a form of punishment (owls, toads). The reasons why bands of warriors oriented themselves toward particular animals and placed them on their coats of arms[5] were probably because of the animals' strength and aggression.

Some animal characteristics seem to be universal. They had similar effects on early people in the most varied regions of the earth. Thus, we know the owl from European fairy tales and as a symbolic animal in stories of African peoples and Native Americans.

[4]Bird flight, cf. Branwen in the Mabinogi.
[5]Cf. Grenham, 1994.

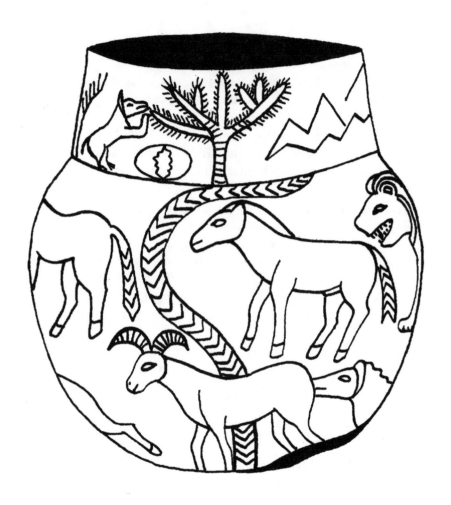

Animal symbols on a Bronze-Age bowl

Altogether, animals offer enough reasons as to why they were among the first divinities or were connected with them by serving as "target wraps" in transformations.[6] The number of types of animal symbols[7] increases with the conversion to Christianity. Geoffrey of Monmouth gives a whole catalog of animals in the Prophecies of Merlin alone.

With the cultural exchange between people of different regions, which became stronger with missionary work, through heraldry, which developed into an organizational structure in chivalry, and with the rise of feudal states, many known animal symbols[8] underwent new interpretations, and new animals were added.[9] Otherwise, these radical social changes, which include the Crusades,[10] led to a dilution of the real course of development. Thus traditions, customs, sects, heroes, and saints that were originally tied to certain civilizations became motifs in the fairy tales of many countries.

A treasure trove of the description of animals and their symbolic strength is in Welsh literature—from its earliest records to modern times. It is not only voluminous, but also strongly rooted in its own tradition. Outstanding poets in this extensive material are Dafydd ap Gwilym, R. S. Thomas, and many others. Without knowledge of the owl and its significance, for example, even modern literature could not be fully understood.

In Ireland, the best known Irish families still have animals on their coats of arms.[11] Pubs in Ireland as well as Britain often have

[6]Cf. chapter "Transformation and Transmigration of Souls."
[7]Cf. chapter "Birds."
[8]Cf. deer, lion, eagle, etc.
[9]Cf. chapter "Peacock."
[10]1096–99, 1147–49, 1189–96.
[11]Heron: Ó hEachthianne. Lion: Brennan/Mac Branáin/Ó Br=áin, Dillon/Ó Duilleáin, Carrolls, Clancy/Mac Fhlannchaidh, Flaherty, Kelly/Ó Ceallaigh, and many others. Boar: Crowley/Ó Cruadhlaoich, McCann/Mac Cana, MacDonagh = Mac Donnchadha, Sweeney/Mac Suibhne. Deer: Doherty/Ó Dochartaigh, Hennessy/Ó hAonghasa. Fish: Keane/Ó Catháin, MacCarthy/Mac Cártaigh. Horse: Maguire/Mag Uidhir. Snake: O'Donovan/Ó Donndubháin. Birds: Sheehan/Ó Sííodhacháin.

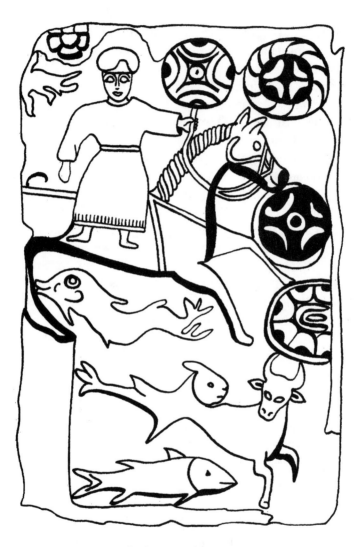

The horse goddess Epona

names such as Boar's Head, King's Head, Black Lion, and many more. In addition, the Irish carry in their hands possibly the most beautiful coins in Europe: they show the peacock on the penny, the crane on the 2 pence, the bull on the 5 pence, a salmon on the 10 pence, the horse on 20 pence, the deer on 1 pound, etc.

Even in today's society, which has largely become estranged from nature, animals still play a part of our everyday slang and figure of speech. Some of the many include "sly as a fox," "slippery as an eel," "high on the hog," "horsing around," "being a scaredy cat" or "as stubborn as a mule," "being a silly goose," "eating like a bird," "being busy as a bee," "an eager beaver," "as strong as an ox," or "hungry as a bear."

Finally, we must not forget Groundhog Day, which is celebrated on February 2. It has its roots in an ancient Celtic celebration called Imbolog. Imbolog marks the midpoint between the winter solstice and spring equinox. Although today, with weather maps and radar readings, we are not as dependent on the groundhog as an indicator of the second half of winter, we still celebrate this ancient tradition.

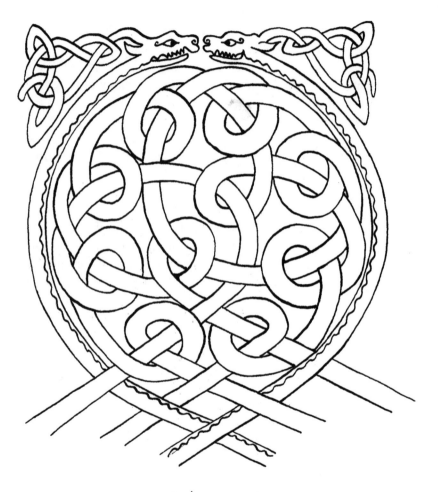

Snake ornament

SNAKE

The first representations of snakes were found in the form of zigzag lines, which were already seen in such earliest evidence as the Hallstatt-period vessels. Later, they appeared as hair locks or clearly as snake lines. Snakes play an important role in many different cultures. They are seen on many levels, including Celtic symbolism. Here, the snake is seen not as a type of animal, but as a multifaceted symbol that represents, among other things, the idea of the creation process. The snake form can adapt different animal parts, such as horns, antlers, a horse or ram head, etc.

Their ability to shed their skin allows snakes to become symbols of rebirth. Since their shape resembles the male organ or the umbilical cord, and since they produce a large number of offspring, they can also stand for fertility. Their poison is deadly, but, like the saliva and breath of other animals (including the dog), it can stand as a symbol for healing. The form and forward motion of snakes represent a connection between river and sea, heaven and earth. They are also associated with the water cult,[12] since they can make a woman pregnant when she swallows a snake (in the tiny form of a worm) with water. That the snake also represents protection can be read from the story in which Conchobar's mother dies when he is born, but the worms that led to her pregnancy are in his hands.[13] Closely related to this is its function as a guardian,[14] in which it often protects the entrance to the Otherworld.

Conall Cernach also owes his life to the snake that he held in his hands at his birth.[15] In one part of the story of the driving out of

[12]Cf. chapter "Water Cult" (source of healing).
[13]Thurneysen, pp. 275f.
[14]Cf. chapter "Dragon."
[15]Cf. chapter "Water Cult."

The undivided progenitor with the snake escaping from the egg

Fraech's cattle, Conall Cernach is brought in contact with the deer god Cernunnos (the lord of the animals), since the snake, in spite of its role as guardian, does nothing.

Fraech (also Fraích) learned from his mother that his cattle, his wife, and his children had been driven into the Alps. Against her advice, he set out to bring the cattle back. He started with twenty-seven men, one dog, and one falcon. On the way, he met Conall Cernach, who joined him. In the mountains, they learned from an old woman of an Irish clan that the cattle had been driven all the way to western Ireland. She sent them to a woman of Ulster, who was herding these cows and was the jailer of the fortress where they were to spend the night. The Ulster woman had the fortress opened, but warned the heroes about the snake who protected the fortress. As Conall and Fraech approached the door of the fortress, the snake jumped, but into Conall's belt, and it stayed there until morning. So they were able to loot and destroy the fortress and there-by free his wife, children, and cattle.

The snake is often a companion animal for all gods that are strongly associated with earth, fertility, and healing cults.[16] On coats of arms, the snake produces fear and has a military association.

The androgynous illustration on page 24 represents the undivided progenitor who is about to split into its male and female components. The act of creation is symbolized by the escape of the snake from the egg. The snake has no legs and is therefore viewed as pre-human. Its egg is the first divine expression of the pre-human past. The snake unwinds itself from the egg (death) and bites into the

[16]Cf. Cernunnos in chapter "Deer."

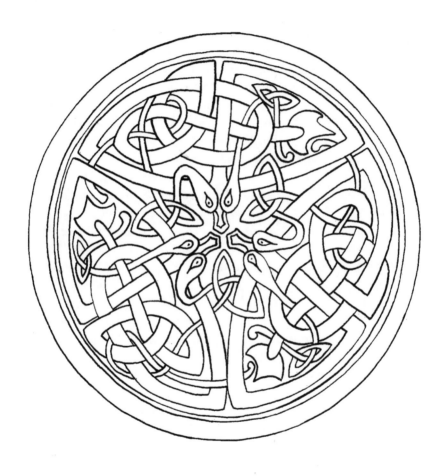

Snake knots

breasts (life). In contrast to the biblical version, in Celtic mythology the man (snake) comes out of the woman (egg).

The snake, with its ability to shed its skin, stands for the creator and therefore becomes the sign of renewal. The dual meaning of its poison, which can bring healing and cause death, corresponds to the Celtic way of thinking. It is based on the thought of nature and gods, which are inaccessible in the end and equally create and destroy. The snake lives according to the seasons: when it becomes cool in winter, it withdraws into the earth. Only in the spring, when the days become warmer, does it come back out from the earth—the place from which man came—and, thus, it holds onto its connection with the underworld.[17] Since it knows life there, it is often called the God of the Underworld, who, in the form of a horse, impregnates the mother goddess.

The snake combines contradictions and rhythms that are also found in the life of humans: it is deadly and harmless, it can live on land and in water, it grows stiff in winter and reproduces only in light and sunshine (in India and Egypt, it is therefore a symbol of the sun), it creeps on the ground or rises up like a tree, it bears life or lays eggs. Worms are snakes in small form. We later encounter flying worms, which look like dragons, or horned snakes (ram-horn snakes) with or without wings. The connection between snakes and dragons is presented by Geoffrey of Monmouth in the Prophecies of Merlin.[18] The feet are later inventions that lead to the dragon, which then appears in many shapes and sometimes also with many heads.

In the Bible, the snake becomes a messenger of the Evil One, and leads to the fall of Adam and Eve. According to legend, St. Patrick drove out the snakes, a symbol for the successful conversion to

[17]Cf. chapter "The Year Circle."
[18]Thorpe, pp. 175ff.

Snake with ram's head

28

Christianity (5th century). We also find it again in Hell.[19]

We still find the snake today as a symbol of wisdom in heraldry, where, however, it can also embody devilishness.[20] Its life/death duality has been maintained to the present with its deadly venom used in healing medications. It is still a sign of medicine today, wound around the staff of Aesculapius, but it can also be frightening and dangerous, as in the saying, "a snake in the grass."

[19]"The Voyage of the Sons of O'Corra."
[20]Rothery, p. 62.

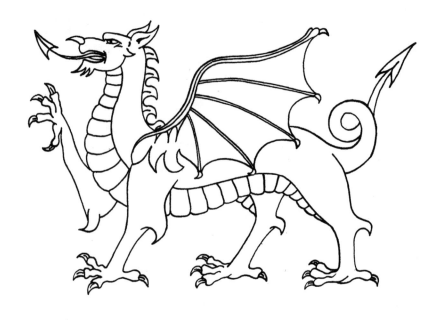

Four-legged dragon

DRAGON

Dragon representations are extremely varied today in fairy tales and folklore, primarily in Asian countries. There, the dragon is similar to a snake with three or four claws (Japan, China) and no wings. In the Near East, it has short legs. In Europe, it has many different shapes; in Scandinavian and Celtic folklore, it frequently has two legs. Pointed ears commonly appear in much of the folklore. In ancient Egypt and among the Celts, the dragon appeared woven into knot work. Occasionally, the dragon has a mouth shaped like a beak. Mostly, it is a snake transformed into a monster. The earliest known Celtic representations are found on sword belts and sheaths, often drawn in pairs, from the 4th century B.C.

Dragons are guardians of treasures, or robbers. In China, the dragon is a god that sends rain and resides in bodies of water. It also represents the male principle. Among the Celts, the (fire-breathing) dragon, which possibly developed from the horned and poisonous and/or fire-breathing snake,[21] has a greater role of guardian than the snake does. In many of the fairy tales, sacrifices are made to the dragon.[22] The Celtic dragon is, like the Egyptian[23] dragon, also traditionally associated with military matters. It stands for armed forces and sometimes even becomes a hero.

Corresponding to its thousand-year-old significance, the dragon appears in Celtic poetry[24] and prose:

[21]Hermann, p. 180; Agricola, pp. 195ff; chapter "Snakes."
[22]Birkhan 1997, p. 707.
[23]Rothery, pp. 65ff.
[24]In Wales: Gododdin, Canu Taliesin.

Fighting dragons: dark (originally red) = Welsh;
light (originally yellow or white) = Anglo Saxon

L *ludd, King of Britain, reigned successfully and generously for many years, as far as London. One day, however, the land was visited by three plagues, one of which was a horrible scream at the beginning of each summer (to Beltene). It brought all life on the island to a stop. Men lost their strength and courage, women the fruit of their bodies, sons and daughters their minds, animals fell over, and the waters became poisonous and were no longer navigable. In order to track down the cause of this plague, Lludd measured the length and breadth of the island of Britain and found Oxford to be its center. He had a pit dug there, put a pot with the best mead in it, and covered it with a silk cloth. Then he saw two dragons wrestling with each other. They represented his people and a foreign, enemy group. As they both dropped to the earth like pigs, exhausted, they fell onto the cloth and with it into the pot. There they drank all the mead and fell into a deep sleep from it. Lludd wound the cloth around them and placed them in a sarcophagus in the safest place to be found in his kingdom—at Mount Snowdon. And it was said that no plague would ever visit the island again as long as they remained in this safe place.*

The dragons (see left) involve a struggle for power between the Welsh (dark dragon, red in the original) and the Angles and Saxons, who were advancing from the east (yellow or white[25] dragon).[26]

Another epic concerns Merlin (Welsh Myrddin):

K *ing Vortigern wanted to build a castle near Snowdon. During the night, however, everything that had been built disappeared, including tools and materials. The king's advisers met and came to the conclusion that a fatherless child must be sacrificed so*

[25]Some sources give different color indications.
[26]Cf. also Monmouth, Prophecies of Merlin.

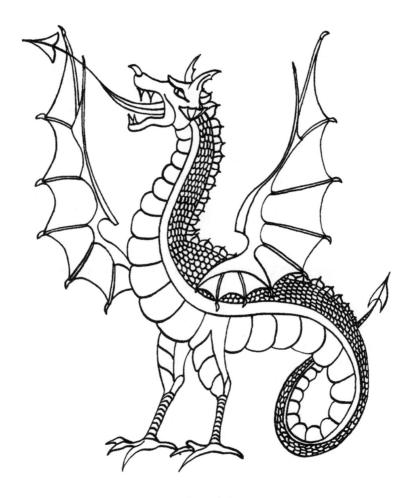

Two-footed dragon

that the construction site for the castle could be covered with its blood. Messengers therefore rode through the land and found a fatherless youth at Car-fyrddin (Eng. Carmarthen). He explained to Vortigern that his blood would not help, because a lake under the mountain would again make the castle sink. Vorigern had his men dig until they came to the lake. At Merlin's behest, they dug further and found two holes in which two dragons were sleeping. They woke up and started to fight with each other. Vortigern asked Merlin what this meant. Merlin explained that they are two peoples, the red dragon the Welsh and the yellow,[27] the Saxons. To the question of which would win, Merlin only laughed mysteriously and the dragons then disappeared in a fog.[28]

In another version, Merlin sees the red dragon—also an emblem of Arthur, who accompanies him in his battles—as a proud victor.

In Wales, the red dragon has been a national symbol since 1901, and it has been seen on a white and green background on the Welsh national flag since 1953. It is present on any national occasion, and it is one of the favorite souvenirs of tourists. The dragon, or a part of it, is often used as a symbol. For example, The language association Cymdeithas yr Iaith chose its tongue.

[27]Sources give different color indications: yellow and white.
[28]Cf. chapters "Basket" and "Horn."

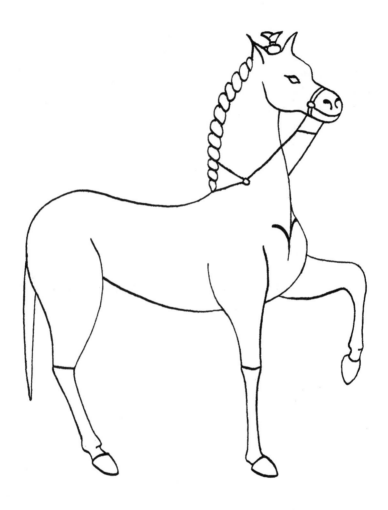

Horse statue

HORSE

In the 8th century B.C., horses came to Central Europe as useful ani-
mals and became the battle emblem of the Celtic riding nobility.
Since the Celts were expanding, there were many military conflicts.
As a result, riders and charioteers gained a high social position. One
of the earliest pictures of a horse is a stone carving from the 6th cen-
tury B.C. found in Roquepertuse, Provence.

The horse appears in the most varied compositions: as sculptures
and on the back side of most coins known so far. The religious sig-
nificance of the horse has many layers in different cultures. It is a
companion of the gods, an emblem of various divinities, and a ded-
ication to such gods as Rudiobus, Blenus, and Macha (see below).
The horse often stands as an abbreviated symbol for the rider or for
the horse and chariot. It is a sun sign, which is also associated with
the water cult, combining in itself life and death (development,
healing, rejuvenation). Other associations are drawn depending on
the rider or companion represented—man, woman, snake, dog,
boar, eagle, raven, etc. The rider is the highest being; he holds the
reins with which he guides and directs. The horse pulls a sun chari-
ot, battle chariots, and barques.

The representations also show mares, namely the horse goddess
Epona, as well as stallions. Epona[29] was worshiped in the 1st through
4th centuries A.D. from Britain to North Africa, and her feast day was
held on December 18. She is never depicted alone, but mostly with
other horses or fruits (fertility, abundance), or riding sideways on a
mare (see page 20). If she appears three times, then there is a mother-
god association. Epona is the goddess of horse-breeding and protectress
of mounted troops. She accompanies those she protects throughout

[29]Celtic ewos = horse.

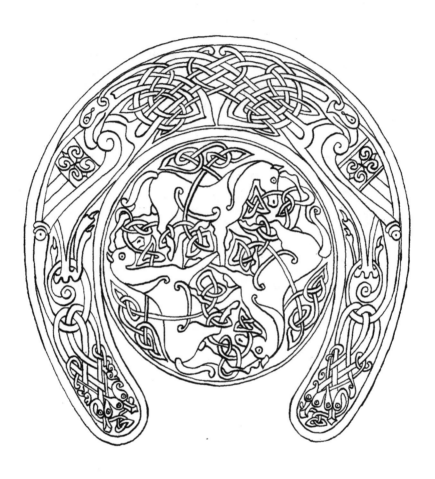

Horse ornament

life and into the Otherworld.[30] For this, the horse later receives wings.[31] Life and the birth and death of heroes are therefore bound together to the life of horses.[32] Epona probably still survives as Rhiannon from Wales,[33] Macha, and Étaín.[34]

Other horse representations show the horse in hybrid form, such as with a human head. With wings, it leads the brave into eternally beautiful realms. Sea horses are occasionally similarly depicted.

Other characteristics of the horse are beauty, speed, sexual vitality, and consequently fertility. The horse is the symbol of life in motion. In addition to the boar/pig, it is the most frequently sacrificed and adored animal.

Consequently, the horse is to be considered not only from Celtic literature. It is mentioned by itself or as a part of names. A cycle of Welsh triads, *Trioedd Ynys Prydein*, is concerned exclusively with the horses of British rulers and at the same time reflects Celtic color symbols.[35]

One of the most beautiful and symbolically powerful stories, which sheds light on the many sides of the horse and its wisdom, comes from Brittany:

A horse-breeder had twelve mares, which gave him eleven chestnut mare foals and an ugly blue stallion. When the breeder groaned, the stallion suddenly started to speak and advise him to kill the other foals and give him all the milk from the mares. The farmer did as the stallion advised, and after 6 months it became a gigantic animal as strong as twelve horses. When the stallion had lost its blue pelt, the

[30]Cf. key at Oisin in Tirnanoge, etc.
[31]Cf. Pegasus, Oisin in Tirnanoge.
[32]Cf. among other things, Pryder, Mabinogi (see Appendix), and CúChlainn, Thurneysen, pp. 268ff, 563.
[33]Cf. Mabinogi.
[34]Ireland; cf. Thurneysen.
[35]Cf. chapter "Triads."

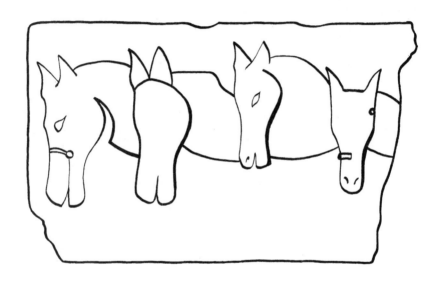

Horse frieze

breeder had to sell part of his belongings because the horse told him that he also needed a silver currycomb. He found one and combed the animal's pelt until it was a brilliant white. The horse now required the breeder to ride it to Nantes, where the nine oldest stallions of the king had become ill. At the advice of the stallion, three shovelfuls of oats were shaken out for each horse, but the stallion ate them up. The nine old stallions were whipped until water ran down from them. The breeder then rubbed the water into his stallion, which made it even more magnificent. After the "bleeding," the king's stallions recovered. Then the king made the breeder a knight and ordered him to bring back the World Horse.

After three hours of struggle and with the aid of 99 protective cowhides, the stallion conquered the World Horse and brought it back. They had just returned to the court when the king ordered the knight to get the princess with the golden hair. So they went out again. When their provisions were almost used up, they met a flock of hungry wild geese with which they shared their last bread. In thanks, the birds brought a barque and pulled them both over the inhospitable lake, where they had camped, to the island of the princess. They conquered her and brought her back to the king.

The king was taken with the princess and wanted to marry her. She stated as a condition of her acceptance that she get her clothes, which were on the island in a chest. She had thrown the key to the chest into the lake as they were crossing it. The horse and the knight set out again. At the lake, they rescued a fish, who brought them the key from the bottom of the lake as a gesture of gratitude. They went to the island, obtained the clothes, and brought them to the princess.

The princess, however, now demanded a younger husband. So the knight and the stallion had to go out again to get the Water of Life and Death. On a field, the stallion ordered the knight to kill him. The knight tearfully obeyed, because the stallion had always been right before. When the stallion died, two ravens came and sat on its body. The knight caught one of the ravens and promised to set it free

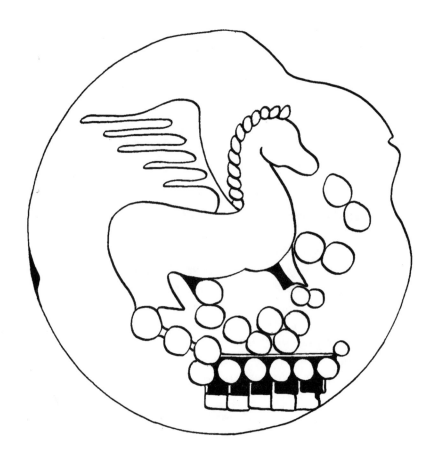

Pegasus, the winged horse, companion of the heroes (coin)

if it would bring him the Water of Life and Death. The raven gave its word and returned with it. The knight then sprinkled a couple of drops on the body of the stallion. It suddenly came to life again as a wonderful handsome prince. He was the princess's brother.

They returned to the court, where the princess shed tears of joy at seeing it. The king first wanted proof that the water was real, and so they sprinkled three drops of the Water of Death on the king's old dog. It died. Then it was given three drops of Water of Life and it immediately reawakened to life, rejuvenated. Then the king wanted the same thing done to him, since he hoped that he too would reawaken rejuvenated. But he received from the princess only the Water of Death, for she fell in love with the knight who had restored her brother to her. She made the knight the new king.

The connection between matriarchy, fertility, and fighting ability is especially clear with one of the three Machas described in Irish epics:[36]

*T*o the lonely house of the king's farmer, Crunnchu, there came one day a wonderfully beautiful woman by the name of Macha, who took care of the household completely without saying many words. She stayed and increased the wealth and happiness of Crunnchu's house. Soon she became his wife and was pregnant. At this time, Crunnchu went to the festival at the army encampment. Even though his wife had warned him against this, Crunnchu boasted before everyone celebrating the horses that his wife could run even faster. King Conchobar heard this and, incensed, had her brought to him. Although her labor had already started, he forced her to race with the horses; otherwise he would kill her husband. She won, but the race killed her. Before dying, she gave birth to twins. Her death cry made the people there shudder and lose their strength. For nine generations, the people of Ulster suffered her curse. Whenever they were in trouble and needed their strength, they had

[36]From Ulter's Childbirth.

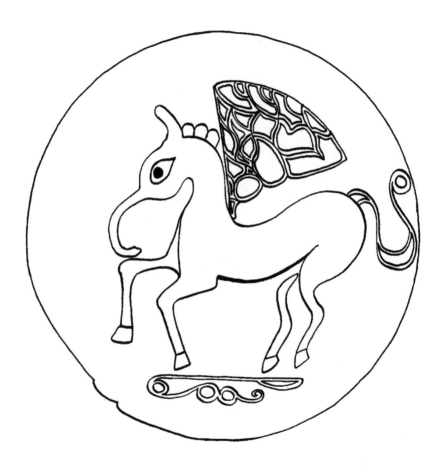

Pegasus with snout for inhaling the breath of life (coin)

for the period of a confinement—5 days and 4 nights, or 4 days and 5 nights—only as much strength as a woman in childbirth.

Irish literature gives a total of three meanings to the Irish goddess Macha: prophecy, victory,[37] and matriarchy. The connection with matriarchy is also reflected in, among other things, the Welsh Rhiannon[38] and the fairy tales of Baranor.[39] Medh, a real matriarch, is also sometimes represented as a horse.[40]

The insular Celts may have conceived the land itself as a horse[41]— perhaps even represented by women like Medh,[42] who married a horse according to the name of her first husband, Eochaid Dala. This was explained better as the frightening enthronement rite that Giraldus Cambrensis went through in 1185–1186 in Ulster under the conditions of the pre-feudal Irish society of that time: the candidate king had to consumate the marriage ceremony on a white mare— unite himself with her and then in a soup from the animal's meat, which his followers had to eat. This way the animal's strength was transferred to him and would benefit his kingdom through him.

That men came into possession of land or became kings through women is shown not only in the Irish epic cycle,[43] but also in the Mabinogi,[44] the Arthurian epics and fairy tales, and in the above story.

In fact, many, primarily Irish, characters bear the element of the horse (Welsh March > Mark) in their names: Mongán "Little Mane," Eochaid "Horse,"[45] Eochaid Ollathir "Grandfather Horse," etc.

The Celts, like the Aedui and Lingones, were in the past and still are (such as, in Llangeitho, Wales) famous for their horse-breeding.

[37]Cf. chapter "Fertility Magic: Women."
[38]Cf. Mabinogi, see Appendix.
[39]Birkhan 1997, p. 542.
[40]Op. cit., pp. 539ff.
[41]Op. cit., pp. 530ff.
[42]Cf. Blodeuedd, chapter "Owls"; Mabinogi, see Appendix.
[43]Cf. chapter "Fertility Magic: Women."
[44]Cf. Birkhan 1997, pp. 541ff.
[45]Ibid.

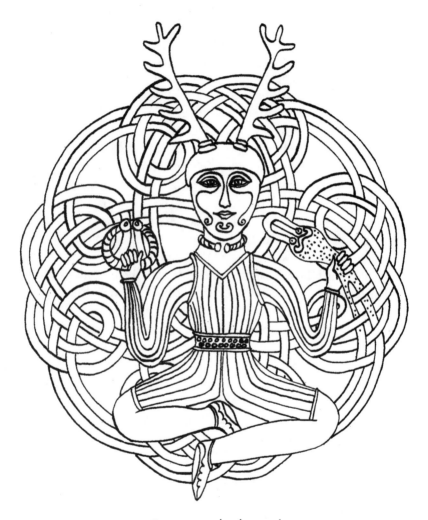

Cernunnos, the deer god

DEER

In grave findings, the deer has been documented as a divine symbol throughout Europe ever since 2000 B.C. This could be because of several of the deer's behaviors that people relate to. The growth rhythm of its antlers corresponds to the sowing and harvesting of grain. In turn, grain serves as evidence of life after death. In addition, antlers could be used as a burial tool.[46] And a doe does not leave her young when its life is in danger.

The deer can also be documented as an animal of ownership and sacrifice. Already among the Celts of the Hallstatt period, it was preserved on objects such as jewelry and coins, and on drawings. It is the emblem of the Celtic god Cernunnos, also called the deer god, which has antlers and is accompanied by representations of various beings.[47] It has, like the horse, a position of honor and is documented already in the pre-Roman epochs of the Celts. Cernunnos is the most impressive half-animal god. It could stand for the change of shape and transmigration between man and animal that is represented in many ways in Celtic literature. Accordingly, in the Irish and Welsh world, the deer is often connected with female persons.

Among the Gauls, the deer is the lord of the animals (corresponding to the animal goddess Cernunna[48]) and of the mysterious abundant forest. The antlers embody the trees, as can be seen on the Gundestrup Cauldron. It also rules over fertility, abundance, and renewal. Its antlers associate it with the female principle (V-shape)

[46]Osborne, p. 15.
[47]As on the Gundestrup Cauldron; cf. Bikhan 1997, pp. 694ff.
[48]Ibid.

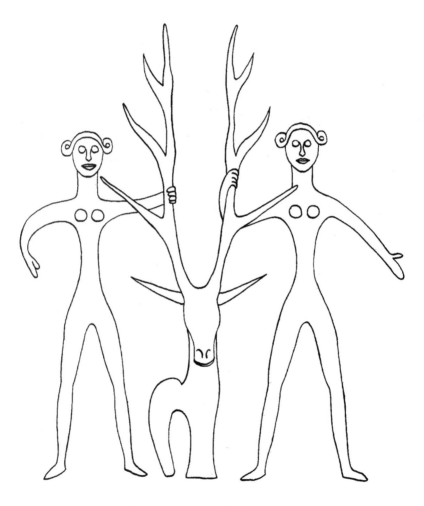

Women with deer

and trinity symbolism. Its prongs associate it with the male princi-
ple.[49] Overall, the theme of fertility predominates, which is fully
demonstrated by the aggressive behavior of the deer during the mat-
ing season.

Deer are portrayed with hunting gods, but they also have other
functions: Pwyll, Lord of Dyfed (Wales), encounters a deer as mes-
senger of the god of the Otherworld. The deer god is also described
as the god of the word and as a provident god with superhuman
intelligence, wisdom, and foresight. Merlin (Welsh Myrddin), the
first adviser of Arthur, organizer of the Round Table and searcher for
the Grail, announces his descent from a deer. In fairy tales, the deer
is often the oldest animal of the forest—243 years old[50] in Welsh
tales—and ready to help.

That the deer is also related to appearance and dignity, since it is
viewed as king of the forest, is told in the Arthurian legend of
Gereint:[51]

*The forest-keeper told Arthur about a deer, the likes of which
he had never seen before. Thereupon, they prepared for a
hunt. Arthur's wife Guinevere (Gwenhwyvar) was to come along. He
agreed with Gawain that the one who captured the deer, whether on
foot or horseback, should give its head to a "female friend of his
choice." The next morning, the followers left but without Guinevere
and Gereint, who had overslept and then encountered other adven-
tures with a few followers. The men around Arthur took the hunters
and set their dogs loose to hunt for the deer. Arthur's dog was the
fastest and drove the deer to Arthur, who cut its head off. As they*

[49]Cf. chapter "Fertility Magic: Men."
[50]Cf. Culbwch ac Olwen.
[51]Cf. also Perdur, "Percival."

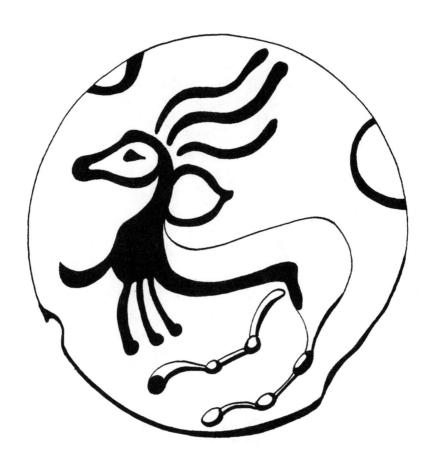

Deer motif (coin)

were riding home, the knights argued over the deer head. Back at the castle, Guinevere proposed that the head of the deer not be given away until Gereint returned. After many adventures, Gereint finally came back to the court and presented Enid as his choice to be given the deer head. Her appearance and manners made all Britain enthusiastic for her. Guinevere decided, in the presence of Gereint, that Enid should receive the head of the deer, since she was the most respected person as well be being friends with and loved by everyone. Upon Enid's receiving the deer head, respect for her and her followers grew.

Today, there are still European fertility customs and religious festivals that are associated with deer symbols. One example is in the English village Abbots Bromly, where a horn dance takes place annually on September 4th.

Steer drawing

STEER/BULL

The bull, as an animal tamed and bred by man, contrasts directly with the deer, which is the unrestrained force of free nature. It shares characteristics with the deer, and appears on helmets, as statues, and as an animal of sacrifice. There is a connection between the crane[52] and the bull. The crane can take on human form by sacrificing a bull.

Cattle is often presented in connection with the house(hold), since cattle breeding (and cattle-stealing) was at that time a means of livelihood. Beef was included in typical Celtic meals, and other valuable foods were obtained from milk, such as butter and cheese. Cattle became more important as it grew into a form of payment. Three cattle lords and three cattle protectors[53] are known.

Evidence of the widespread and early importance of cattle is found in personal, place, and clan names: Taurisci is a clan name, Donnotaurus "Lord-Bull" is the name of a Swiss man mentioned by Caesar who had the same name as one of the two famous bulls from the epic "The Cattle Raid of Cooley [Cualnge]":

Medb, the Mistress of Connacht, was preparing for battle in order to capture the brown bull of Cooley. She started out, without putting on winter clothing, in early November, since she knew that all men in Ulster were in a weakened condition[54] and could hardly put up a resistance. However, 70-year old CúChulainn was full of strength. He went up against Medb, who was advancing.

[52]See chapter "Crane."
[53]Contained in Scottish sagas.
[54]Bromwich 1978, p. 11.

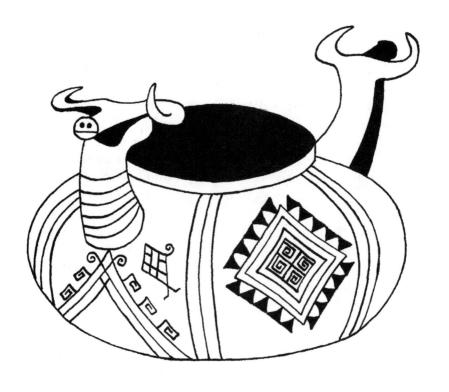

Pot with bull-headed handles

He was able to delay and weaken the advance of the attackers, although the bull was stolen. Still, he tried to prevent the retreat of the Connacht people until the Ulster people were again able to fight. Since he was killing warriors from Medb's troops every night, they agreed on a deal: they would send one man every day to fight a duel, and not advance further if CúChulainn won. Although he was severely wounded, CúChulainn was able to keep the thieves from escaping until some Ulster warriors woke up, went to battle, and killed most of them. Finally, all the Ulster men returned to fighting strength and a duel started with the white-horned Finnbennach of Connacht, during which both died.

The difference between bulls and deer is reflected in two Irish epic cycles. In the epic cycle of Finn mac Umaill,[55] told mostly in Leinster, Finn is the leader of the king's guard and group of foot soldiers, who practiced in hunting in addition to fighting. The two main heroes were called Os(s)car, [Old Ir. *os(s)+car*] "deer+beloved", and his father Oissín (Oisin), "deer+flax."[56] The latter is Finn's son, who was himself originally called Demn, "deer+linen." One clan from Leinster was named Osraige, "deer+rich." The Finn cycle differs with the Ulster epic, in which the charioteers predominate. Accordingly, in addition to fighting, cattle-breeding is the most important occupation here, and cattle are the most important animals in addition to pigs/boars,[57] chariot-pulling horses, and dogs. Sometimes horses were replaced by deer in front of the chariots, thus also with the Ulster hero CúChulainn. Findings give evidence of tamed deer.[58] The

[55]Joyce 1996.
[56]MacPherson: Ossian.
[57]Cf. chapter "Boar."
[58]Birkhan 1997, p. 703.

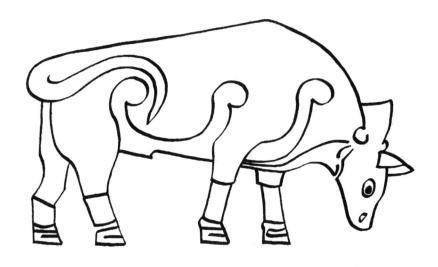

Pictic bull

ability to tame the deer, here the king of the forest, shows the extraordinary power of the heroes.

There are cattle myths and rituals that are still unknown: whether cattle breeding in Ireland went as far as in India; whether a hero makes a cattle-oath by eating cow dung and drinking cow urine, and sleeps on the floor with them without scratching himself in order to become a bull under the kings. In any case, the Church was compelled to make the drinking of animal urine punishable. Other cultures, such as the Scythians, knew these connections and decorated horses with deer antlers. Cattle are considered holy in India even today, and we also know the expression, "Holy Cow!"

The lord of the forest is probably also behind the expression "*Ilwybr tarw*" = "path of the bull/steer," which we refer to as "shortcut."

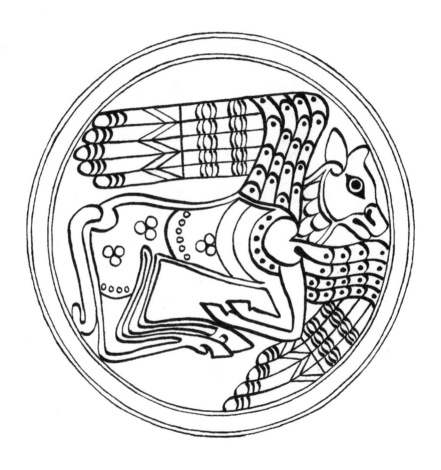

Winged ox, symbol of St. Luke

OX

The ox is likewise significant, although it is not easy to distinguish from the other cattle. It is also an animal of transmigrations; it is consumed, honored, and stolen; and it is also found after the conversion to Christianity as the ox of St. Luke, where the ox is selected as a consecrated sacrifice and a symbol of Christ's priesthood.

In the Welsh story "Culhwch ac Olwen,"[59] three of the forty tasks to be performed by Culhwch involved capturing oxen:

First, Culhwch was able to obtain the oxen of Gwlwlydd ("Brown Hair"), and thereby plow the land of Ysbaddaden properly. His next task was to place a yellow, a pure white, and a spotted ox in the same yoke. These three are the main oxen of Britain.[60] Finally, he was to connect the two horned oxen, one of which lived on the other side of the Horned Mountain and the other on this side, together to the same plow team. The oxen are Nynnyaw and Peibiaw, two kings who were transformed because of their sins.

Oxford, which is documented already in "Cyfranc Lludd a Llefelys"[61] specifically as the center point of Britain, should also not be left unmentioned.

Like steer, bull, and other animals, the ox survives today in heraldry.[62]

[59]Cf. "Boar" chapter.
[60]Bromwich 1978, p. 45.
[61]Cf. chapter "Dragon."
[62]Cf. Rothery, pp. 41ff.

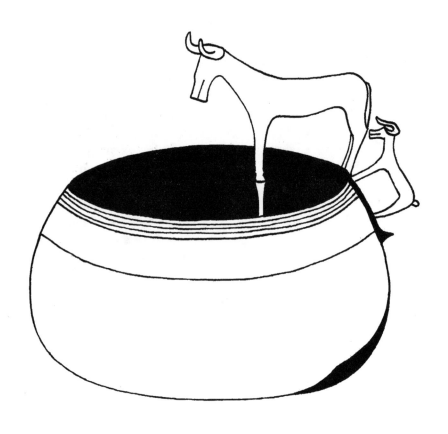

Cow with calf on a cauldron

COW

The cow occupies a special position among cattle, based primarily on the fact that Celtic society survived under matriarchy longer than elsewhere in Europe. This is still reflected today in the world of epic. It stands for sacrifice as well as rebirth and strength.

The appearance of divinities as cows and heifers, the cow's association with fertility, and studies in linguistics support a relationship between the words for woman and cow.[63]

The Welsh triads[64] have three main representatives of this kind for Britain: the spotted cows of Maelgwn Gwynedd, the gray-hides, and Cornillo, "Small Hide."

Even after the conversion to Christianity, the cow remained an important symbol: a red-eared white cow was ridden by the Irish St. Brigid, who could tolerate no other food than cow's milk. Animals with red ears[65] are said to come from the Otherworld, although there are still white cattle with red ears in Britain. The story of St. Brigid shows us that the pagan world of beliefs could still survive in early Christianity.

[63]Birkhan 1997, p. 705.
[64]Browich 1978, p. 119.
[65]Cf. chapters "Dog," "Boar," etc.

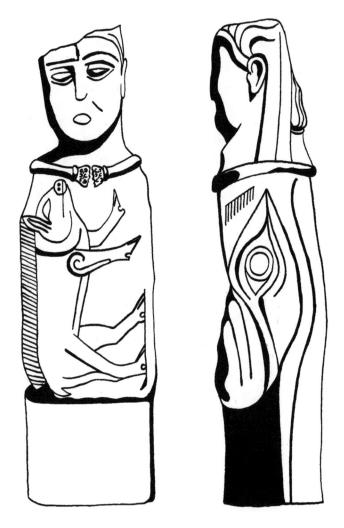

Torque-decorated gods in human form with boar and eye

BOAR/PIG

The boar, like the deer, owes its appearance to its origin from the mysterious forest. It is depicted, often with ruffled bristles, on brooches and coins, and it appears in statues and especially as a helmet attachment. Its natural aggressiveness makes it a symbol of war; its fury is menacing (see Twrch on pages 67 and 69). Boars were carried as an emblem into battle before Gaulish troops; this could have expressed royal dignity/lordship, sovereignty of a clan, or wealth.

The boar was associated with the god Esus, the god of the forest, and his caretaker, later the patron of loggers.[66] It stands for an advanced form of fertility. It is distinguished by great courage in warriors, exploitation of the forest, and new possibilities for clan leaders: as a new tree grows in place of one that has been cut down, so a fallen warrior is reborn.[67] The boar's relationship with the forest is especially strong, since it is fed with the fruit of noble trees, oaks.[68] A striding boar on coins embodies the striving for (royal) power, as does the stealing or hunting of boar described in Celtic literature. Boars that kill snakes possibly represent cults in competition with one another.

The boar is often represented together with the deer. Both stand for change of shape and transmigration. Both were among the most hunted animals. The pig as an emblem of hospitality and feasts, or as a food at banquets, is typically Celtic in this world and the next. It is eaten and reborn in order to be eaten again. It serves as a food for the dead or for introduction to the Otherworld.

[66]Lengyel, pp. 224.
[67]Cf. chapter "Trees."
[68]Cf. chapter "Oak."

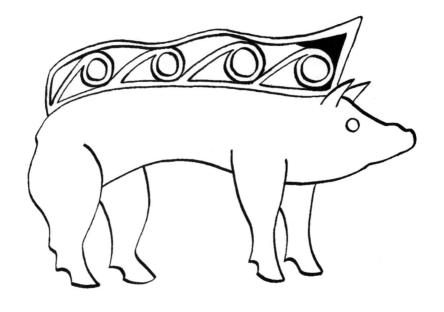

Boar with comb on top

The pig is considered a guarantor of eternal youth,[69] health,[70] and carefree living. Immortal pigs could bring both well-being[71] and disaster. The lords of the Otherworld are often accompanied by boars. Graves were often given and sacrifices made to pigs.

The pig's symbolism is reflected in many ways, primarily in Irish and Welsh epic literature. However, pigs in the insular Celtic tradition are essential animals in the Otherworld, coming from there as domestic animals. The number seven is often associated with them.[72] Here are two stories about this:

MacDathó,[73] King of Leinster, had a dog named Albe that protected his land. He lived in one of the six "buidens"[74] with seven doors, to which seven paths led, and with seven hearths, on which seven cauldrons filled with beef and pork stood, from which anyone who came by the path could eat out of once.

One day, the lord of Ulster, Conchobar, the lord of Connacht, Ailil, and Medb all wanted the dog. MacDathó was advised by his wife to decide the new owner of the dog by a competition. So he slaughtered a giant pig that had consumed the milk of sixty cows for 7 years, and also forty oxen, and invited those people to a feast. According to custom, the bravest warrior was to carve the pig, which required nine men to carry. The warriors of Ulster and Connacht bragged about their deeds, which included the animals taken and the number of heads they had cut off or body-part injuries they had inflicted. Conall Cernach, who happened to have with him a rival's head that he had just cut off, carved the pig, devoured its stomach, and gave its front

[69]Cf. arawns "pigs"; Mabinogi.
[70]Cf. Lugs "pig hide," etc. in "The Fate of the Children of Turenn."
[71]Cf. Henwen, Trioeed Ynys Prydein.
[72]Cf. chapter "The Number Seven."
[73]"Son of two dumb people," a reference to MacDathó's Origin from the Otherworld (dumb = dead?), cf. also the warriors from Matholwch's pot, chapter "Pot."
[74]"Place of the other side," the Otherworld.

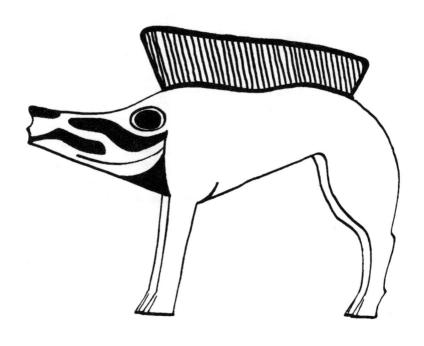

Boar with bristles standing on end

feet to the Connacht men. The blood that flowed out of the pig passed through all seven doors of MacDathó's house and caught fire so that the liquid of life poured out. Finally, MacDathó let his dog decide for himself. Albe chose the Ulster people and chased the Connacht men, during which he was killed by the charioteers of Ailill and Medb.

*C*ulhwch, the first nephew of Arthur,[75] was brought into the world by his mother in a stall full of pigs. Seven years after her death, the father took a new wife. She ordered that Culhwch should marry only the maiden Olwen, daughter of Ysbaddaden,[76] the leader of the giants. Culhwch fell in love with her immediately and rode off on his magnificent fast steed, who was 4 winters old and raised four clods of earth with every hoof, to ask for Arthur's help. He gathered his troops and set out. One of the troops was Olwydd, the "track reader," whose father's pigs had been stolen 7 years before his birth and who had tracked the pigs down again and brought them home in seven stoves.*

Before the house of the giant, Culhwch met Olwen. She told him that the giant had set forty tasks for him. In addition to stealing oxen, a harp, Rhiannon's birds, dogs, a horse, men with equipment and followers, and killing the boar Ysgithyrwyn, "White Fang," Culhwch was to obtain the comb, razor, and shears that were stuck between the ears of the boar Twrch Trwyth,[77] an enchanted king who had sinned. Helping in the subsequent hunt for Twrch were a deer, owl, and eagle, and salmon. Twrch was already in Ireland and had destroyed one-third of it. The Irish as well as Arthur's followers fought Twrch for a whole day without success. From the third day on, Arthur battled the boar for 9 days and nights, but could kill

[75]Birkhan indicates cousin twice and nephew twice. Green indicates cousin.

[76]Many translations are unclear or ambiguous: ysbaddu = castrate, twrch = boar, etc.).

[77]See previous footnote.

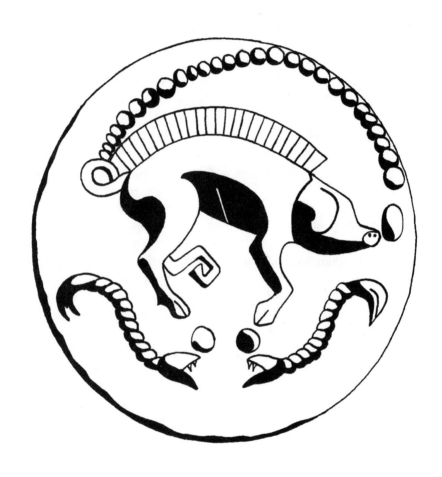

Boar crushing a snake (coin)

only a piglet. Then Gwrhyr, an interpreter transformed into a bird, flew to Twrch's camp with seven transformed piglets in order to negotiate on Arthur's behalf. But Twrch and his followers went to Arthur's land of Wales. Arthur and his men followed. Twrch advanced rapidly and killed the animals and people in Milford Haven. Then he captured four warriors and eight of Arthur's sons. Arthur and his men attacked Twrch at the River Severn [Hafren]. He escaped and ran to Cornwall where another gruesome battle took place. This time, however, the comb was obtained and Twrch was driven from Cornwall into the sea. No one knew where he ended up, and Culhwch[78] finally received Olwen.

Geoffrey of Monmouth[79] speaks in The Prophecies of Merlin about the boar of Cornwall. The Irish St. Brigid was also said to have conquered a boar from the Otherworld, namely Torc Tríath. In the British Gododdin of Aneirin (6th century), "Torch Trychdrwyt" is used as a metaphor to praise a prince.

Some of this romantic story and its symbols have found their way into the French comics, such as "Asterix and Obelix" by Goscinny/Uderzon in the characters Obelix the glutton (boar) and the stone carrier. Otherwise, the pig is of minor importance in today's Celtic communities. Large forests have been unknown in Celtic regions for a long time; lacking natural places of nourishment, the pig therefore now plays only a subordinate role.

Its resurrection was celebrated with Twrch Twyth, a pig transformed completely from an evil to a good character, a beloved children's figure at the Eisteddfod Festival of the Bards in Germany in 1995.[80]

[78]It is suspected (Jones 1986) that Culhwch is himself a boar. Olwen "White Track."
[79]Thorpe, pp. 175ff.
[80]Cf. chapter "Horn."

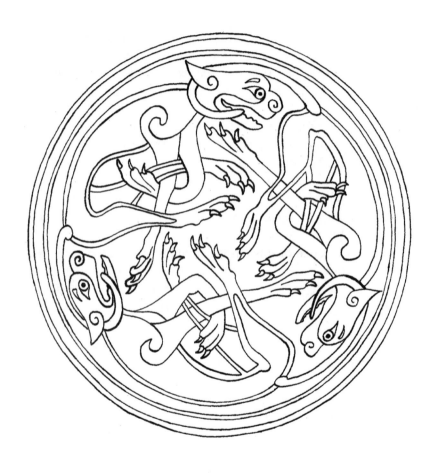

Dog ornament

DOG

Dogs are found as a subject among the Celts starting with the 5th through the 3rd centuries B.C. They appear as companions of female and male divinities and have many layers of symbols, not only in Celtic mythology. The basis for its many layers is the dog's senses of hearing, smelling, and orientation, which are shared in humans. The female side stands for fertility, healing (licking wounds), and love (child's)/house animals/companions.[81] The male side stands for hunting, fighting, and death or its announcement.[82] The releasing of dogs is a privilege according to Welsh laws.[83] Dogs are also protective animals/watchers,[84] both in this world and the Otherworld. As hunting animals, they have a dual function as aggressive attackers and as protectors of their master and his riches.

There is evidence of this among findings in children's graves and by the following Welsh story about the dog Gelert:

Gelert was the dog of Llywelyn, a Welsh prince. He was the bravest hunting dog as well as the most faithful and favorite dog at home. One day, Gelert did not show up for the hunt. Llywelyn rode out sadly without him. Coming home early, he was shocked to find Gelert covered with blood. Llywelyn ran to the nursery. He had left often left Gelert to watch out for his son. Now he could not find his son, only blood everywhere. He believed that Gelert had killed his son and stabbed him with his sword. Shortly afterward, Llywelyn heard his son cry. He found him completely unharmed and safely hidden in a corner. Next to him was a dead wolf. Gelert had defend-

[81]Cf. also historical roles as lapdogs, e.g. with the mother goddess Naix; Botheroyd, p. 280.
[82]Cf. dogs of Annwn in Mabinogi (see Appendix).
[83]Cf. starting to carve a pig in Ireland.
[84]MacDathó, Brendel 1984; cf. CúChulainn.

Vignette with dog motif

ed the child from this wolf. Llywelyn was deeply troubled by the senseless death of this dog and had an impressive tomb built for him—Beddgelert ("Gelert's Grave"; the name of a village north of Aberystwyth).

The most important hero of the Irish epics, CúChulainn, has a close relationship to the dog. He calls himself the dog of his foster father,[85] the smith Caulann, since his first and last (heroic) deed was to kill the Hound of Death—Caulann's dog.[86] CúChulainn is also documented to have taboo connections with dogs. One of them is against eating dog meat. As soon as a smoked shoulder joint of a roasted lapdog is placed under his thigh, he loses his strength.[87]

The various names in the Irish epics that contain the element "dog," such as Cuno, cú, con, coin, cona, conaib, are striking: CúRoi fights against the dog heads,[88] Conchobar ("Dog of Assistance") is king of Ulster, Conall Cernach is one of the three beheaded ruad-choins ("red dogs"). Then there's the military aspect of the dog-breeding of Conall Cernach,[89] who fights the chariots of the horses. His mare, the "Red Sad One," has a dog's head that rips out the entrails of the enemies.[90] There are also fighting dogs, bred from wolves, among the Celts.

Dogs have remained significant in Celtic society. They were and still are gifts,[91] protection animals, hunting animals, guardians, herding animals, and companions for children. They were and still are bred and sold abroad.[92] They are also represented frequently and in many ways. Their frequent appearance as elements in Irish and Welsh names also speaks for the importance of the dog—e.g., the Irish O'Conor, the Welsh Cynon. Dogs also appear in heraldry.[93]

[85]Cf. chapter "The Number Five."
[86]Cf. Thurneysen, p. 563.
[87]Op. cit., p. 551.
[88]Conchinn; Birkhan 1977, p. 371.
[89]Cf. chapter "Snake."

[90]Cf. Pryderi in Mabinogi.
[91]Cf. chapter "Snake."
[92]Cf. the Welsh sheepdog.
[93]Cf. Rothery, p. 43.

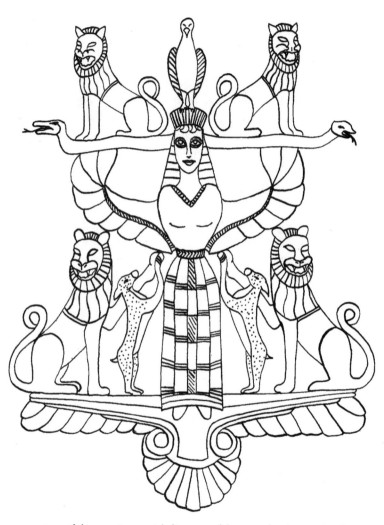

Set of decorations with lions, goddess, and other animals

LION

Although the lion symbol can be found early among the Celts, it is viewed in Celtic mythology research as similar to the dragon. It represents warrior gatherings and appears on coats of arms of Irish clans[94] as well as in the literature. It is found on helmets[95] and as a guardian[96]—probably having arrived in Europe from Asian (e.g., Indian) and African (e.g., Egyptian) cultures through the Greek culture. The lion and other cats appear in Irish and Welsh epics.[97] In the world of fairy tales, the lion was and still is the king of the animals.

In the story of the Duchess of the Fountain, the lion is portrayed with an importance similar to that of a dog—as a guardian:

Owain was saying goodbye to the duchess in order to look for the ends of the world when suddenly he heard a great bellowing in the forest. It turned out that it came from a white lion, who was being threatened by a snake. Owain killed the snake with his sword and proceeded onward. But the lion followed him and played around him like a dog. As Owain rested in the evening and kindled a fire, the lion quickly gathered enough wood for three nights. Then it also brought a roebuck, which Owain cooked over the fire, and lay between the fire and its new master. As Owain cut up the roebuck, he heard a great wail. He found the daughter of the countess, Lunet, who had been locked in a sarcophagus because she defended Owain mac Urien. She could only come out at a certain time and be saved by Owain. Owain shared the pieces of meat with the maiden. He gave the rest to the lion. When Owain camped the next night in a fortress,

94Cf. chapter "Fascination with Animals."
95Cf. Breddwyd Rhonabwy.
96Cf. Perdur.
97Among others, Voyage of Maildun and The Demon Cat.

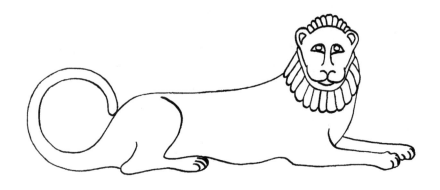

Lion drawing

the lion lay down next to Owain's horse, and no one dared to come near the horse. At mealtime, the lion sat under the table between Owain's legs while Owain fed it. Owain noticed a mourning in the fortress. The lord of the fortress told him that a giant had captured both his sons and would kill them if he did not give him his daughter. With the assistance of the lion, Owain defeated the giant. The giant didn't think it was a fair fight, so Owain kept the lion in the fortress and fought him alone. But when the lion found out that Owain was having trouble fighting the giant, it climbed up on the roof of the palace and jumped over the wall to help Owain. It bit the giant from the shoulder down to the loins, so that all his intestines fell out. The duke thanked him as Owain hurried to Lunet just as two youths were about to throw her into a fire. Owain put the lion in the sarcophagus in which Lunet had been previously placed. Before that, he also built a stone wall in front of the sarcophagus. He started to fight the youths. When the youths were beginning to win, the lion roared, jumped out of its confinement, bit into the wall, and ripped the boys to shreds. In this way, Lunet was saved.

The lion was used in Christian symbolism and stood for St. Mark to emphasize Christ's power and royal dignity.

With the development of chivalry, lions became the most important animals in heraldry because of their characteristic strength, majesty, and aggressiveness.[98] Other animals that also represented heraldry included the leopard, eagle, and boar.

[98]Rothery, pp. 35ff.

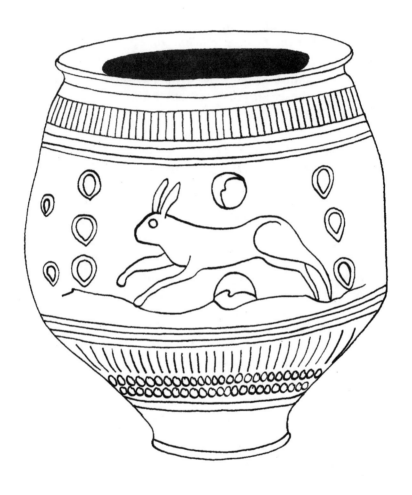

Gaulish-Roman pot with rabbit motif

RABBIT

Among the Indo-Europeans, the rabbit is the animal of the world and stands for growth and fertility (and love?[99]). In Greece, it is the sacrificial animal of Aphrodite. It is active both day and night, fast, and eager to reproduce. In early Britain, it was a holy animal and was not eaten.[100] On the continent, in contrast, there are numerous representations of rabbit hunts and piles of rabbit bones. Later in Britain, possibly from the conversion to Christianity,[101] the rabbit became an animal of witchcraft.[102] Because, according to insular Celtic tradition, the rabbit could transform itself,[103] it later became a figure not clearly defined in international fairy-tale motifs.[104]

The story of the rabbit witch[105] associates the rabbit with witches, which, however, does not correspond to its original significance:

So I was hunting rabbits when I saw an especially fine rabbit doe wiggling her ears and winking with her big eyes. I was excited to have such a fine one before me and that even jumped toward me, as if wanting to say, "You can't catch me." I gathered the last grains of powder together and shot her. Oh, the cry that the rabbit gave would have frightened the bravest man. And suddenly, fog came between us so that I could no longer see her. When the fog cleared away, I saw blood where it had been sitting and followed the trail. This led me to the house of Kathy MacShane. There I heard crying and groaning. As I opened the door, I saw the rabbit sitting in the

[99]Many statements are not sufficiently documented, but rather suspected.
[100]Cf. Ross, p. 437.
[101]Cf. Chapter "Fascination with Animals."
[102]Cf. Chwedl, Taliesin.
[103]Cf. Chwedl, Taliesin.
[104]Cf. chapter "Fish."
[105]Booss 1986.

Celtic-Roman hunting god

form of a woman. A cat was sitting by her, whose back fur she was rubbing. As it became aware of me, it hissed. I asked the woman how she was and what she needed. She said that she had been splitting wood with a hatchet and had wounded her leg, from which marvelous blood was dripping.

Bird ornament

BIRDS

Up to this century, hardly any ability was so impossible to attain, and yet so much desired, as the ability to fly. The abilities to freely fly and swim in order to experience inaccessible worlds are important foundations of mythological belief in connection with birds. The fantasy of these abilities evokes in people both amazement and fear. Likewise, for example, the song of the nightingale, the strength and fearlessness of the raptors, and the special ways by which birds of prey and swimming birds obtain food have been especially prized. Some birds (swallows, cranes, etc.) are said to bring winter to other countries. This therefore indicates that they must come from an Otherworld. Others, such as crows, can be seen frequently in the cold seasons, when nature seems to die. They are therefore often associated with death. At the same time, the flight of birds is a bridge between the worlds—this world, earth, water, and the Otherworld. Birds also have secret knowledge, giving them the gift of prophecy, which the Church later disputed.[106]

Birds have many layers of symbolism that correspond to their various natural behaviors, some of which are still unclarified today. Thus, birds can be harmonizing, life-supporting, and healing, and also destructive and demonic. Birds are also messengers in the broadest sense. They can be omens, as swallows are,[107] or bearers of messages, as is the dove or the starling of Branwen in Mabinogi.[108] Since the birds' abilities were generally strived for by people, birds have also played a central role in transformations, which in every case confer new or even different abilities. As representatives of the

[106]Low, p. 117.
[107]Cf. the proverb "One swallow does not a summer make (... but it announces it)."
[108]See Appendix.

Birds in the tree of life

Otherworld, birds also change into humans[109] who lure people on earth into the Otherworld. For certain tasks, heroes can change into birds in order to obtain information from a safe and high altitude.[110] Sometimes people are changed into birds as a form of punishment.[111]

Because birds can fly without limitations and accumulate experiences, they also symbolize wisdom. They appear as wise beings and advisers[112] or even kings (as does the eagle). Because of their importance, birds appear often in the earliest literature. These include water birds, birds of prey, and some songbirds.

In Culhwch ac Olwen, the owl (of Cwm Cwmlwyd), the eagle (of Gernabwy), and the blackbird (of Celli Gadarn) are mentioned together. These three are identified in the Welsh triads, the "Trioedd Ynys Prydein," as the oldest animals in the world.[113]

Birds are especially close to the Druids and poets, who sometimes decorated themselves with feathers.[114] Unfortunately, we do not know the date of this ceremony. The ability to understand birds represents the highest art that a poet can achieve. Merlin (Myrddin) achieved this ability after he lost his mind and withdrew into the forest.

With the conversion to Christianity, the abilities of the birds increase.[115] This brings to mind the Native American ceremonies. Birds are the messengers of Christ and they carry souls to heaven or hell.[116] They later appear as angels, and more rarely as the voices of the unborn. For Maildun,[117] the many experiences with birds and bird islands are striking. The use of many varieties would also have been supported by the spread of heraldry.

[109]Cf. Lady of the Lake.
[110]Cf. Culhwch ac Olwen.
[111]E.g. Blodeuwedd, Mabinogi.
[112]Cf. chapters "Owl," "Blackbird"; Culhwch ac Olwen.
[113]Cf. chapter "Eagle."
[114]Low, p. 110, but the heroes also did this, cf. chapters "Crane," "Crow and Its Relatives."
[115]Cf. "The Voyage of the Sons of O'Corra."
[116]Cf. chapters "Peacock," "Blackbird."
[117]Cf. "The Voyage of the Sons of O'Corra."

Owl heads

OWL

The owl appears throughout the world as one of the most important mythological figures. We find it in Africa, America, Asia, and Europe—always in association with old traditions. In Europe, large eyes were seen as the symbol of the Great Mother. The owl therefore appears on all possible objects, such as torques and cauldrons, and takes on roles including the role of protector.

It is also a bird that lives in the highly respected forest and orients itself well, especially at night. As is known, among the early Celts the day comes forth from the night,[118] for which reason the owl must have special abilities.

The wisdom of the owl is documented in "Culhwch ac Olwen."[119] In the Mabinogi,[120] transformation into an owl is described as a punishment:

*G*wydion, brother of Aranrhod, raised the latter's son, since he thought she was an unworthy mother. Mistreated by her brother, Aranrhod decided that Lleu should never have a human wife. Gwydion consulted with Math, his uncle, who proposed that Lleu should have a wife of flowers. So the two of them formed a woman from oak petals, nectar, and meadow petals, and Math gave Lleu land. He went with his wife, who was baptized Blodeuedd, and they reigned happily.

One day, Lleu went away to visit his great uncle Math. It happened that Gronw Bebyr was hunting and, surprised by nightfall, was invited in by Blodeuedd so that he would not have to seek lodg-

[118]Cf. chapter "The Number Two: Eye and Moon."
[119]Mabinogion (see Appendix), "Story of the Eagle."
[120]See Appendix.

Bronze owl statuette

ing in the dark. But Blodeuedd, lacking any human experience, fell in love with him. Both were so smitten with each other that they planned to murder Lleu. Blodeuedd subtly asked Lleu how he would probably suffer death. Lleu, impressed by her care, described precisely what would have to happen for his life to end. Thereupon, Blodeuedd arranged with her lover to make the arrangements to kill Lleu. They hit Lleu with Gronw's sword. He flew away as an eagle, badly wounded and crying. Gronw took over his wife and land.

Math and Gwydion heard what had happened. Gwydion searched for Lleu and came upon a house at Arfon. He noticed the behavior of the sow that belonged to the house and decided to follow it the next day. The sow ran to a tree where Lleu was sitting as an eagle, eating the meat that was falling off him and the worms that were eating him. Recognizing that it was Lleu, Gwydion changed him back and took him to the best doctors. As punishment, Blodeuedd was transformed into an owl named Blodeuwedd, "Flower Face." She did not dare to show her face in the daytime or else the other birds would attack or annoy her. Lleu dueled Gronw and reestablished his power.

Here, the elements of punishment through ugliness, cold, and loneliness are in the foreground. Later, owls are often accompanied by witches. In heraldry, the owl is included as, among other things, a bird of wisdom.[121]

Since Blodeuwedd in the Mabinogi,[122] the owl has never been absent as a subject in Welsh literature. The founder of modern Welsh drama and a nationalist, Sanders Lewis named one of his dramas "Blodeuwedd," which became the most important Welsh-lan-

[121]Rothery, p. 53.
[122]See Appendix.

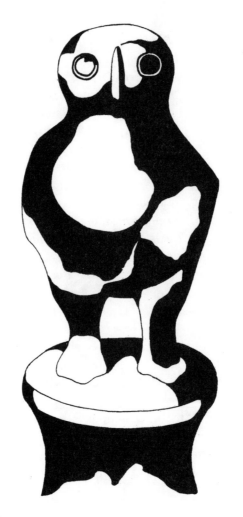

Owl figure

guage novel of the eighties (Yma o Hyd, "Still There"). Blodeuwedd, its heroine, is sitting alone in a shockingly gruesome prison after a crime in the struggle to maintain the Welsh language. Another large novel, *The Owl*,[123] is full of stories that elaborate the theme of Blodeuwedd.[124]

The owl is still seen a protector, as it is used on many signs as a symbol for protecting the landscape. It is also associated with wisdom when it is depicted with a mortarboard sitting on books. But the owl's dark side is also prominent among us, as is evident when we fear something ominous upon hearing an owl screech.

[123]Y Dylluan—A. Jones.
[124]Cf. Elin ap Howel: Owl Report and others.

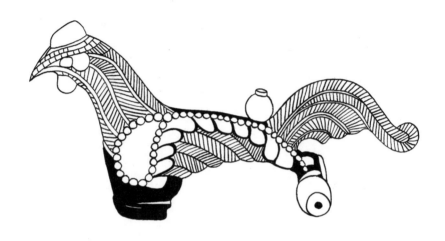

Rooster-shaped clasp

ROOSTER

Like the crane, goose, and rabbit, the rooster is a holy animal that is not eaten in some Celtic regions. The rooster is the announcer of the new day, embodying the active side of life. It is also a symbol of the lust for love and life and of fertility.

The rooster accompanies divinities, such as Mercury/Hermes, who are associated with abundance and financial success.[125] This god is sometimes represented with three faces or three phalluses. The rooster appears in Gaul accompanying the Mother Goddess, who symbolizes fertility.[126] As a bird of battle, it can be seen on helmets and on coins minted in Gaul.[127] In addition, it has contributed its proverbial and natural lust for fighting (namely over hens).

Today, the rooster is the animal on the coat of arms of France, which originally meant "Kingdom of the Franks." The rooster as a symbol spread as the Franks occupied much of the territory except for Britanny. Roosters were one of the birds that were used most in heraldry.[128]

The association of the rooster with fertility is especially evident in this German proverb, which applies more to thin than "macho" men: "A good rooster is not fat." And also at Easter, as in the early Mediterranean region, we care for the baby chicks.

[125]Ross, pp. 107ff.
[126]Op. cit., p. 337.
[127]Rothery, p. 54.
[128]Rothery, pp. 53ff.

Peacock motif

PEACOCK (SWALLOW, GULL, SONGBIRDS)

The peacock, primarily beloved in the East (Persia, China), is one of the birds most frequently used in heraldry.[129] It is associated with the sun cult. Its impressive feathers can stand either for the firmament or path of the sun. Not much has been handed down about the Celtic cults, including the sun cult.[130] Likewise, little is found in literature about the peacock.

The representation of the peacock is known today primarily from its use after the conversion to Christianity. Here, the peacock developed into a symbol of immortality. Its tail carries all the colors of the rainbow. In heraldry, it stands for pride.

Similar developments occurred for the swallow, gull, nightingale, starling, and other songbirds. They are only mentioned in some stories,[131] and each appears only in later literature or heraldry, such as in "Dafydd ap Gwilym"[132] and in modern Welsh and Breton literature.[133]

[129]Rothery, p. 53.
[130]Cf. chapters "The Number Two: Eye and Moon," "The Numbers Three and Four: Sun."
[131]The swallow in Thurneysen, p. 137.
[132]Cf. Loomis.
[133]Cf. Kate Roberts and Anjela Duval.

nt én gaires asin tsail
álainn guilnén as glan gair:
rinn binn buide fir duib druin:
cas cor cuirther, guth ind luin.

Och, a luin, is buide duit
cáit sa muine a ful do net:
a díthrebaig nad clind cloc
is bind boc síthamail t'fet.

(Dillon/Murphy)

The bird, who from the meadow sang
the wonderfully beautiful song of a little swallow,
lovely yellow lips of a strong young black:
Wonderful white was played, the voice of a
 blackbird man.

O blackbird, you are at peace
no matter where your nest is in the thicket
Hermit, who touches little bells,
your melody is soft, peaceful, and sweet

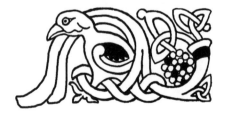

BLACKBIRD

In Wales, the blackbird is considered one of the oldest animals. Though it mostly appears only briefly, it is mentioned relatively often in traditional Celtic literature:[134]

nt én bec *The little bird*
to léic fet *has sent a pipe*
do rind[135] guib *from the tip of its beak*
glanbuidi *brilliant yellow*

fo-ceird faíd *it sends a song*
ós Loch Laíg *about a lake, Loch Láig,*
lon do chraíb *from a branch of the wide forest*
chrandbuidi *a blackbird*

(Anonymous, 9th century, Ireland)

[134]Including Cross, p. 423; Birkhan II 1989, p. 71.
[135]The spelling varies according to the various sources and editions: rinn/rind, guib/guip, chrandmaige/chranbuidi, etc.

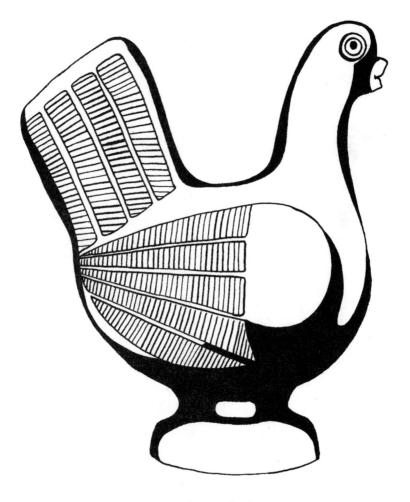

Clay figure of a dove

DOVE

The dove was the companion of Venus, the Roman goddess of love, and stood for peace, harmony, and affection. Among the Celts, it also seems to receive healing characteristics. It is scarce in traditional literature, but it reached its significance with the blossoming of Christianity and heraldry, and in fairy tales, such as Cinderella.

One of the three patron saints of Ireland, St. Columba, is called Colum Cille, "Church Dove." Traditionally, there was a connection between religious authority or a person from the Otherworld with birds other than the dove. The introduction of the dove seems to have arisen from Christianity[136] to become the symbol of the Holy Ghost. Another old "dove function" is that of the oracle.[137] It also symbolizes peace and care for all living creatures.

Colum Cille was either a poet or like a poet, and his fame was based on his visionary ability, his hymn writing, his learning, his noble descent, etc.[138] His relationship to poets was conflicted, since his religious functions disagreed with his traditional tasks, such as supporting the king.[139]

The dove is once mentioned in connection with a great massacre—the slaughter in which CúChulainn[140] is killed.[141]

In the following Welsh poem,[142] the dove is a lover:

[136]Cf. birds in the Bible.
[137]Green, p. 85.
[138]Cf. Welsh, p. 109.
[139]Cf. Low, p. 112.
[140]Cf. chapter "Transformation and Transmigration of Souls."
[141]Thurneysen, p. 560.
[142]Jones 1978, p. 31.

Glomen

Fel roeddwn i ryw fore hawddgar
Yng nghwr y coed ac wrth fy mhlesar
Ar frig y pren, mi glywn ryw glomen
Yn cwyno'n glâf "Aw! Beth a wnaf
Am f'annwyl gymar?"

A nesu wnes yn nes i wrando
Beth oedd y gangen ferch yn cwyno;
A Mentro wnes a gofyn iddi
"Y lana o liw, a'r fwyna'n fyw
Begth yw dy g'ledi?"

"Rhyw g'ledi mawr sydd yn fy mynwes
Wrth gofio'r cur a'r poen a gefais;
Wrth gofio'r mab a'r geiriau mwynion
I'm calon rhoes drwm glefyd loes—
Fe dyr y nghalon."

Y Glomen fwyn, O paid a chwyno
Fe gyfyd haul ar fronnydd eto
A phan y dêl, daw'r coed i ddeilio—
Ti golfio'n dda, pan ddelo'r ha'
Daw'r gweilch i rodio.

(Author unknown)

100

The Dove

As I was one morning
At the edge of the forest full of lust
A dove on the tip of a branch
I heard complaining sadly: "Oh! What shall I do
About my dearest one?"

And I listened more and more closely
to the song of the maiden of the branch;
And dared to ask her—that I did:
"Most beautiful apparition and dearest living being,
What is your sorrow?"

"A great sorrow is in my breast
Cut and stabbed while thinking;
While I was thinking about the man and his dear words
He gave me a terrible bleeding wound in my heart.
Alas—he broke my heart."

Dear dove, so stop complaining,
The sun will surely rise over the hill,
And when it comes, the forest will come to life—
Always remember that, when the summer starts,
the heroes will come to hunt.

The dove, who announces divine peace at the end of the Flood with an olive branch end, also embodies the Holy Ghost in the New Testament. It has retained its symbolic force until today. It is the best known symbol for peace, and this symbol is strengthened by a palm branch. It is also still today a messenger animal.

Eagle statuette

BIRDS OF PREY: EAGLE

The eagle and its impressive wingspan are associated with strength. In Asia, it was a holy bird[143] and later became an imperial symbol that carried the soul of the ruler to heaven. It was a companion bird[144] to the Roman (Jupiter) and Greek (Zeus) gods. Until the Middle Ages, it was thought that it could fly toward the sun with its eyes open and rejuvenate. As a result, the eagle was also said to have originated from fire.[145]

The eagle has decorated the helmets of warriors.[146] In Welsh tradition, it is considered one of the three oldest animals[147] and people have wanted to transform into this bird in order to, for example, survive in the Otherworld.[148] The eagle also stands for wisdom and visionary ability, which gives it royal dignity.[149] Geoffrey of Monmouth[150] tells how Arthur, on his excursion to Scotland, discovered in Loch Lomond sixty islands with sixty nests and as many eagles, which gathered there every year to talk about things that were to occur in Britain during the coming year.

The following Welsh story tells about the age and wisdom of the eagle:

A fter the death of his wife, the eagle, king of the animals, was sitting on a cliff on the coast of Pembroke at Stackpole, looking at the sea, and asking himself aloud where he would find a new companion who would be worthy. The South Wind answered him

[143]Rothery, p. 47.
[144]Ibid.
[145]Lengyel, p. 28.
[146]Cf. Breddwyd Rhonabwy.
[147]Birkhan II 1989, p. 237.
[148]Lleu flees from death as an eagle, fourth branch of the Mabinogi (see Appendix).
[149]Cf. The Ancients.
[150]Thorpe, p. 219.

Eagle as helmet ornament

that he should marry the owl. He followed the advice of the wind but first set to find out whether the owl was worthy to become a queen. He sought advice from his friend the red deer. Although the deer was almost as old as the oak, he sent the eagle to that tree. The oak had grown for 700 years, bloomed for 700 years, and been dead for 700 years. But the owl was already old when she met the oak for the first time. So the oak sent the eagle to the salmon, who was even older. But it sent the eagle to an even older blackbird. The blackbird was so old that it had chipped away a cliff until it was small. It only knew the owl as an old woman and, therefore, sent the eagle to the toad. But the toad, although it had consumed the land between the Preseli mountains in the meantime and there was not enough left over to satisfy its hunger, only knew the owl as a venerable lady. Now at last the eagle was convinced that the owl came from a good family and married her. He welcomed the animals because of their age.

In the *Book of Kells*, the eagle in St. John stands for the ascension to heaven. It keeps its gaze directed steadily on the unchangeable truth, and looks with a thirst for knowledge and clear eyes. The eagle is still considered a majestic bird. In heraldry, it is second only to the lion in importance.[151]

[151]Rothery, p. 47.

Ornament of birds of prey

HAWK, FALCON, ETC.

The ways in which birds of prey obtain food make them suitable as hunting animals. Like all successful warriors under the conditions of early society, raptors brought fame to those who possessed them. They were especially favored as helmet ornaments, and they therefore stand for power, strength, and aggression. Their importance has also been preserved in heraldry.

In the Welsh Arthurian epic "Gereint ap Erbin," the hawk plays an important role in entertainment:

Guinevere [Gwenhwyvar], the wife of Arthur [Artus], over-slept at the start of the hunt, as did Gereint.[152] Therefore, they both set out alone. On their trip, which was full of adventures, Gereint met a dwarf, who was pulling a knight and a woman that were both seated on a large horse. The dwarf answered no questions and immediately struck Gereint mercilessly with his whip. After that, Gereint continued on his way. While the dwarf, the knight, and the woman were entering a castle, celebrating, Gereint took shelter in a run-down house, where he was generously accommodated. It turned out that the residents—a very old man, his wife, and a very beautiful maiden—were the former builders and owners of the castle, which had been taken away from them by the current owner, their nephew.

One day there were preparations for games: in the middle of the meadow, two forked branches were set up, each of which held a silver rod. Hawks were placed on these so they could be fought for in the tournament. A man was admitted only if he came with the

[152]Cf. chapter "Deer."

Eagle motif scratched in stone

woman he loved most. Whoever won a hawk three times in a row was able to keep it. Gereint thereupon asked his host for a weapon and for the hand of his daughter, whom he wanted to take as his beloved for the rest of his life. Gereint had to drive away the hawk, which was now sitting on the hand of the woman, from the knight whom the dwarf had been pulling. The two fought each other until their weapons broke. The old man handed new weapons to Gereint and the dwarf gave the hawk to the knight. Recalling the injury that the dwarf had originally caused him, Gereint gave the knight a severe blow and won the hawk tournament.

At the time of the conversion to Christianity, raptors were also associated with water to symbolize rejuvenation and rebirth.[153]

Like much else in nature, birds of prey are today threatened with extinction. Although there are still many birds of prey in the Celtic lands, people are generally aware of the environmental hazards here as well, and protective measures have been taken. For example, in Central Wales today, the red kite, which is just as elegant a bird of prey as the famous silvertail, is watched and protected during mating and incubation periods. With increasing environmental pollution and an associated lack of prey animals, they will surely also have to be fed by us.

[153]Cf. "The Isle of the Mystic Lake."

Attachment in the form of a duck

WATER BIRDS

Water birds are especially loved in the Celtic mythological world of birds. Their symbolic force is strengthened by their connection with the water cult (see chapter "Water Cult," page 265). In addition to having the abilities of all birds, water birds can also dive and swim. People of early times could comprehend an Otherworld at the bottom of a body of water more easily than a completely unknown space of heaven.

Water birds can be frequently seen on pins, belt hooks, and useful objects. In fairy tales, they often bring back magical objects that have fallen into water, which makes them part of the magic.

Swan-shaped attachment

SWAN

The graceful long neck of water birds, such as the swan, goose, and crane, has inspirated decorations on chariots and vessels in early Eastern Europe[154] (7th–6th century B.C.). The swan and duck pull boats or religious carts and form a barque. The two birds are usually of the same importance and difficult to distinguish from one another, for example, on helmets. In the insular Celtic epics, swans stand before ducks. They are capable of destruction, but they are mostly birds of temptation or escape from and in the Otherworld. For example, Midir disappears in this manner with Étain,[155] after he has courted her for a long time.

People are changed into swans as a form of punishment or revenge.[156] The swans often enchant people through their song or sing them, including CúChulainn, to sleep. The role of birds of temptation or escape, as with Midir and Étain, is also played by the swans in the "Dream Story"[157] of Aengus. They are from the Otherworld and must always be kept separated from each other by chains.

Swan pairs remain together for life. This could be the reason why they also appear in heraldry in chains and why in some cases people prefer to be transformed into swans.[158] The brilliant white color of their feathers, which stands for purity (a prized characteristic of beautiful women in many literatures), and their grace possibly make the swan a creature that women wish to transform into.

[154]Green, 203.
[155]"The Wooing of Étain."
[156]"The Tragic Story of the Children of Lir" (Eng. "Lear," Welsh "Lyr").
[157]Thurneysen, pp. 300ff.
[158]Cf. chapter "Transformation and Transmigration of Souls."

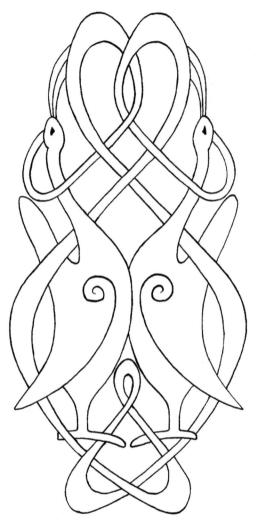

Vignette with water birds

*A*fter Lir's wife died, the king of all Ireland, Bove Derg, offered him one of his daughters. Lir chose the eldest, who bore him twins. During the birth of the second, she died. Lir then went again to Bove Derg and was given his second daughter, Eva, as a wife. She at first took care of his children with love. Eventually, however, she became jealous of them and wanted to kill them. On the way to her father, who was happy to take care of Lir's children, she asked people in the entourage to get rid of the children. They refused to do so, leaving her to do it herself. She failed, but changed the children into swans and went to her father alone. He, surprised that his grandchildren had not come along, had people ask Lir about them. Lir, also shocked that the children had not arrived at Bove Derg's castle, began a search for the children, suspecting that Eva was behind their disappearance.

At Lake Davra, Lir encountered four magnificent snow-white swans. His daughter, Finola, revealed their fate to him. In addition to having to spend three times 300 years on various bodies of water (Lake Davra, the Moyle ocean current, and the Sea of Glora), North and South would have to unite and St. Patrick come to Ireland and hear the Christian bells announcing him before they could resume their human thoughts, voices, and (Irish) Gaelic language. As swans, they could sing sweetly and rock anyone into a soft sleep, with their magical music, from which that person would awaken recovered free of all cares. The next day, Lir left his children, after their song had eased him. At the court of Bove Derg, Eva received her punishment and was changed into the most hated being—a bird. The four swans spent the next 300 years in Bove Derg and Lir's entourage engaging in pleasant conversations and songs. From then on, swans were no longer hunted in Ireland. Then they had to go to the Moyle ocean current where they suffered the greatest pains from wind and weather. The winter storm turned the skin of their feet to ice. Their breast

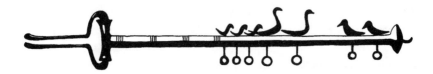

Fishing hook with a family of swans

and wing feathers stuck to the cliffs. Their wounds were burned by the salt water. With each danger, Finola took her brothers under her wings and breast in spite of her hunger, fear, and pain. Only once were they found by Bove Derg's entourage. After 300 years, they again had to move, to the Sea of Glora. There they suffered the same pains. At the end of these 300 years, they went to their father, but his house was abandoned and dilapidated. Deeply upset, they flew back to the west to the island of Glora and landed on a lake. There they sang so beautifully that in the evening all the birds came down to the lake after searching for food. Finally, the swans heard the sound of bells and met Kemoc, who fed and taught them. The king of Connacht heard about the swans and wanted Finola for his wife. But since Kemoc did not want to give them up, the king took them by force. On the trip back, the swans lost their feathers and regained their human forms. They were now four old people with white hair, bony and wrinkled. Finola sat down one more time and asked to be baptized. She wanted to be buried with her brothers, as they always had been together: one under her breast, the others at either side of her. Kemoc did as he was asked and erected an Ogham stone to them.

This epic shows a successful conversion to Christianity, which is embodied in Lir's dilapidated and abandoned house as well as by the bells and baptism. The swans become soul-bearers. The transformation into swans as a form of punishment later became a well-known motif in the European world of fairy tales.

In heraldry, swans are the royal animals of hunting and chivalry.[159]

[159]Rothery, p. 51.

Goddess with goose

GOOSE

In addition to having the characteristics of other water birds, geese can be aggressive, which associates them with warriors.[160] Today, they are still known as attentive watchers.[161] These two aspects made the goose a beloved animal[162] that was added on military graves or accompanied gods of war.[163] The goose was not an animal to be eaten.

The following story is told about King O'Toole and his goose:[164]

There was once a king by the name of O'Toole to whom the churches belonged in the early years. His life was happy. Everything changed when his health got worse and he was no longer able to hunt. He obtained a goose to take care of him and protect him. Every Friday, it caught trout for him. Then he met St. Kavin, who asked about his goose and offered to rejuvenate it. The astonished king whistled for his goose as if it were a dog, and it came waddling up. The agreement was reached that the king would give the young man all the land, but the rejuvenated goose could flee. Thereupon Kavin threw the goose high into the air. And it flew as fast as a swallow before the approaching rain, as light as a lark. The king kept his agreement and gave Kavin, the greatest of all saints, all his land. The saint, satisfied with the king's test, supported him for the rest of his life. The goose also served him until it mistook an eel for a trout and was killed by it. The king, however, ate none of the goose, since the saint had blessed it.

[160]Botheroyd, p. 350.
[161]Cf. "King O'Toole and His Goose."
[162]Caesar, "The Gaulic War," V.12.
[163]Green, p. 107.
[164]Booss, 1986.

Container in goose shape

This is another myth depicting the conversion to Christianity. In addition, the old Celtic rule of not eating geese, since they are holy, is done out of respect for the Church.

In another story ("The Twelve White Geese"), Irish traditions later become similar fairy tales in various countries.

In the Welsh tradition, the appearance of geese in the night is an evil omen,[165] since they were then viewed as witches.

In 1691, the Limerick Agreement was signed and, thereby, the conquest of Ireland was finally and irreversibly completed. As a result, the Celtic social relationships in Ireland collapsed and numerous Irish officials emigrated. This process is known in history as the "The Flight of the Wild Geese."

[165]Ross, p. 343.

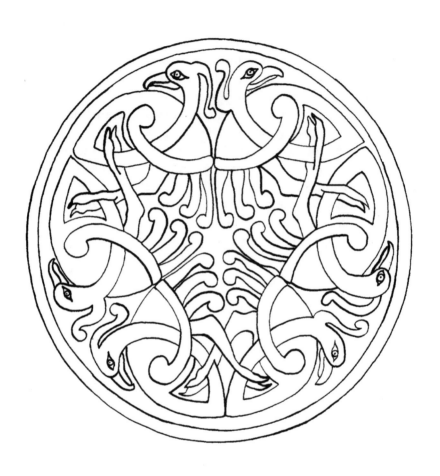

Intertwined cranes

CRANE

Cranes appeared in the period of the urn fields (1200–1000 B.C.) and were associated with the bull.[166] They are found on coins and weaponry such as sheaths, shields, and helmets, thus giving the crane a military aspect. Otherwise, cranes stand for contradictions; they can take strength from the enemy, or they can bring luck to the warriors.

Cranes can also stand for miserliness: Athirne[167] made three cranes fast for their lack of hospitality to the lord of the Otherworld, Midir. The cranes cried: "Don't come!" "Go away!" and "Away from the house!" Whoever saw them could not hold a battle against an equally-strong enemy on that day. Later, there was a prayer that was to protect a person from cranes.[168]

People can be turned into cranes and sometimes can only be returned to human form with the blood of a bull.[169] Like herons, cranes are associated with water and meadows.[170] They are also connected with death and life.[171] The mystique of the crane is not clearly understood. It must have been a holy animal, since until the high Middle Ages there was a taboo against crane meat in Ireland.[172] Its respect is shown by the "Lonely Crane," one of the wonders of Ireland: since the beginning of time, as told in the Mayo region of Ireland, there has lived on the island of Iniskea a crane who will live there until the end of the world.[173]

According to legend, St. Columba himself nursed a crane (or heron) back to health, but then changed a queen who opposed him into a crane as a revenge.[174] As a man of God, St. Columba took in an outcast creature, in this case, the crane. But he was also a master in the ways of punishing disobedient persons.

[166]Botheroyd, p. 351.
[167]Thurneysen, p. 513.
[168]Low, p. 117.
[169]Botheroyd, p. 352.
[170]Green, p. 68.
[171]According to Green 1968.
[172]Birkhan 1997, p. 814.
[173]Joyce, p. 29.
[174]Low, pp. 111ff.

Statuette of a crow

CROW AND ITS RELATIVES

Crows, ravens, jackdaws, magpies, etc., are widespread symbols throughout the world. In India, the raven was the preferred bird of fleeing for human souls. In the western U.S., it was an ancestor for various Native American tribes as a creator of the world. The crow and its relatives were also respected among the Germans and Vikings. The Vikings used it as a standard in A.D. 787 against Britain.[175]

Among the Celts, crows and their relatives (it is difficult to differentiate the species when they are used in pictures) can be seen on coins and helmets and are associated with gods. Women appearing with them are connected with war and death or as prophets in that they can take on the shape of crows, etc. This pertains mainly to Macha, Badh, and Morrigán.[176] Thus, the crow can be a bird of slaughter. Medb also appears as a crow.[177]

Ravens play a role in the founding of Lyon (France), where they are said to have fallen from heaven. The raven on the coins of Lyon can probably be recognized on the coins and on the Lyon silver cup from the 1st century. To the west of Lyon, there was also a clan by the name of Branovices, "Raven Warrior."

It is assumed that the crows and their relatives originally represented unrest and causing disputes. Perhaps they were even wise and spoke the truth.[178]

There are some places that include the word "raven" in their name, and there may even have been a raven god. It could be rep-

[175]Rothery p. 52.
[176]Cf. chapter "Transformation"; Thurneysen, pp. 63f, 564.
[177]Thurneysen, p. 176.
[178]Birkhan 1997, p. 723.

Horse figure with birds

resented in Bendigeidvran, "Blessed Raven," brother of Branwen, "White Raven."[179] Its military characteristics seem to disappear in the face of magic. When Bendigeidvran is nearing death, he predicts to his surviving wife the next 87 years. He also has his head buried in London, presumably where today the tower stands about which the ravens fly.

The association of crows and their relatives with the military is shown by the following Welsh Arthurian epic, the dream of Rhonabwys. It involves the raven of Owain, the deadly military power of this leader of the Britanny army:

*A*rthur [Artus] and Owain ap[180] Urien were seated and play-ing the Gwyddbywll game[181] while their two armies were in battle. Three of Owain's squires came and reported to him that Arthur's warrior, Owain, had brought down, attacked, and killed some ravens. Owain asked Arthur to withdraw his warriors. They ended the game and started a new one, and again a squire appeared with a similar report. Owain again asked Arthur to order his men to stop, but Arthur did nothing. The game ended and a new one start-ed. Once more, a squire came and reported the death of many ravens. Owain again asked Arthur to call his warriors back. Since Arthur appeared not to hear this and instead asked Owain to keep playing, Owain had a stand erected amidst the battle turmoil. His ravens recovered and went over to counterattack. They carried away the heads, eyes, ears, and arms of those they had wounded, broke them into small pieces, and swallowed them. One of Arthur's knights immediately came and told him of the death of many of his warriors. Arthur asked Owain to retreat. This time, Owain insisted on contin-*

[179]Cf. chapter "Cauldron."
[180]Welsh for "son"; see Appendix.
[181]"Wood understanding"—a board game related to chess.

Crow in flight

uing to play. And so the slaughter went on, until again one of Arthur's knights came and announced the butchery of so many good sons of Britannia that it would no longer be easy to defend the island. Again, Arthur asked Owain to call back his ravens. But Owen insisted, undisturbed, on continuing the game. And so they finished it and started a new one. And when this game was coming to an end, another knight came to Arthur and reported that all the noble youths of the island had been killed. Arthur once more demanded the withdrawal of Owain's ravens and, in so doing, he ground the golden game pieces to dust. Now Owain lowered the stand for the first time and peace prevailed again.

It is interesting that the charioteer of the Irish hero CúChulainn is decorated with a hooded cloak of (raven) feathers as he prepares for war.[182]

Legend also holds that Arthur, as a giant raven, having ascended after his murder in the slaughter at Camlan,[183] hovers over Britannia and Brittany and waits for the opportunity to appear as the ruler of the united British peoples.[184]

We encounter crows or their relatives again in fairy tales, primarily as companions to witches and magicians.

The destructive aspect of crows has been preserved also in Welsh proverbs:

rhwng y cwn á'r brain—"between the dogs and crows"
= it's going/breaking down
ym mhig y frân—in the crow's beak
= under the most difficult circumstances

[182]Thurneysen, p. 179.
[183]Cf. chapter "Owl"; the story of Blodeuwedd.
[184]Rothery, p. 52.

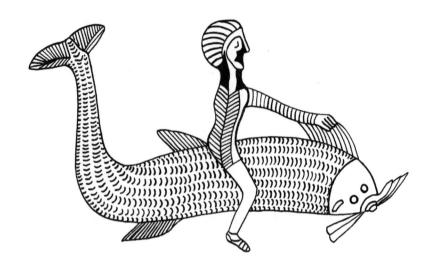

Motif from the Gundestrup Cauldron

FISH: SALMON

Fish, such as salmon and trout, and possibly dolphins, appear on coins, cauldrons, stones, scepters, etc. Salmon was the most important food fish of the insular Celts.[185] In many Irish stories, it is one of most important foods. Salmon saved Maildun from hunger,[186] as did apples,[187] on his trip, and it is sometimes the only edible thing, such as on an island full of giant salmon.[188] On this island, the salmon is associated with the water cult as the source of healing, as in the fairy tale of Baranor: he catches and eats the blind salmon to become the world's strongest man. Everything he does also turns out good for him. Baranor can heal with a few drops of the juice (oil) of the salmon and water.[189]

Salmon, trout, and later sometimes also eel belong to a holy fountain.[190] There are parallels to this in China, Africa, and America.[191] The fish, by its nature, wanders between worlds where it is attracted to its spawning grounds; the eel even changes elements and goes over land. Fish are bodies of transformation[192] and later become carriers of souls, such as that of CúRoi.[193]

In the insular Celtic tradition, it is the salmon that carries the liberator through water[194]—in contrast to the continental Celtic tradition in which the dolphin carries dead souls to the Otherworld—as shown on the Gundestrup Cauldron[195] (see left).

[185]Birkhan 1997, p. 729; Thurneysen, p. 490.
[186]Cf. "The Voyage of Maildun."
[187]Cf. chapter "Apple Tree."
[188]Joyce, pp. 149f, 169ff.
[189]Hetman, pp. 30ff.
[190]Cf. chapter "Transformation and Transmigration of Souls"; Morrigán.
[191]Low, p. 77.
[192]Cf. "Liban the Mermaid."
[193]Thurneysen, p. 434.
[194]Birkhan II 1989, pp. 73f.
[195]Birkhan 1997, pp. 378ff.

Phantom rider with fish (coin)

In the Irish and Scottish traditions, there are several variations of the "Salmon of Knowledge"[196]; in many it is the incarnation of the first man in Ireland. In "Culhwch ac Olwen," it seems to be the oldest being, as only it knows where Mahon vah Modron lives.[197] Also an old river being is suspected to exist as a salmon,[198] and must be appeased in order to get a rich catch; he is possibly a salmon god among the insular Celts.

A long time ago, it was predicted that a man named Finn would be the first man to eat the Salmon of Knowledge, which swam in Lake Linn-Fec near Boyne, and thus obtain knowledge and the ability to prophesize. This prediction was known by an old poet named Finn, who, hoping that he would be the first man, moved into a house by that lake. He fished there every day from morning to evening in the hope of catching this fish.

At that time, there lived a youth named Demna, who fled in disguise from place to place in order to avoid the enemies he had inherited. He came by chance to this lake and was hired by the old man as a servant. It took some time, but in the end the poet hooked the salmon. He gave the fish to the youth to bake, but warned him neither to eat nor even taste it. Demna did as he had been told and placed the fish on the fire. Soon afterwards, the heat caused a blister to form on the side of the fish, which Demna tried to push back in with his thumb. In doing this, he burned himself and without thinking put his thumb in his mouth and accidentally hit a tooth. After the salmon had been cooked, the poet asked the youth whether he had eaten any of the fish. He denied this, but told about his burned thumb, which he had immediately stuck in his mouth. The poet

[196]Joyce, p. 468; Baranor above.
[197]Birkhan II 1989, pp. 73f.
[198]Birkhan 1997, pp. 729f.

Human head with fish (coin)

immediately cried out, "Your name is not Demna, but Finn. The prophecy is fulfilled in you, and you are now a prophet and a man of knowledge." And since that time, whenever Finn wanted to see into the future or had to consider his future course, he always placed his thumb on the tooth which he had hit while cooking the salmon.[199]

In Scotland, there are two similar stories based on a literary tradition that was essentially shared with Ireland up to the 17th century. Here, the hero was called Fionn MacCumhal, but in one of the stories a trout appears in place of the salmon.[200] Knowledge also comes to Gwion Bach,[201] who becomes a poet after a few drops fall out of Ceridwen's cauldron onto his finger.

With the conversion to Christianity, the salmon eventually became a symbol of Christ himself.[202]

[199]The Boyhood Deeds of Finn.
[200]Agricola, p. 36.
[201]Cf. chapter "Transformation and Transmigration of Souls."
[202]Low, p. 78.

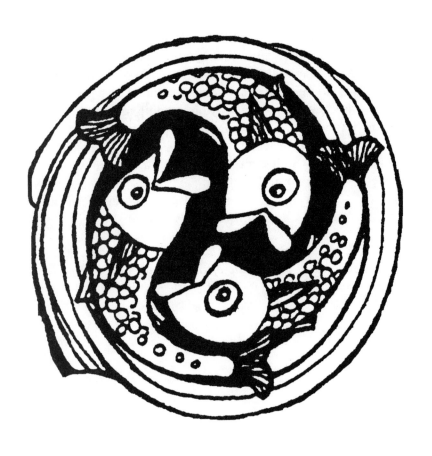

Modern Celtic-oriented fish motif

TROUT

The trout is also one of the most important food fishes of the insular Celts. It is sometimes interchangeable with the salmon, and it appears in European fairy tales.

Accordingly, it too can appear[203] as a symbol of Christ or as a bearer of souls. As such, it is naturally taboo.

*F*or a long time, a beautiful woman had been promised to a king's son, but he died and was cast into a lake. She lost her mind and followed him. After that, a white trout that had never been seen before appeared. No one knew anything about the trout until one day there came an evildoer who said he had caught it and eaten it for dinner. In fact, he took it home and placed it in a pan. As it whimpered and cried, he laughed. He fried both sides and stuck his knife and fork into it so as to have a taste. Then there was a loud cry. The trout jumped to the middle of the corridor and changed into a beautiful woman, dressed in white, with blood running down her arms. She scolded the wicked one for disturbing and hurting her, for she was searching for her loved one. She said if her loved one had come by during her absence, she would transform the wicked one and hunt him forever. The wicked one asked for mercy. She told him to become a good citizen, go to confession, and put her back in the lake. Before he could say anything, the woman disappeared, and only the trout was still lying on the floor. He immediately brought the trout back to the lake, where it colored the water red when he put it in. To this day, trouts have a red mark on the side. The man not only became a good citizen, but ended up as a hermit, who prayed for the soul of the white trout.[204]

[203]Low, p. 77.
[204]From Booss 1986.

Tree motif scratched in stone

TREES

Trees seem to be a universal object of deification. In Asia and Africa, Australia and America, they are objects of worship and spiritual belief. Their symbolic content extends as far as their branches and has many forms.

In relation to the living conditions and state of development of the Celts, wood is an important raw material for heating, building houses, providing fortifications, building streets, and producing weapons and various important objects, including carts, boats, musical instruments, containers, baskets, and religious objects.[205]

The first representations of trees are branches on useful and decorative objects. On a column from the 6th century B.C., there are already leaves and human heads together. Unfortunately, no specific type of tree can be recognized in the representations.

Personal names have also been formed from tree names.[206] Eburonen "People Living around the Yew/Yew People"; Mac Daro, "Son of the Oak"; Dar Charithinn, "Daughter of the Rowan"; Mac Cuill, "Son of the Hazel"; Mac Dreign, "Son of the Blackthorn"; Dar Ibair, "Daughter of the Yew," and many others.

Caesar's companions fearfully reported about the Druids, who, in deep and remote forests and groves, taught with intertwined branches and summoned clans together there to fight against the Romans. Groves, therefore, had not only a religious but also a political significance—which is the reason why the Romans burned or chopped the groves down.[207] Up to as late as the 18th century in

[205]Cf. chapters "Cart," "Harp."
[206]Cf. Birkhan 1997, pp. 645, 881.
[207]Op. cit., pp. 751ff.

Symbol of a conifer

Wales,[208] Celtic clans or disciples of Christianity would appropriate for themselves the holy sites of rival clans during conflicts.

Oaks, hollies, yews, or even maples were used for holy groves. Important components of them were wooden steles (*xoanon*), which possibly represented gods. Different clans probably revered certain trees (perhaps as divinities) and planted them in order to perform their societal ceremonies. Coronation of a leader[209] (perhaps a marriage/merger with divinity[210]) were also included. Aspects of survival (of power), identification with the area, majesty, and wisdom were thus associated with the leader. The ceremonies produced a relationship with deer, which followed natural rhythms like trees, and with boars, which not only ate the fruits of trees but often also embodied royal dignity.[211] The relationship with royal dignity is also produced with Medb (goddess of power?) in that a tree grew wherever she placed her horsewhip.

In the Roman-Celtic connection, the dove is closely associated with the tree.[212] Perhaps trees are mediators between the worlds: their branches reach far into heaven and their roots reach deep into the earth. In addition, trees accommodate living creatures, such as birds, that wander between the worlds. Trees strengthen the concepts of long, healthy, and eternal life. Although deciduous trees lose their leaves seasonally, they will eventually return again and again. Conifers, in contrast, thrive year-round, never losing their leaves/needles. Because of their characteristics, trees are associated with holy springs, which have a similar symbolic strength.

[208]Rees, pp. 114f.
[209]These ceremonies could also be connected with stones or mountains.
[210]Low, p. 82.
[211]Cf. chapters "Deer," "Boar."
[212]Cf. chapter "Dove."

Trees can also be seen as an entrance into the Otherworld.[213] Avalon, where Arthur (Artus) is said to be buried, is the Apple Island itself (Welsh *afal*, Bret./Corn. *aval*). The close relationship between man and tree becomes clear when Blodeuedd[214] is created in order to give a man a woman, or Kai is compared with the length of the tree. A tree sometimes represented a person, such as when sacrifice ceremonies were performed in which trees were used in place of people.[215]

Trees that were considered holy by the Celts were primarily the oak,[216] yew, ash, and hazel. Other important trees were the willow,[217] birch, beech, broom, apple, ivy, holly,[218] elder, sloe, and elm. Different trees were treated differently. For example, apple, black-thorn, willow, and hazel trees were not burned while the rowan, oak, alder, holly, and birch were.[219]

Tree names were probably also used to identify the early alphabet of the Celts, the Ogham alphabet, which is therefore also called the tree alphabet. Ogham inscriptions were carved into stone or notched into wood. A usage similar to that of the Nordic runes contradicts the content of the Ogham small texts, which mainly contain personal names and titles. Ogham is a very simple writing technique. It is based on fifteen consonants and five vowels of the Latin alphabet, each of which represents the first letter of the trees or plants that were the most respected. Thus trees were also a source of inspiration: thoughts roam and can proliferate just like branches. Consequently, Druids and bards are associated with trees. Thus those who became, but more likely pretended to be, insane after battles, the bards Suihne (Ireland) and Myrddin (Wales), fled into the forest and lived for a while in treetops.[220]

Stories also show that wood played a role in prophecy, although it remains unclear how this actually occurred. From later times, the Welsh tradition says that birch branches were gathered at midnight and hung over the door for purification or buried to drive out ghosts.[221]

The battle of the trees, Welsh Cad goddau, was first mentioned in the "Llyfr Taliesin." In this poem, people were advised to change into trees, bushes, and flowers in order to fight the enemy. The poem consists of seventy-four verses and mentions thirty-four plants. Obviously, the motif was well known, as it appears in, among other places, "The Drunkenness of Ulster": as Medb leaves two Druids on guard, they disagree on whether they see an army or an oak forest, since to one of them chariots seem to be castles, shields to be stone columns, spearheads to be deer antlers, etc.

In the description of CúChulainn's death battle[222]: the children of Cailitin, who has one arm and one leg cut off by Medb and whom he raises for 7 years, imagine a battle between armies of stems, grass, and leaves. Witches promise to help Lug somewhat differently[223]: they enchant trees, stones, and balls of earth so that they look like an army.

The theme of trees seems still current and continues in heraldry, primarily with the oak, hazel, holly, willow, ash, apple.

[213]Cf. Gereint, who sees an apple tree before a red tent; Birkhan I 1989, p. 243.
[214]Cf. chapter "Owl"; Blodeuedd.
[215]Dannheimer, pp. 173, 206; Botheroyd, p. 30.
[216]Cf. chapter "Owl;" Blodeuedd.
[217]Ibid.
[218]Drystan in Birkhan II 1989, p. 118.
[219]Thurneysen, p. 544.
[220]Cf. chapter "Oak."
[221]Rees, p. 115.
[222]Thurneyesen, p. 560.
[223]Cross, p. 41.

TREE OF LIFE

Which tree is the true Tree of Life is not known. For some Nordic peoples, it is the birch; for others it is the rowan, whose red fruit is used as medicine against diseases and at the same time has an association with the Otherworld. Beeches also provide food for humans and animals in winter with their beechnuts. Elderberries and sloes are likewise consumed, as are yew nuts, acorns, and hazelnuts. The hazel, which is mostly found near springs, is used as the source of inspiration and knowledge; in the stomach of the salmon, it to become the symbol of wisdom.[224] There is also a comparison between empty hazelnuts and hollow stones.[225] All fruits have special common characteristics for the body and spirit.

Religious knowledge, including that about the sun, moon, and other cults, such as totemism, belonged to the knowledge that was especially sacred and, therefore, was transmitted orally. But the information is essentially lost to us. The exceptions are observations by witnesses at the time who provided documentation or artistic representations. In this case, however, since the Tree of Life is a such a universal symbol,[226] there is a danger that interpretations have been influenced by it.

For a long time, it was thought that placing tree bark in your pocket promised protection.[227] Trees also play an important role in the establishment of monasteries.[228]

Perhaps the Tree of Life should be understood in terms of a companion through life.

For Ireland, there are five famous trees that correspond to the provinces: three ashes, one yew, and one oak. For felling a yew, the Welsh prince Hywel Dda (died 950 A.D.) established the death penalty, as did the Irish law. There are also taboos and curses as consequences for woodcutting and forest use.[229]

Trees have remained important up to the present in fairy tales, prose, poetry, and many other artistic expressions. Their beauty and other characteristics are praised.

Trees maintain life and, like many animals, they are witnesses to the condition of our environment. Today's lack of trees, especially in Ireland and South Wales, is shocking and due to the woodcutting industry. A testimony to the forested past is again language, which in Ireland and Wales knows many places, rivers, and other names associated with tree names: Ir. Moville, Tobervilly (< billy < bile "holy tree"); Welsh Bro Deri "oak region (grove?)."

Trees and their significance still exist today. There is a maypole, which people are invited to dance under, and Christmas trees. There are crowns woven from trees on various occasions. The purpose of these customs is probably to inspire us to become as strong, patient, and long-lasting as a tree.

[224]Cf. chapter "Salmon."
[225]Thurneysen, p. 514; cf. chapter "Stones."
[226]Cf. the Viking tree Yggdrawil, trees in the Bible, date trees in Egypt, etc.
[227]Low, p. 79.
[228]Cf. St. Columba; chapter "Oak."
[229]Low, pp. 92f.

OAK

The oak, already important among the Romans and Greeks, is one of the most significant trees among the Celts. It is not clear whether the word "Druid" is translated as "oak-knower" or as "reliable knower."[230] The Welsh word for Druid, *derwydd* ("oak man"), seems to be better. Celtic names that are connected with the oak are Derva, Dervaci, Dervius, and the clan name Querquerni.

Its strong wood is good for making sturdy things, such as carts, streets, and above all ships. Since oak trees have a long life, they are used as metaphors for things aged and respected.[231]

The oak's acorns are winter food for both animals and people. They also alter consciousness when eaten raw. This is to help people "wander" between worlds, achieve additional knowledge, obtain

information, become inspired, escape reality, or gain courage and self-awareness. The healing tannic acid in oaks help people who feel weak, or who suffer from gastrointestinal diseases, etc.

In addition to its healing function, the oak has also provided protection—and not just against sun and rain. Could these functions, in addition to the oak's hardness and longevity, have determined the selection of its wood for the construction of tombs?

Worthy of consideration is the oak–pig–seven connection. Seven identifies the pig as the animal of the Otherworld in the insular Celtic tradition.[232] Acorns are one of the most important foods of pigs. It is possible that oaks first received an exceptional standing in this connection. In "The Battle of the Trees,"[233] a short verse is devoted to it:[234]

> *The oak is fast,*
> *Heaven and earth tremble before it,*
> *It is a valiant gatekeeper before the enemy.*
> *Its name is a support.*

St. Columba honored the oak when he had his monastery built near oak forests. In the *Annals of Ulster*, the death of oaks between 1146 and 1178 is noted as a great misfortune.[235] Also in heraldry the oak remains important and is often associated with signs of sea travel.

[230]Cf. Birkhan 1997, p. 898.
[231]"Culhwch ac Olwen," p. 72.
[232]Cf. chapter "The Number Seven."
[233]Cf. chapter "Trees."
[234]With reservations, according to Le Roux, p. 188.
[235]*Annals of Ulster.*

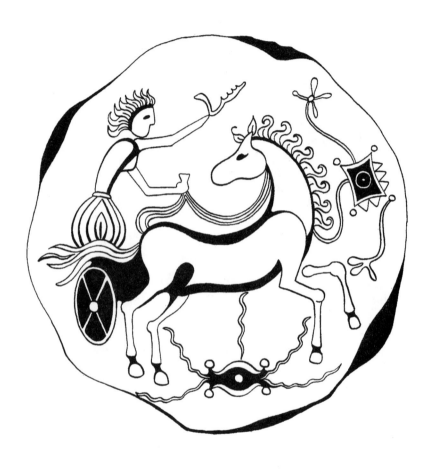

Rider with a branch of mistletoe

MISTLETOE

The deciduous oak mistletoe played an important role, especially in Celtic medicine. The Druids taught that mistletoe heals everything, promotes fertility, and is an antidote to all poisons. It was accordingly used, especially as an anesthetic.[236]

Since oak mistletoe is absent from Britain, other trees were probably used in its place. Oak mistletoe thrives well in winter, when the other trees lose their leaves, and is thus an indication of flourishing life.

In general, mistletoe is not common, for which reason it was even more respected. It was also harvested with a sickle only at a particular time—namely, on the sixth day of the moon—when it was supposed to be the most potent.[237] The harvest itself was a ceremony. Then the mistletoe was placed, like a torque, around the horns or other body parts of animals—primarily a bull. The question arises again of whether the bull, with its two horns, is being compared to the moon.[238]

Today, mistletoe is a sign of fate. Whatever one does in its presence happens.

[236]Cf. Birkhan 1997, pp. 631f.
[237]Cf. chapter "The Number Two: Eye and Moon."
[238]See previous footnote.

ree of Ross
a king's counsel
a right of a prince...
the best of creatures
a strong god
door[239] *to heaven*
quality of a house
of good fellows
man of the word
full of generosity
the triply powerful...
Mary's son
a fruitful sea
diadem of the angels
power of victory
stern judge
glory of Leinster
vitality and
magic of knowledge
tree of Ross.

(extract)

YEW

There are fewer yew trees in Europe today than in the past. The shade and moist soil in which the yew thrives have become more sparse. All parts of this tree are poisonous. In early times, it was used not only in medicines but also in weapon technology. Its flexible wood has multiple uses and, like the oak, it grows slowly but has a long life.

Since the vapors of the yew can also be poisonous, close contact with it on warm days can send a person into light dreams. These vapors were considered a means of connecting the present and the Otherworld. In Ireland, the yew, together with other trees, seems to have been more important than the oak.

In the Book of Leinster (12th century), thirty-three titles are given for the yew, the tree of Ross, in which many meanings, strongly influenced by Christianity, that are assigned to the trees are represented.[240]

Also in our latitudes, many names attest to the yew's former greater occurrence: Ibersheim, Iba, Ibach.[241]

[239]Many translations are not completely unambiguous.
[240]Cf. names in the chapter "Trees."
[241]Cf. names in the chapter "Trees."

ASH

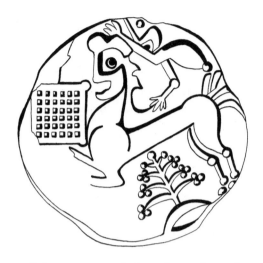

Ash wood also serves as a raw material. The ash is, besides the oak and yew, the most important tree in Irish literature. In the story of "The Fairy Palace of the Quicken Trees," ash trees form, covered with their red berries, the boundary between this and the Otherworld.

Other aspects of the ash, such as the motif of the (wild) man in the tree or as the source of food, are described in the story of "Sharvan the Surly Giant and the Fairy Quicken Tree":

The people of Dedannan had nuts, apples, and red ash berries to eat, which they brought from the Promised Land. Because these fruits had various secret characteristics, the Dedannans wanted to let a nut, berry, or apple fall onto Irish soil. As they went through the forest of Doores, one berry fell down. But they proceeded onward, taking no notice. From this berry, there immediately grew a large ash tree, as in the Promised Land. Its berries tasted like honey and whoever ate them felt a joyful flow of the spirit as if they had alcohol. A 100-year-old person eating the berries would be turned back to age 30. When the Dedannans now heard about the tree, they sent a Fomori warrior, the one-eyed giant Sharvan, to guard the berries so that no one should taste them.

Dermat and Grania, who were fleeing from Finn after Grania had chosen Dermat instead of Finn as her husband, arrived in this forest and met Sharvan. For a long time, they lived peacefully with

Sharvan. Although Dermat hunted on this land, he paid no attention to the tree. One day, however, two of the warriors sent by Finn came to bring back either Dermat's head or a handful of berries. Ignoring the warning of Oisin, and hoping for rank and respect in the warrior band, they set off. They were soon defeated by Dermat. Grania heard about the berries and turned against the warrior band. Dermat let mercy prevail and promised to get the berries, but the giant refused to give them out under any circumstances. Dermat rushed bare-handedly at him whom fire could not burn, water could not drown, and weapons could not wound. He jumped on him by surprise, threw him to the ground, and used the giant's own club to strike three blows to the forehead. He gave Grania the berries from his own hand. He also gave a handful of berries to both of Finn's men and sent them on their way. From then on, Dermat and Grania lived for a long time on the berries, which were especially tasty in the treetops.

As the warriors gave Finn the berries, he immediately detected Dermat's smell on them and realized that they had not been picked by his men. He gathered his people and advanced against Dermat. Arriving at the forest of Doores, Finn sat down with his band of warriors under the ash tree and started to play chess with Oisin. Oisin and his adviser played well, and there finally came a critical move for Oisin. Dermat immediately threw a berry at the chess piece to be moved, and Oisin won. A new game of chess started that ended like the first. The third game went the same way. But Finn became ill and asked Dermat, who was sitting in the tree, for help. After a brief discussion, it was clear that Finn still wanted his head, so Dermat catapulted himself out of the reach of Finn's warriors with his famous jump and escaped.

APPLE TREE

The apple tree is the tree most often associated with the Otherworld. It is a sign of life/immortality, and as such its fruits are often the only food, like the salmon,[242] for heroes. But it is also a symbol of love: Connla lives for a month only on apples from her beloved, and does not lose weight.[243]

The apple is also part of the compensation that the sons of Turenn must give to Lug after they killed his father, Cian:

*T*he sons of Turenn were to get apples from the garden of Hisberna. These apples were not only especially beautiful, but they also had mysterious characteristics: they had the color of pure gold and tasted like honey. If a wounded warrior or a deathly ill person ate one, he was healed immediately. These apples also never became smaller when eaten; they remained large and complete. With the aid of the apples, every hero could accomplish the heroic deeds he

desired by throwing one of them, and it would come back to him. Accordingly, Brian, one of the three brothers of Turenn, used an apple to obtain a famous spear: he threw it at the forehead of the king of Pezar, so that the apple went through the king's head and killed him.

When Maildun had to undergo the dangerous adventures of his trip, it was apples, in addition to salmon, that saved his life more than once.

*H*e came with his companions to an island in the middle of which grew a wonderful apple tree. All its branches were so long that they reached over the hill down to the sea. Maildun grasped one of the branches as he neared the island. He let the branch slip through his hands as he went around the island, which took 3 days and 3 nights. At the end, he found a bundle with seven apples. The travelers took these with them, and the apples provided each of them with food and drink for 40 days and nights. As they traveled onward, they came to an island where red-hot piglike animals and birds were eating apples. So Maildun put all the animals to rest for the night. Then he and his men loaded the boat with as many apples as it could hold.*

Golden apples, silver and crystal trees, and trees full of singing birds have parallels in the Bible and probably go back to original traditions, such as burning trees.[244] The apple island, Welsh Ynys Avallach,[245] is Avalon, where Arthur [Artus] found his last resting place.[246]

[242]Cf. chapter "Salmon."
[243]Cross, p. 489; chapter "The Otherworld."
[244]Peredur in Birkhan I 1989, p. 152.
[245]Cf. Gaulish Aballone, "Place of the Apple"; Ir. Emain Ablach, "Emain of the Apple Trees."
[246]Cf. chapters "The Otherworld," "Sword."

ilh

rizek tilhenn stank ha stank
Stok-ha-stok war ar c'hleuz kras
Sonn o fenn en oabl glas
D'en amzer m'edon yaouank
Int 'oa dija bras
Trizek tilhenn en ur blokad
Boked glas-du
Divent. Ramzel.
War an dremmwel.

An tilh-mañ n'int ket va zra
Ar gwir am eus memestra
D'ober o diskar
Emaint o sunañ sev va douar
Gant o gwizioù ken hir. Met ne rin.
Bez e rafent diouer din.
Rak un darn int eus an daolenn vev-se
A ra stern va buhez
Bez e rafent diouer din.
Bez int va ograou,
Bez int va zelenn,
Pa c'hoari enno an avel
E vil notenn disheñvel.
Pa goag ar vran
'N o skourroù noazh er goañv
Pa sut 'n o begoù du
Ar voualc'h beg melen,
Ha pa zirulh eus o barr uhelañ
Beradoù strinkennek
An eostig noz.

(Anjela Duval)

LINDEN

Besides the general attributes of trees that have already been mentioned, the linden has a practical aspect, and the Gauls used its sap as a dye. Diodorus notes that the Gauls, who were natural blonds, often washed their hair with linden stock, and thereby bleached and thickened it, so that it stuck out like bristles.[247]

The linden is also known as a symbol of Berlin.

Linden

Thirteen lindens, thicker than thick,
Tightly pressed on a dry embankment,
Extend their heads to the blue sky.
I was still young,
They were beautifully large.
Thirteen lindens together,
A black-green strip
Breaking through, gigantic,
On the horizon.

These lindens, they do not attack me,
But I also have the right
To cut them down.
They suck the sap from my earth
With their roots so long. But I allow it.

I would miss them
For they are one facet of this living image
That surrounds my being like a frame.
They would be a loss for me.
They are always my music,
They are my song,
When the wind plays in them
A thousand different tones.
When the crane caws
In its winter-cold branches,
When the blackbird with its yellow beak
Trills from black treetops,
And when the nightingale
bubbles crystal sounds
From the highest tips.[248]

[247]Cf. chapter "The Number Two: Eye and Moon"; CúChulainn's description in rage.
[248](German) translation according to a draft by Mrs. Tristram.

Irish harp

LYRE/HARP

In France and Germany, the harp is comparable to the lyre (Lyra) and is one of the Celts' many plucked instruments. Plucked instruments are depicted on coins, but it is not clear to what extent they have been stylized according to a Mediterranean model. Although early forms have not three but five angles and have three, five, or seven strings,[249] they have also been associated[250] with triskeles[251] (Celtic spiral design)—that is, with the sun cult. Whether or not the basic melodies came from sun rays, the lyre/harp was called the "Wood of Joy"[252] and viewed as an instrument with a soul of at least three melodies: laughing, sighing, and slumbering. It symbolized the immortality of the soul. A harp with a soul can also be an effective support to its owner.[253] Accordingly, it has two names: Oak of the Four Greens and Four-plucked Music.

In Wales, it is questionable whether the harp is actually a harp or a square plucked instrument (Welsh: *crwth*). In addition to these three melodies, as also in stories from our culture, the harp has been played in battles as a means of support.

In the following epic of the fairy harp, one of the three melodies and the soul aspect of the harp are emphasized:

*I*n the mountain of Cader Idris there lived many fairies, who often went to the villages to test the friendliness of the people. The people were generally friendly, and they received gifts for this. The few others were punished. One day, Tudor ap Rhys was sitting at home alone and waiting for his wife to return. He passed the time singing until someone

[249]Botheroyd, p. 130; Birkhan 1997, p. 1098.
[250]Rothery, p. 191.
[251]Cf. chapter "Triskele."
[252]Rothery, p. 191.
[253]Cf. Dagda's Harp; Cross, p. 47.

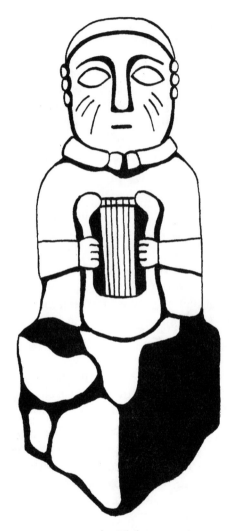

God with lyre

knocked at the door. Three exhausted wanderers entered and asked for something to eat. Rhys gave them everything he had and was upset that he could not place anything fresh on the table, since his wife was still on the way. The wanderers thanked him and asked Rhys to make a wish, which they would fulfill for his hospitality. Rhys at first declined, but then expressed his wish for a harp, which everyone had misunderstood and ridiculed. The wanderers waved their hand and the harp appeared behind him. Before he could thank them, the three wanderers disappeared. From then on, he could play wonderful, beautiful melodies, even though his hands were not talented. All people invariably had to dance to his music: his wife (when she came home), their companions, their friends, and the villagers and visitors (who now came from everywhere). One day, one of his enemies came to insult him. Rhys played and only stopped when the enemy was exhausted. After he had gone away, Rhys now wanted to play the harp once more, but it stayed silent. A sweet voice said that fairy music was not intended to be played out of hatred. No one could be seen. When Rhys wanted to play his harp again after a sleepless night, it disappeared.

In Ireland, the harp has become the official national emblem.[254] The originally Welsh noble family of the Tudors may have played an essential role in this.[255] In the other Celtic countries, the bagpipe had an equal or even a greater importance.

In Wales, the harp is the most important traditional instrument, for which reason there is a triad according to the three tasks in this theme:

| Tri chynneddf telynor | The harpist has three characteristics |
| —peri chwerthin, llefai na chysgu | —laughing, crying, and bringing sleep |

[254]Cf. chapter "Dragon," dragon for Wales.
[255]Cf. Rothery, pp. 191ff.

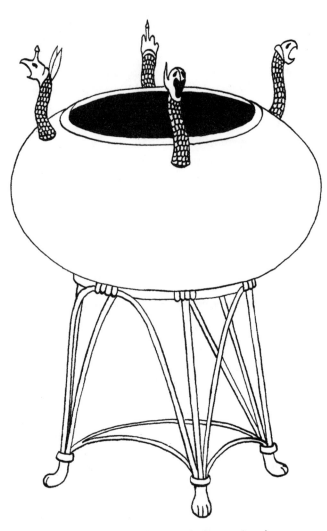

Bronze cauldron with dragon heads

CAULDRON

Metal vessels replaced earthenware toward the end of the Bronze Age (about 1200 B.C.) for eating, cooking, serving, and storage. In Ireland, the copper cauldron was the main object of value in the house.[256] It gained importance and became in the late Hallstatt period (about 600 B.C.) a primary ritual vessel for the Celts. Accordingly, it could have enormous dimensions.[257] Its multiple uses depended on its owners, who were often godlike heroes. Probably from its funeral-urn use, the cauldron became the cauldron of rebirth. The person buried would hopefully be resurrected on the next day or later. In the early-modern Scottish custom of calling people, Scot. *taghairm nan Daoine*, the cauldron took on an intermediary role between the living and the dead: the "magician" brought a large cauldron to the holy burial ground, let the dead appear before him, and asked them questions about the future and past.[258] Thus, the cauldron also became a vessel for sacrifice, burial, and oblation. Findings in places near water also indicate a connection with the water cult[259] where burials and water were probably closely connected.

The cauldron was also a vessel for provisions, or a "treasure box," as in when Arthur (Artus) brought the cauldron of Diwrnach with treasures from Ireland to Wales,[260] as well as on the way to the Otherworld, where it was indispensable. From its importance as a vessel for the preparation, serving, and storage of food, the cauldron developed into the cauldron of abundance[261]

[256]Called "treasures" in the literature; Thurneysen, p. 82.
[257]Cf. Birkhan 1997: pp. 811f.
[258]Mackenzie 1931, p. 44.
[259]Cf. chapter "Water."
[260]Cf. "Culhwch ac Olwen."
[261]Cf. Dagda's cauldron in "Rolleston" 1995.

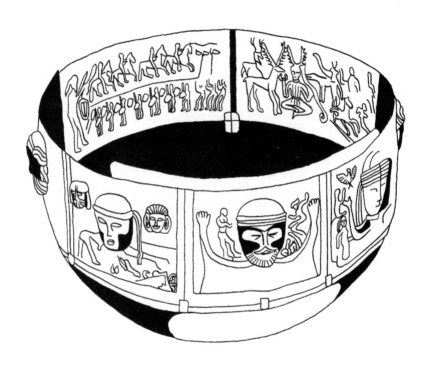

The Gundestrup Cauldron

that became associated with hospitality and inexhaustibility (as in the Otherworld). It is likewise known as the cauldron of renewal/healing and rejuvenation. But healing is also coupled with its opposite, namely death,[262] in which a goddess, who can combine healing and death, appears.[263] In addition, there is the cauldron of inspiration and wisdom, as Ceridwen used for her son[264] or Arthur stole from the Otherworld.[265] Many cauldrons won't work if you're a coward.[266]

The cauldron also offers a kind of protection: heroes' weapons are sometimes immersed in a cauldron filled with poison, etc. Also, documented is its practical function where people lightly cook stones in them.[267] The cauldron has also been used as a trap.[268]

Because of its importance, using the cauldron at mealtime is provided with ceremonies that view the meat cooked in it as a sacred object and the broth as a fertilizing power.[269] The cauldron combines the life-sustaining elements fire and water. It can, like other vessels, be viewed as a divine form, which, like the shot of the Mother Goddess, generates and destroys life.

The cauldron is also viewed as a prize and precursor of the Holy Grail—a valuable possession to be sought after because it gives its owner new or magical abilities, and, thus, confers power, as can be read in branch 4 of the Mabinogian:

The Welsh giant Bendigeidvran ("Blessing Raven"), son of Llyr, lord of the Island of Giants and associated with London, once received Matholwch, the king of Ireland, who asked for the

[262]Cf. Mac Conglinne's Vision in Brendel 1984.
[263]Cf. chapter "Fertility Magic: Women"; Hetman, pp. 36ff.
[264]Cf. Chwedl, Taliesien.
[265]Cf. chapter "The Otherworld."
[266]Cf. chapter "The Otherworld."
[267]Thurneysen, p. 545.
[268]Op. cit., pp. 543f.
[269]Including MacDathó; chapter "Boar."

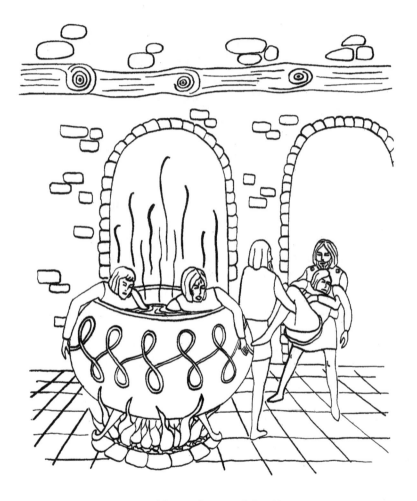

Cauldron of renewal/healing

hand of Bedigeidvran's sister, Branwen ("White Raven"). But Evnisien, Bendigeidvran's brother, felt excluded from the decisions that affect Branwen. In retaliation, he mistreated Matholwch's horse. Bendigeidvran compensated by giving Matholwch a cauldron, among other things, with wonderful powers. When one of Matholwch's men was struck, it was only necessary to throw him into the cauldron, and the next morning he would be healed and ready to fight—albeit without being able to speak.

On the next day they both went to another part of the land, and as they sat together, Matholwch asked Bendigeidvran where he had gotten the cauldron that he gave him. Bendigeidvran responded that the cauldron came from a man who had been in Matholwch's land and had possibly found it there. He asked Matholwch whether he had not heard anything about this story. Matholwch had and added to what was said by Bendigeidvran: Afterwards, he himself looked one day while hunting at the "Lake of the Cauldron" and saw a large man with yellowish-red hair coming from the lake, carrying a large cauldron on his back. The man was gigantic and looked like a robber. A woman was following him. Matholwch approached them. The man explained that his wife would give birth in 1½ months to a fully equipped warrior. Matholwch took them both in. After a year, their behavior made them disliked by everyone in the land. After some meetings, it was therefore decided that an iron chamber would be built for all three with the aid of all Irish smiths. The woman, man, and their offspring were sent into it with meat and drink. They became drunk. As they slept, charcoal was piled up around the chamber and ignited. When the iron became white hot, the man woke up and broke it with his shoulder so that he and his wife were able to escape.

According to their agreement, Matholwch returned to Ireland, accompanied by Branwen. Branwen was very generous to the Irish. After a while, it

was said throughout Ireland that Matholwch had been punished severely in Wales for mistreating his horse. His entourage demanded that Branwen should be punished for this. She was driven out of Matholwch's room and had to cook for the court. In addition, the butcher slapped her face every day after he had cut the meat.

Three years later, Branwen sent a a starling to her brother Bendigeidvran, informing him of her unfortunate situation. Bendigeidvran decided to free her. In advance of him and his warriors, his brother, Evnisien, ran ahead to look through the house where they would be received. After he had killed all the Irishmen hidden in the food sacks, the friends from the island met the Irish people in the house. As compensation, the Irish promised royal dignity to Branwen's son, and peace was made. Evnisien felt disadvantaged and threw Branwen's son into the fire. Thereupon, a great tumult arose. The Irish kindled a fire under the Cauldron of Rebirth and threw their dead men into it. The next morning, mute but healed, they were able to fight again. Evnisien saw the dead men from the Island of Giants. Since he felt responsible for what had happened, he was overcome with shame. He crawled under the dead Irishmen and was thrown into the cauldron. He stretched out and burst the cauldron as well as his heart. Thus, the men from the Island of Giants won in victory.

The cauldrons found indicate that there were regular exchanges between the people of this time. It is assumed that the cauldron played an important role among the Germans as well. Human sacrifice was probably also connected with the cauldron.[270] Some of them were relaxed in a cauldron and then killed.[271]

Cauldrons also remained important during the conversion to Christianity. Patrick received from Daire of Armagh a large cauldron, and Mac Conglinne banished the (food) devil to a cauldron,[272] making it now also used for punishment.[273]

Later, we encounter the cauldron primarily as a vessel for witches to brew hazardous drinks.[274] Miraculix the Druid, the most important adviser to Asterix, brewed a magic drink in his cauldron that conferred the necessary strength to all and restored health to the heroes. In the tale of Asterix the Gaul, Miraculix produced a drink that made the Romans grow exceptionally troublesome beards and hair. And finally, treasures[275] also had to be transported in cauldrons from time to time.

Today, cauldrons are still used primarily in Scotland in order to produce from the real single malt (pure Scottish whiskey) the *uisge beatha*, "water of life."

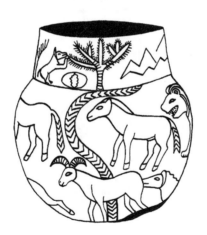

[270]Birkhan 1997, pp. 812f., 919.
[271]See "Llasar, His Wife and Child."
[272]Brendel 1984, p. 147.
[273]Agricola, p. 142ff.
[274]Cf. various fairy tales.
[275]Cf. "Asterix and the Magic Cauldron."

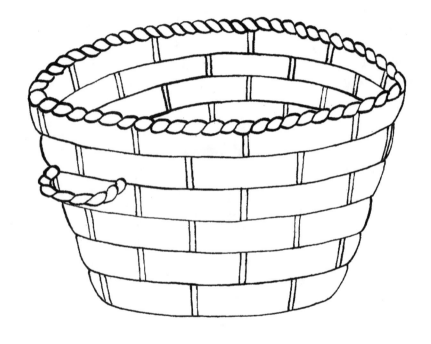

Basket for provisions

BASKET

The basket greatly resembles in its functions a "portable cauldron" and leads, like it, in the development of the Grail. In the Irish epic cycles, it finds its counterpart in Bricriu's Hero's Bite, where it was fought over. The basket is one of the thirteen treasures of Britain and is often an object of gifts.

The meaning of abundance is represented in "Culhwch ac Olwen."[276] In order to win Olwen, Culhwch had, among other things, to obtain the basket of Gwyddneu Garanhir. Everyone would find in it the food he wished, even if the whole world gathers around him.

The theft of the Grail is indicated in "Cyfranc Lludd a Lleflys."[277]

*A*nother of the three plagues that visited the land under Lludd was a man who stole all the food and drink provisions from the island. Lludd then lay down to wait. He saw a giant, who piled everything around him and then squeezed it all into a basket and disappeared. Llud engaged in a duel with him where glowing sparks flew out of their weapons. In the end, Lludd was able to bring the bring the giant down. The giant begged for mercy. After he promised to restore all that had been damaged, his life was spared.

We also encounter baskets after the conversion to Christianity. In the tale of Little Red Riding Hood, she brings food (health) to her grandmother in a basket.

[276]Cf. chapter "Boar."
[277]Cf. chapter "Dragon." Dragons were the first plague to visit the land.

BARREL

The barrel is originally a utility object. It preserves food[278] and water. As a butter barrel, it also serves for the production of food. Fatty milk and butter are signs of wealth. For this reason, the barrel can then also be considered an object of value,[279] but it also preserves valuables that are connected with such pleasurable items as mead. It can improve[280] or worsen[281] the quality of life, or evoke vitality (rejuvenation, strengthening). Its use in calming fervent heroes, such as CúChulainn, indicates wisdom.[282]

The barrel is used especially frequently and in many ways in "Bricriu's Feast":

*P*art of the feast in Bricriu's house was a hero's bite, which the three heroes—Laegaire Buadach, Conall Cernach, and CúChulainn—each claimed for himself. It consisted of a barrel in which there was room for three Ulster warriors, a 7-year-old boar (fed with milk, hazelnut kernels, wheat, and meat), a 7-year-old ox (fed with milk, fine grass, and grain), and a hundred loaves of wheat bread backed with honey (made from twenty-five sacks of wheat flour). The feast itself included a filled gigantic barrel, which was provided with ladders because of its size.

Since the dispute could not be decided very quickly, the three heroes turned in their rage to Medb.[283] To calm them down, she sent them to get one hundred fifty women with bare breasts and three barrels with cold water. After

the three heroes had undergone other adventures,[284] *CuChúlainn was promised the hero's bite.*

A barrel was also one of Iubdán's treasures,[285] specifically one that assured a triple lifetime to anyone who bathed in it.

While overcoming the three plagues of the island of Britain, Lludd[286] likewise used barrels. First he caught two fighting dragons in a barrel filled with mead and buried them. Then Lludd used a barrel of water to keep watch and capture the giant who stole all the food in the land.[287]

Today, oak barrels are especially in demand in Scotland for storing single malt properly.

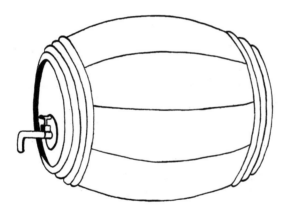

[278]Cf. chapter "Basket" and the Grail function.
[279]Cf. Iubdán's barrel.
[280]Cf. Iubdán's barrel.
[281]Cf. chapter "Cauldron."
[282]Cf. chapter "Fertility Magic: Women."
[283]Cf. chapter "Fertility Magic: Women"
[284]Cf. chapter "The Number Two: Eye and Moon.
[285]Cf. chapter "Fertility Magic: Men."
[286]Cf. chapter "Dragon."
[287]Cf. chapter "Basket."

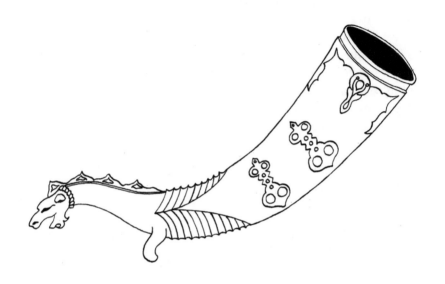

Drinking horn with dragon-head decoration

HORN

The horn is an expressive symbol that was also important to people such as the Germans and Vikings. Excluding nature, specifically horned animals, it unites male and female principles and their associated male concepts: wildness, strength, and fighting, and female concepts: reproduction and fertility. The full horn contains the gifts of the Mother Goddess. Accordingly, various animals can appear with horns, such as snakes, water birds, and boars, or receive an additional horn, as is sometimes the case with bulls.

Gods and humans also receive horns[288]—humans mostly on helmets. Many horn shapes have balls at the end. A possible explanation is that of apples,[289] which take away an animal's danger but not its strength by being put on the end of its horn, and place the animal in the service of people.

The fact that one drinks from horns shows it as a symbol of renewal and revival of vitality. From the Hallstatt period until the high Middle Ages, drinking horns bestow high respect on their owners and those that drink from them. As with all food consumption, drinking from a horn can also be a ceremony in which certain rules are observed. If the meat distributor has official status with the ruler, then there is a drinking sequence for drinking from the horn.

With Lludd,[290] the horn has yet another function: it is used as a speaking tube, which prevents the enemy from overhearing conversations. But horns are also included in military equipment and can

[288]Cf. chapter "Deer."
[289]Cf. chapter "Apple Tree."
[290]Cf. chapters "Dragon," "Basket."

Horned helmet

call people to a coming battle or serve to acoustically direct a battle.[291] Fergus uses the horn as a trap.[292]

And thus it is told in "The Pursuit of Dermat [Dermaid] and Grania":

*F*inn set out to seek a new wife after the death of his wife. His friends advised him to choose Grania, the daughter of King Cormac of Tara, who was the most beautiful, educated, and noble one in Ireland. Everyone was aware that any woman would be only too happy to become Finn's wife. So to honor him, a festival was held in Tara. Grania learned the reason for Finn's visit from the Druids, and she was not happy, because Finn was older than her father. She

would rather have had one of the young warriors who accompanied him. As a result, she had Finn's warriors presented by the Druids. When her eyes fell on the handsome Dermat, she immediately fell in love. She asked her servant to bring her her magnificent drinking horn. Grania filled it and had the servant to take it to Finn, so that he would drink from it. Finn, visibly honored, took a deep drink and then gave the horn to the king, who passed it on to the queen after taking a drink. The king's son and all others to whom Grania offered it drank from the horn. Shortly thereafter, they all fell into a death-like sleep. Now at last, she could go to Dermat and ask him to marry her. He agreed gladly, and the two of them set out on a long flight from Finn.[293]

Another task in Culhwch's battle with Olwen[294] was to steal the horn of Gwlgawd von Gododdin, the cup-bearer at the banquet, before the battle of the Northern British against the Anglo-Saxons.[295]

The devil might have developed from horned people or god figures,[296] who had, among other things, the power of destruction.

The (drinking) horn is still popular in Wales at the Esteddfod. This is the greatest festival of literature and art in Europe. It is held every year during the first week of August and can be traced as far back as 1176 in Aberteifi. The most traditional and outstanding event is the ceremony in which the best bard is chosen. Here, the horn is extended to the highest Druid as a welcome greeting. This custom was first documented in Victorian times in connection with the literary tradition.

[291]Birkhan 1997, p 1126.
[292]Cf. chapter "Cauldron."
[293]Cf. chapter "Oak."
[294]Cf. chapter "Boar."
[295]Cf. "Canu Aneirin."
[296]Cf. chapter "The Number Two: Eye and Moon."

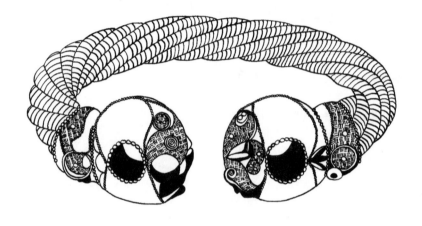

Torque from the insular settlement region

TORQUE

A torque is usually a heavy, open neck ring, often with many strands of iron, gold, or bronze. It is not of Celtic origin. In the East—for example, in Persia—it is very widespread. It is assumed that it originally represented the moon. The end knobs can have or represent various shapes, such as loops, puffs, and many others. The ring of the La Tène period (about 480–80 B.C.) is often decorated with ornamental jewelry of rank, spiral and circular ornaments, and turned into itself; it is then called a twist ring. Torques with ball ends are a special Scandinavian form.

The fashion of neck rings appeared in the late Hallstatt period (about 600 B.C.) and was one of many ring fashions in the La Tène period.[297] The torque was worn by Celtic warriors (men and women), even when they were otherwise fighting naked, and it generally served as jewelry for prominent persons. It is mentioned often in the Irish and Welsh epics. It seems certain to have had a religious or cult significance. Whether it primarily represented strength, power, and protection, and then only later became a form of decorative jewelry, is still unclear. The torque is no longer part of grave presents, but it appears on coins or is raw material for such.[298]

The aspects of power and prestige were shown when thick gold torques, consisting of 94% pure gold, were given by or taken from defeated people as objects of sacrifice.

The importance of the torque was confirmed by Giraldus Cambresis as late as the 12th century. He tells about a torque that

[297]Cf. Birkhan 1997, p. 365.
[298]Filip, pp. 89ff.

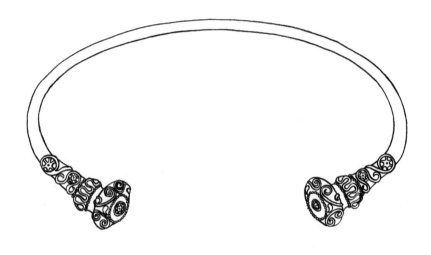

Torque from the continental settlement region

belonged to St. Cynog. From its appearance and weight, it was considered to be a torque of gold. Its welding points showed that it was produced in four parts. In the middle, it was divided by a dog's head, which was represented as being held high and with teeth bared. The natives considered the torque a very powerful relic, and no one would have dared to break a promise that he had made before a torque. On the torque, there was the imprint of a powerful impact. This was made by a man with an iron hammer when he tried to break the torque because of its gold. But he was punished by the gods, who made him blind so that he had to dwell in darkness for the rest of his life.

Today, we find jewelry pieces similar to torques, primarily as arm bands. Many of them are valued as calming and healing, while others are beautifully made but expensive pieces of jewelry.

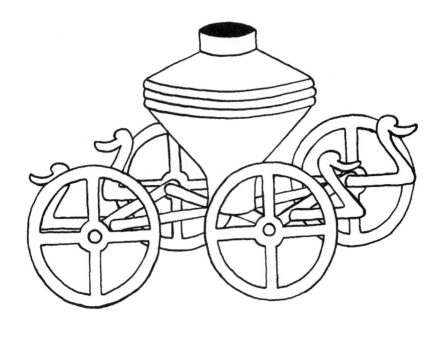

Bronze cart model with cauldron load

CART

Carts with wheels of wood or stone were already in existence before the Celts. Both the Hallstatt and the La Tène periods had carts, primarily in the latter period, mostly with spoked wheels. The track width (about 4.3 feet) has probably not changed much since the New Stone Age.[299] However, there have not been enough findings to determine what was behind the various cart designs that have come down to us. There were general carts, giant carts, battle carts (chariots)—probably two-wheeled in the La Tène period—and show carts. Carts were also sun (and moon) symbols,[300] and as such they were religious objects. Four-wheeled chariots and religious carts from the Hallstatt period are difficult to distinguish. They can be documented archaeologically primarily on Ynys Môn (Anglesey, Wales). A sword fighter stood next to the charioteer.

Chariots either brought the warriors to battle or were used as military devices. Only the first function has been documented beyond doubt. Carts as such had two or four wheels, but for purely religious purposes they probably had four wheels. The existence of an army of chariot warriors is disputed, since chariots were selectively used by certain persons and therefore were considered to be a status symbol.[301] In Ireland—whose epics are full of chariots and their male and female charioteers—no graves have been found with chariots, but only parts that could possibly have belonged to chariots. This leads to the assumption than the materials in epics partly derive from Britain or from the continent (Hallstatt period). Also, the natural features of Ireland, such as its extensive moors, do not favor the use

[299]Today about 4.6 feet—cf. Birkhan 1997, pp. 1111ff.
[300]Cf. chapter "The Number Two: Eye and Moon."
[301]Cf. Birkhan 1997, p. 419.

of chariots. The crescent cart[302] has not been documented archaeo-
logically, but because of its mention, for example with CúChulainn,
it should be assumed to have existed.

*I*n the dispute over the hero's piece,[303] CúChulainn's charioteer
Laeg mac Riangabair indicated that it had probably been
received by the Ulster men. CúChulainn ordered him to hitch up the
chariot immediately. His charioteer was so fast with the gray horse of
Mach and the black horse of Sainglenna that he came to Cruachain
third. Because of the stormy journey of the Wetteifernds, the noise in
Cruachain was so great that the weapons fell off the walls, and the
people were so frightened that every one of them was like a reed stalk
in a brook. Medb was astonished with the thunder and had her
daughter describe the approaching chariots she saw:

"The first has two fiery, spotted duns, with the same colors, the
same shape, equally splendid, fast, able to jump, lively, and valiant,
with a spike on the forehead, high head, small muzzle, spotted on
top, well cleft, slender below, wide on top, with wavy mane and wavy
tail. The chariot of willow wood is delicate; the two wheels are black;
the chariot rods are hard, straight as swords; the chariot box is firm;
the yoke is curved, of hard silver; the reins have tassels and are firm
and yellow. In the chariot is a handsome man with long, wavy and
braided hair of three colors: dark hair on the top of the head, blood
red in the middle, golden at the end. He is Laegire the Victorious.

"Before the second chariot stands a white-headed horse, copper-
colored, stout, lightning fast, able to jump, with wide hooves and
wide breast, and has to be measured by the flight of the birds, so that
it is difficult to capture its running. The other horse is red, with a
wide forehead and broad back, slender below, with a long build,
with solid tassels, braided hair, wild, strong, able to crush anything.
The chariot of willow wood is delicate; the two wheels are light in
color and of metal; the shaft is white with hammered silver; the box
is high in back and creaking; the yoke is proudly curved and firm;

both reins have tassels and are firm and yellow. In the chariot is a man with beautiful locks of long hair; his face is half red, half white. There is a flame of red lightning in his red-glowing fist. There is a roof of wild birds over his chariot box. He is Conall Cernach.

"The third chariot has a gray horse with broad hips, long mane, high head, broad breast, and is wild in flight, able to jump lightly, and mad. The earth under its hooves sprays sparks. It follows birds as fast as a victor. The horse's breath is fiery red. The other horse is pitch black, stately, with a stout head, round, with thin legs, a broad back, a long, wavy mane, long tail, tassels, strong, nimble, agile, long-striding, and leaping strongly. The chariot is delicate and of willow; both wheels are of yellow iron; the shaft is covered with silver bronze; the box is of solid, bent tin; the yoke is curved and of solid gold; the two reins have tassels, which are firm and yellow. In the chariot is a gloomy man, the most handsome in Ireland; he has eight red dragon stones in his eyeballs, his cheeks are blue-white and blood red, his breath sprays fire, he jumps with a hero's leap. He is CúChulainn."

Medb now had to act cleverly if she did not want to run into danger and see the land laid waste in the battle of the three heroes.[304]

[302]Ibid.; cf. chapter "The Number Two: Eye and Moon"; CúChulainn's crescent cart.
[303]Cf. chapter "Barrel."
[304]Cf. chapter "The Number Two: Eye and Moon."

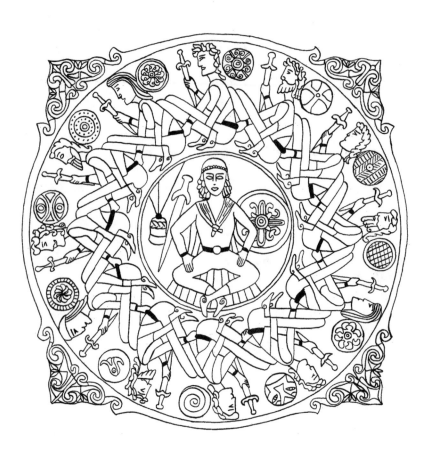

Arthurian motif in the sword dance

SWORD

Weapons are indispensable objects in times of military conflict, and those who produce them well are some of the most important heroes,[305] or even gods, such Lugus, the god of crafts, among the Iberian Celts. In the field of weaponry, the Celts have made really impressive achievements; otherwise the Romans would not have adopted some of them, such as their most important weapon, the *gladius* (sword).[306]

In the Hallstatt and especially La Tène periods, swords, lances, spears, and sword sheaths were richly decorated according to their importance. Depictions of snakes and human-shaped handles are striking on these weapons. They are possibly connected with the religious use of swords (and other weapons).[307] For example, Irish epics (such as "The Second Battle of Mag Tured") contain talking swords that announce heroic deeds and which are respected by humans and gods. Does the sword seek out its own destiny after the death of its master, as among the Scythians?[308]

Cutting and stabbing weapons are sometimes assigned to the sun cult because of their lightning shape.[309] In fact, every vital and useful item could become a religious object among early peoples in the hope of a good life after death. Accordingly, it is not necessary to seek a religious symbol in every practical shape.

The fact that cults used weapons is evident from the many different names given to them and by the names given to people. In the

[305]Cf. smiths in the Scottish and Irish epics, especially those about CúChulainn, Finn, and Fionn.
[306]Third branch of the Mabinogis (see Appendix).
[307]Birkhan 1997, pp. 1137f.
[308]Cf. Arthurian epics about his death; Birkhan 1997. pp. 814ff.
[309]Cf. Lengyel.

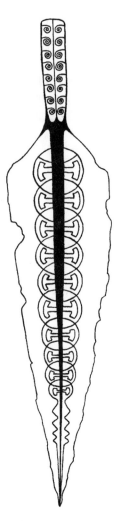

Short sword

Welsh epics, there is a whole family of swords, with its ancestral lord Cleddyf Difwlch ("Sword without Nicks").[310] He has a son, Cleddyf Cyfwlch ("Sword with Nicks"),[311] who in turn has three sons: Bwlch ("Nick"), Cyfwlch ("With Nicks"), and Syfwlch. And they have three wives, namely: Och (German *Ach*), Garym ("Call"), and Diasbad ("Cry"). One of the grandchildren is called Lluched ("Lightning").

Although the spear is very well-documented linguistically and in epics, the sword is the most important weapon. For the Gauls, their long sword (about 32 inches long) developed in the La Tène period from the dagger (about 18 inches long) and the short/stabbing sword (about 26 inches long), which was not bad in comparison to the short sword from the Mediterranean region, but it was not always the best. The Iberian Celts are known for their excellent art in forging short swords.[312] All sword forms are found in Ireland. Thus, Irish heroes, such as CúChulainn, Dermat, and Finn, had both short and long swords. There were also spears,[313] lances, and other cutting and stabbing weapons, which were used according to the battle situation.[314]

The best-known Celtic sword was Arthur's (Artus's):

U thyr Bendragon ("The Terrible, the Dragon Head"),[315] ruler of Britain, married Eygyr, who was already pregnant by someone else. The pregnancy was kept secret. On the advice of Merlin [Myrddin] the beautiful boy born was given to Kynyr, the bearded one, to raise. Kynyr baptized him Arthur [German Artus] and raised him until he was 14 years of age. At this time, Uthyr died and a successor was sought, since Eygyr had only given birth to daughters after Arthur, whom no one knew about. Time was pressing, as the Saxons, who had settled there by

[310]Many translations are unclear or not completely unambiguous; cf. Birkhan II 1989, pp. 102, 225, 236f.

[311]Many translations are unclear or not completely unambiguous.

[312]Birkhan 1997, pp. 1130f.

[313]Cf. "The Blazing Spear of the King of Persia."

[314]Cf. "The Pursuit of Dermat and Grania."

[315]Many translations are unclear or not completely unambiguous.

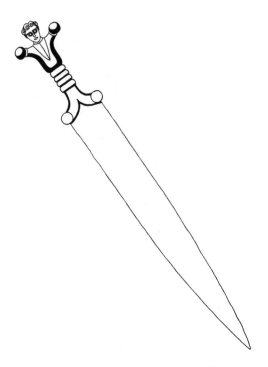

Sword with head handle

Vortigern, brought new forces from Germany after the death of Uthyr. They spread throughout the island from the mouth of the Humber. People turned to Merlin for advice, as Christmas was coming and with it the birth of the Lord of Lords and King of Kings, whom the weak and the strong equally obeyed. So they all gathered together, including Kynyr and his natural son Kay [Kei], in the church of the archbishop. After the mass, the people came out to a stone within the walls of the monastery, in which a sword was stuck. And around the stone, in golden letters, it was stated that whoever was able to pull the sword out with the help of God

would become king. A dispute broke out among the men for permission to pull the sword. After another mass and supper, 250 men, in order of age, tried but were unsuccessful in pulling the sword. So games were tried. Kay also participated in the games. His sword broke at that time, and he sent Arthur to the lodge to get a new one. But he could not get there because of the many people who had come for the games. Depressed, Arthur started to go back, this time by way of the monastery. He saw the sword unguarded and sticking out of the stone. Arthur pulled it out, hid it under his clothing, and brought it to Kay. Kay recognized the royal sword and told his father happily that he would be the king. Since Kynyr did not believe him, they went back to the stone together. Kay became dizzy. Arthur stuck the sword in and pulled it out again. Kynyr realized that Arthur would be king and wanted recognition for his work in rais- ing him and for his natural son Kay, who had been partly rejected because of Arthur: Kay would become the seneschal over Arthur's entire kingdom and not be responsible for his own mistakes. After Arthur agreed to this deal, Kynyr turned to the archbishop and asked him to per- mit Arthur, who was not yet a knight, to pull the sword. The nobles of the land were angered and demanded other attempts for themselves. Only at Easter was Arthur recognized as their king. After further tests, Arthur was awarded the dignity of a knight at Pentecost and enthroned on the next day. The stone was not seen from then on. Arthur kept the sword as long as he lived and named it Caledvwlch ["Hard Sword"].

The name of Arthur's sword is also found in the Irish tradition in Fergus's sword, Caladbolg ("Hard Sword"). It was also named Calad-c/holc ("Hard Sword").[316] Geoffrey of Monmouth latinized it to Caliburn(us)[317] and Excalibur, which is its most common name

[316]Thurneysen, pp. 114f, 541ff.
[317]Thorpe, pp. 225, 255.

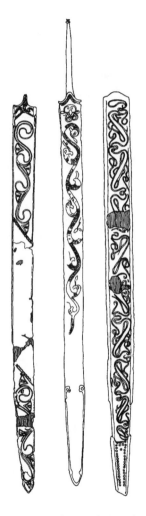

Decorated sword sheaths

today.[318] Excalibur now comes, however, from Avalon, Arthur's last resting place.[319] The Welsh epics of the robbing from the Otherworld[320] tell that Arthur got his sword there. Today, there are many legends in which it is interwoven: thus, Excalibur is now sometimes obtained from a lake.[321] With the burgeoning Arthurian literature, Arthur's fame and prominence as a royal ruler increased. In fact, however, he was probably originally a Northern British, thus Celtic warrior of the 6th century, who spoke a language similar to early Welsh (Arthur of the Welsh). In the story "Culhwch ac Olwen,"[322] in which all knights of the later Round Table, including Owain and Kay, appear, he is one of many heroes, although already somewhat more famous. In "Breuddwyd Rhonabwy,"[323] Arthur's sword has two golden snake images. And when the sword is pulled out of its sheath, one sees two flames striking out of the mouths of the snakes[324] that are so terrible that no one can look at them easily. Here too, he is defeated by Owain.[325] The association with Merlin (Welsh Myrddin) and the Grail is made only later.[326] For the Welsh, however, Arthur was for a long time the personification of hope for salvation from the Anglo-Saxons/English.

Long swords continue among the knights and receive a cross handle. They, like other weapons, also appear in heraldry. In church heraldry, they stand for authority and martyrdom.[327]

[318]Cf. Morpurgo 1996, where some Arthurian epics have been collected together.
[319]Cf. chapter "The Otherworld."
[320]Cf. chapters "Apple Tree" and "The Otherworld."
[321]Morpurgo; cf. the sword of the Scottish Highlanders.
[322]Cf. chapter "Boar."
[323]Birkhan II 1989.
[324]Cf. chapter "Dragon."
[325]Cf. chapter "Crane."
[326]Cf. Bromwich 1991.
[327]Rothery, pp. 102f.

Place of worship

STONES

Stones, besides bones and wood, are probably the most important natural materials for the production of weapons, places of worship, housing, fortifications, and artistic and religious objects. Metal is also an important material, but it is man-made.

Stones are important primarily as early Celtic documentation,[328] from which we have come to assume eleven Celtic languages so far: Gaulish, Galatian, Iberian Celtish, Lepontish, Irish, Scottish Gaelic, Manx, Welsh, Cumbrian, Cornish, and Breton. Pictish is so far still uncertainly classified.[329]

In the spiritual field, stones were also healing agents[330] (they could even be cooked!), what people transformed into or used for protection, for religious purposes,[331] and as a means of prophesying.[332]

Other functions represent a mixture of everyday and religious use, depending on whether the stones are in their original shape or carved. Unhewn, they could serve as places of birth,[333] rest,[334] orientation[335] or accidental death,[336] as altars for the placement of trophies (such as heads),[337] and as grave, event, or cult markers where they embodied, for example, the center point of the world, gods, and/or fertility. The *menhirs* ("long stones") were probably sought out and

[328]Cf. grave stones, Ogham stones, also cf. chapter "Trees."
[329]Cf. Birkhan 1997, 62ff.
[330]Materials used for this, such as gems, are already mentioned in the epics; Thurneysen, p. 457.
[331]Cf. chapters "Fertility Magic: Women, Men."
[332]Cf. chapter "The Year Cycle."
[333]Thurneysen, pp. 276, 573.
[334]CúChulainn, ibid., p. 132.
[335]CúChulainn, ibid., p. 466.
[336]Buan, ibid., p. 465.
[337]Ibid., p. 556.

Ogham stones

erected according to their special shapes. From there, it was a short transition to worked stones. Here there are phallic shapes,[338] god figures,[339] and many others.

Smaller stones or stone fragments were used more as weapons—namely shots, ammunition for stone catapults,[340] and spear and lance tips.[341] They could also be toys for children.[342] Whether hewn or not, large or small, they also could be used as a form of protection when they were erected as a palisade or piled up at Samhain—to mark a grave for spirits?[343]

Stones, like trees, could accompany people in the three most important steps of their life. They are associated with (1) birth; (2) maturation (rite of passage), renewal (sleep), healing, fertility, and joy; as well as with (3) death (grave markers).

The story of Conchobar's Conception illustrates the association of life and death:

*A*sa *("Pleasant"), daughter of Eochaid Sálbuide, king of Ulster, was raised by twelve stepfathers. Cathbad, a warrior and Druid, kills them all. Because her own father would not take revenge, Asa, now Nesa (< Ni-Asa, "Unpleasant"), set out at the head of a band of twenty-seven. While searching for Cathbad, she destroyed the border region between the two lands. But Cathbad caught her alone, bathing. She saved herself by becoming Cathbad's wife. He thus received Nesa's homeland on the brook Conchobar. When Cathbad was thirsty one night, Nesa brought water from the brook. Although she strained the water through her veil, in the light, two worms were found in the cup. Cathbad forced her to drink the*

[338]Cf. chapter "Fertility Magic: Men."
[339]Cf. destruction of trees in chapter "Trees."
[340]CúChulainn; Thurneysen, p. 170.
[341]Ibid., p. 132.
[342]Thurneysen, p. 137.
[343]Cf. ibid., p. 573.

water. As a result, she became pregnant. On the way to her father, Nesa went into labor. Cathbad predicted that the child would be a very famous king if she could delay the birth until the night, because on the same night the holy child Jesus Christ would be born into the world in the East. On a stone plate, Nesa laid down at night and died after giving birth to a boy named Conchobar who was holding a worm in each hand.[344]

A figure similar to Obelix, but without a magic potion, is also found in the Celtic epics[345] of CúChulainn. He juggles a set of stones, because he cannot lift them all at once. Even though he is 11 years old, he is bound with numerous chains on his feet, arms, and neck and held by 11 × 7 men. As a child, CúChulainn has killed enemies with hand stones[346] and smashed his stepfather's dog on a stone pillar so that its limbs flew in all directions.[347] In the battles at the ford for the brown bull of Cuailnge,[348] he also smashes heads with stones. On one occasion, his people provide him with stones. He fights for 3 months. His stones and his enemy's collide so that they break apart in the air.[349] CúChulainn himself is described with eyes like gemstones.[350] He sleeps on a stone[351] and he is finally struck dead by a stone. On his deathbed, he rests on a rock base.[352]

The best-known group of stones is probably Stonehenge. It was first built as an earthen wall and probably used for religious purposes for as long as 5000 years. After wooden structures, a stone temple was erected, with stones weighing up to 25 tons each from modern Wales, over 217 miles away. Ruins that are still impressive bear witness to a once mighty structure.

The result of this prehistoric technical achievement was taken over by the Celts for their purposes. Since groves were a preferred place of worship,[353] it is assumed that they taught astronomical knowledge here or used it in practice.[354] Since about 1600, Stonehenge has undergone constant destruction. It has been misused as a quarry for building houses and streets, and damaged by visitors.

Stones remain significant and are found in churches as baptismal stones; the first monasteries (for example, Kelling Michael in Ireland) were hewn from stones or erected on rocks.

Today, there is a New Age use of stones as a healing element. Crystals and gemstones are offered in ground form or in their essence.

Stones can be purchased as souvenirs today in Wales in front of caves that have been developed for tourists—for example, in Dan-yr-Ogof, "Under the Cave" (near Glyntawe).

Moreover, stones, specifically slate stones, have been developed as a typical raw material for constructing houses in Wales. Especially in North Wales, they are processed everywhere at present in the form of houses or enormous piles as well as into small items, such as dragons.[355]

[344]Cf. chapter "Snake."
[345]Ibid., p. 479.
[346]Thurneysen, p. 133.
[347]Ibid., p. 134.
[348]Cf. chapters "Bull" and "Transformation."
[349]Thurneysen, p. 198.

[350]Ibid., p. 182.
[351]Cf. chapter "The Year Circle."
[352]Thurneysen, p. 563.
[353]Cf. chapter "Trees."
[354]Cf. Osborne, pp. 15ff.
[355]Cf. chapter "Dragons."

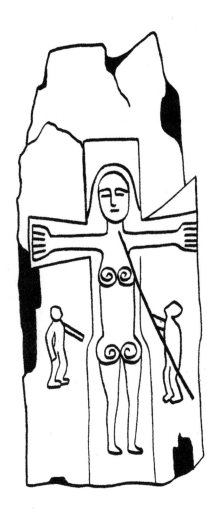

Crucifix scratched into stone

CROSS

Celtic crosses are typically provided with a circle. They are probably the high point of a development that started when (Ogham) stones hewn for graves, places of worship were erected.[356] Their style was especially clearly influenced in the 8th century by the interwoven ornaments of the bronze- and goldsmiths.[357] They constitute the artistic high point in early Christian Ireland. After that, mostly biblical and other scenes were depicted.

As a representation of the structure of the world, the cross is just as basic as the circle. Combined together, they are also called "wheel crosses," which appeared already in rock drawings.[358] The cross can stand, on the one hand, for the four directions and, on the other hand, for the world tree. With its four limbs, it holds the underworld, the earth, and the vault of heaven together and, thus, prevents chaos.

To what extent this also applies to the Celtic cross is not quite clear. Did it arise from the circle as a sun symbol into a spoked wheel and then to the swastika and finally to a cross with beams of almost equal length to the modern cross form? Did the long beam pointing downward and the circle develop for technical reasons of construction and stabilization? Or are old traditions and concepts continued in the derived form? Is the sun being portrayed? Or the moon, which confers the most power when full,[359] or the stars?

The circle as protection can also be seen in the building style of the fortress of Hillfort and earlier houses (round huts). Likewise,

[356]Cf. chapter "Trees"; continually in the epics.
[357]Cunliffe, p. 176.
[358]Elser, p. 188.
[359]Cf. chapter "The Number Two: Eye and Moon."

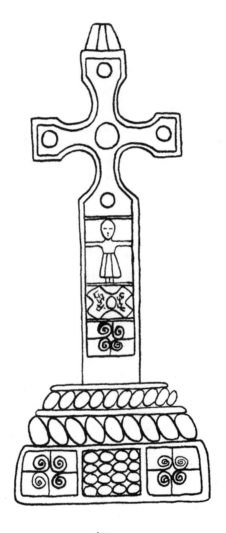

Celtic cross

many places of worship and Stonehenge[360] are round. There is also a year circle. Reference should also be made to the frequent representation of CúChulainn's jewelry: his special technique for catching birds and salmon jumping involves moving in a circle in each case.[361]

The high cross survived to the 12th century. Thereafter, the signs of a new era became predominant. Christianity had established itself as an ideology of feudalism; the next penetrations into Celtic lands are the Vikings in the 9th and 10th centuries, and the Normans between the 11th and 13th/14th centuries. This was reflected in the strongest Celtic place of refuge, Ireland, where there were new developments in art, literature, and language. The Scottish probably started to separate from the Irish, and the Manx somewhat later. Cumbrian was already dead. The Welsh and Cornish, and Bretons somewhat earlier, and their literature went through a new phase. The process of penetration into insular Celtic languages had taken on an increasing force.

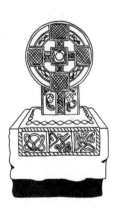

[360]Cf. chapter "Stones."
[361]Cf. chapters "The Number Two: Eye and Moon," "The Year Cycle."

Various egg symbols

THE NUMBER ONE: EGG

In the symbol of the egg, the sperm and ovum are united, which indicates that they are of the same origin as, for example, the oak, and that life is constantly renewed. The egg is part of a worldwide symbol that is preserved not least in our Easter customs.

The egg appears mostly in the spherical form, including wheels, and accompanies humans and animals in many arrangements, primarily on coins. Depending on the arrangement, it may increase in value—for example, to become a Mother Goddess or give signs of fertility. The egg, especially that of the snake,[362] also stands for the uninterrupted creativity without beginning or end. There is no original beginning, only a beginning in the continuum of descent.

The egg also stands for the number one. Here, as with other numbers—for example, three and seven—the numeric value has no significance.

The following story is one of rejuvenation and rebirth:

The Sullivan family believed that their youngest child had been enchanted by fairies, since he had shrunk overnight and would not stop whining and crying. They also thought that the face was not their son's. One day, a wise woman known throughout the land came by and told Mrs. Sullivan to take a pot full of boiling water and throw into it the shells of a dozen freshly laid eggs. Mrs. Sullivan decided to follow the wise woman's advice. While Mrs. Sullivan boiled the water and threw in the eggs, the child watched with amazingly calm and relaxed. He finally asked with the voice of

[362]Cf. chapter "Snake."

Relief with egg in the center (coin)

a very old man, "What are you doing there, mother?" It was now obvious that it was a fairy. So Mrs. Sullivan quickly made her poker red-hot and, as advised by the woman, set to stab the fairy. In her haste, however, she slipped with the poker so that the fairy fled to another corner of the house. After a while, she found him. As she was about to take the fairy and throw him into the pot of water, she found her rosy-cheeked son sleeping calmly in his bed.[363]

The egg's symbol as life is still a motif in some fairy tales, where, for example, certain animals carry an egg inside them that must be broken in order to drive the life out of a magician or witch.[364]

[363]"The Brewery of Eggshells"; Booss.
[364]Cf. "CúRoi's Death."

Moon god with crescent horns

THE NUMBER TWO: EYE AND MOON

The eye is often associated with the number two and thereby with the moon cult. As with the egg, the numeric value of two has no significance; nor do the anatomical characteristics of the eye. Instead, the eye symbolizes absolute vision/knowledge and bestows on the hero magical knowledge and demonic strength (as with the Germanic hero Wodan). It is often depicted on coins as a symbol of comprehensive significance.

Besides the moon and the number two, one-eyedness and imparity are considered to be signs of demonization, as are one-armed, one-legged, and similar beings. Medb,[365] the main enemy of CúChulainn, prepares a trap for his death by cutting off the right foot and the left arm from the three sons and daughters of the wife of his enemy Cailaitlín, whom he had killed, and by blinding one eye.[366] She and Morrigán can appear with one eye.[367] Conall Cernach fights against a one-armed woman,[368] Finn's enemy is a one-eyed (?[369]) demon, as is the enemy of Lug, hero of the conquest myths, namely the giant Balor,[370] who in turn probably has his Welsh counterpart in Ysbaddaden, the father of Olwen.[371] Balor can kill enemies with his eye or change them into stone.[372]

The description of CúChulainn in "Rage (The Driving Out of Cuailnge's Cattle),"[373] who is retreating to the neighborhood of the moon cult, is interesting:

CúChulainn, who was sometimes described as one-eyed[374] because those in love with him were stricken with blindness

[365]Cf. chapter "Fertility Magic: Women"
[366]Thurneysen, pp. 558.
[367]Ibid., pp. 175f.
[368]Ibid., pp. 510, 555.
[369]"The Pursuit of the Gilla Dacker."

[370]"The Fate of the Children of Turenn."
[371]Cf. chapter "Boar."
[372]Joyce, p. 459.
[373]Cf. chapter "Bull."
[374]Brendel, p. 74.

Relief with a single eye (coin)

until they could speak to him, was angered by Medb's attacks. All his limbs and joints trembled, his body turned in its skin so that his feet and knees pointed backward, his buttocks and calves pointed forward, and the muscles of his calves lay on his shinbones like fighting fists. His face became like a black shell. He pulled his one eye in so that even a crane could hardly have reached it in his cheeks; the other eye jumped out in front onto his cheek. In distorting his mouth, his cheeks came loose from behind the chin so that his throat was visible; his lungs and his liver flattened in his revenge. He pulled his jawbones together and fire blew out of his neck and mouth. The beating of his heart was like the bellowing of a slaughter-hound or the roar of a lion. His hairs stood on end so that apples could be stuck on them. From his voice, the battle moon (?[375]) arose as thick as a grinding stone and as long as a nose. High as a mast, it shot a ray of brown blood from its slit and formed a dark, magic fog. After this distortion, he jumped onto his chariot, which had been fitted with crescents on the wheel hubs.

In other cultures, the eye is connected with the number three. Thus, in Christianity, a triangle in the eye indicates the omnipresence of God. Buddha, in contrast, has a third, divine eye of omniscience.

Additional symbols of two, and thereby of the moon cult, are the torque,[376] the female genitalia,[377] the almond shape, the crescent, and not least, the half moon itself and horns.

The moon cult is important not only in Celtic culture. The Iberian Celts made sacrifices to the full moon and danced through the night,[378] but there is hardly any indication of that among the insular Celts. Only the Scots still called the moon in earlier centuries *lòchran mòr an àigh,*

[375]Many statements are not sufficiently documented, but suspected.
[376]Cf. chapter "Torque."
[377]Cf. chapter "Fertility Magic: Women"; Sheila-na-Gig.
[378]Birkhan 1997, pp. 591ff.

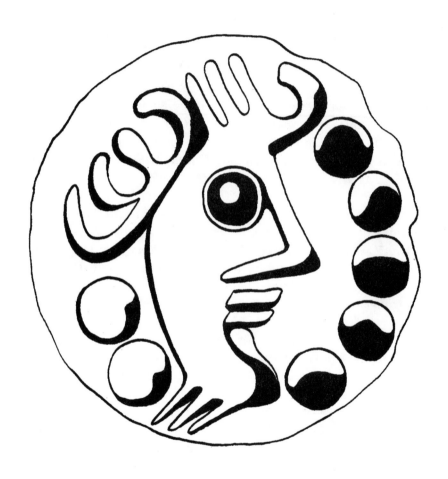

Head in the form of a moon crescent (coin)

"great lamp of God." It is certain that the moon was important for rituals, destinies, and reckoning time. Thus, as the Germans were afraid to fight before the setting of a waning moon, it was also important for the Celts to find the right point in time for ritual events—for example, the mistletoe cult, prophecies from the blood of humans sacrifices, political decisions such as wars, and a wide field of activities for Druids. However, very few Celtic sky gods (heaven, star, moon, sun, thunder, and other gods) can be documented. Nevertheless, the Celts were known for prophecies and especially for prophecy customs based on the moon. Astronomical observations must have been made over many years, coupled with knowledge from ancient megalithic times, leading to the astronomical structures that were built.

Also interesting is the calendar of Coligny, Gaul, which was probably developed in the 2nd century. Generally, there was a moon or sun calendar. Here, however, the two were connected together, and therefore mathematical problems (?[379]) were posed that were relatively difficult for that time: the year divided into 12 months was adjusted by a leap month of 30 days every 3 years. It is unclear whether the leap month was created by the Druids, and, since they also had other systems for reckoning time,[380] it may have served religious purposes. At this point in time, the Julian calendar had already existed for 220 years. Irish documents also indicate a sun calendar. On the other hand, there is only a divine name for the moon (Lugo[ues]?[381]). It is certain that the Celts also associated the waning moon with decreasing strength, the lowest point of which is the dark of the moon. The defeat of the Galatians (Gauls of Asia Minor) in 218 happened at such a time.

[379]Many statements, word derivations, and dates are not sufficiently documented, but rather assumed.

[380]Cf. chapter "The Year Circle."

[381]Many statements, word derivations, and dates are not sufficiently documented, but rather assumed.

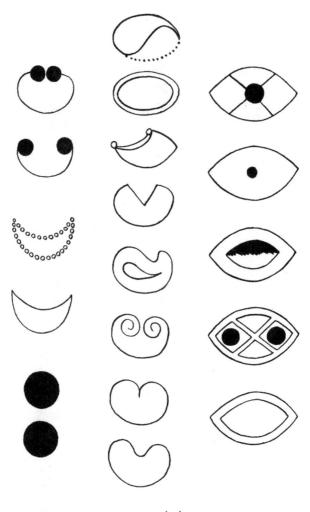

Moon symbols

At first, the Celtic calendar divided the year into dark and light seasons, whereby night and death and thereby the origin of life were explained as starting from the dark. Likewise, the night came out of the day. People probably reckoned according to the night as they still do so in Wales today: *wyth-nos* ("eight nights") = week, *pythfnos* ("15 nights") = 2 weeks. In English, there is "fortnight" = 14 nights,[382] in Breton, *antronoz* = "beyond the night" = day.

Samhain[383] was celebrated at the full moon following November 1. The phases of the moon, its disappearance and reappearance, proved to the Celts that death was never final. A connection was also made between the tides of the sea, which are determined by the phases of the moon,[384] and between the moon and a woman's monthly cycle. The moon cult therefore stood in close association with fertility and growth; it listed the triptych death–fertility–rebirth together with the emphasis placed on rebirth. The meaning of strength (renewal) may also fit in here, which the early peoples lost with the waning moon.[385]

The nightly ceremonies were devoted primarily to nocturnal animals, such as cats, dogs/wolves, rabbits, and snakes. Does the positive aspect of the owl[386] (wisdom associated with age, as in the "wise old owl") play a role in making decisions at night accompanied by the moon? Nightly rituals, specifically at midnight, must have been very widespread up to our times.[387]

The number of the moon, two, is probably expressed in the torque,[388] among other things. The moon is represented by various

[382]See previous footnote.
[383]Cf. chapter "The Year Circle."
[384]Association with the water cult.
[385]Cf. Galatians.
[386]Cf. chapter "Birds of Prey: Eagle"; owl in "Culhwch ac Olwen."
[387]Cf. chapters "Oak," "Mistletoe."
[388]Cf. chapter "Torque."

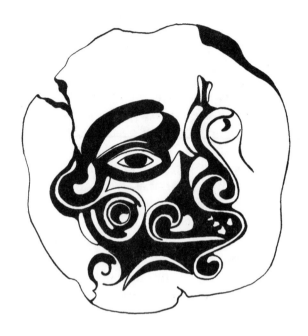

Coin with eye motif

cultures as a horn or a crescent with two ends. The crescent moon is used to represent various body parts, such as nose, mouth, ear, horse belly, hair, and vulva. Under a root system or connected with other motifs—in particular, horns—additional meanings arise.

The moon was also depicted as an oval, which associates it with the vulva.[389] The "V" motif also stands for the moon (legs, wings, muzzle, helmet, staffs) and unites male and female principles. As for number symbols, MacDathó[390] prepares 7 times 50 campsites, which correspond to the 350 days of the lunar calendar.

A clear (Christian) indication of the old moon cult is given in "The Journey of O'Corra's Sons":

O'Corra *and his wife, in spite of their great desire for each other, remained childless. As a result, they turned to the devil, and eventually the wife gave birth to three sons: one at the beginning of the night, one at midnight, and one toward the end of the night. Although they were well raised, they started to plunder and destroy more than half of the churches in Connacht. They spared the church of their grandfather at first. Finally they went there to desecrate it at night when all had gathered were asleep. That night, they dreamed that they should break away from the devil. And so their journey started...*

Irish heroic epics also refer to the moon, such as when three of their greatest heroes are arguing over the "hero's piece"[391]:

*T*he decision was to be made by their night watch over CúRoi's city. At first, Laegire kept watch. Toward the end of the night, the shadow of a giant approached. Laegire tried in vain to fight him. He was almost torn apart by the shadow giant, between its palms like a chess piece. When Laegire was near death, the giant threw him on a manure pile in front of the palace. Conall Cernace fared no better. When it was CúChulainn's turn, he had an even worse encounter; about midnight, there was a piercing cry. Nine men tried to attack him, but he threw himself at them and they fell to the ground, dead. He took their heads along to the guard place. But soon afterwards, a new cry started, and he struck the next nine. Now he was able to make a pile out their heads and weapons. When he wanted to lie down, tired, he heard the sea rage in a wild surge. He saw the foaming waves give birth to a horrible monster. So he set off in his own manner of hunting by encircling the prey like a rolling wheel. He closed his hands around the monster animal, stuck his*

[389]Cf. chapter "Fertility Magic: Women"; Sheila-na-Gig.
[390]Cf. chapter "Boar."
[391]Cf. chapter "Barrel"; the dispute over the "hero's piece."

o the Moon

Be greeted, cameo of the night!
Beauty of heaven, cameo of the night!
Mother of the stars, cameo of the night!
Foster child of the sun, cameo of the night!
Majesty of the stars, cameo of the night!

o the New Moon

Be greeted, New Moon, friendly jewel of the way!
I kneel down before thee, I offer thee my love.
I kneel down before thee, I raise my hands to thee,
I direct my eyes to thee, New Moon of the times.
Be greeted, New Moon, most beloved of love!
Be greeted, New Moon, thou dearest of good things.
Travel on thy path, thou who directs the tides.
Queen of the way, Queen of happiness,
Queen of love, New Moon of the times.

arm deep into its throat, and tore its heart out. It fell to the ground. CúChulainn beat it into small pieces. Now he left the head intact and placed it by the others. When he then sat down, weakened, another monster appeared at dawn from the sea. As it was about to grab the two heroes, like the night before, CúChulainn performed his high salmon jump and again drew his circle as fast as a wheel around the prey. The monster begged for mercy and promised to fulfill three wishes for him. CúChulainn released him. The hero's piece then belonged to him,[392] which the monster promised him, however, only after yet another adventure.

CúChulainn generally liked to kill his victims at night. In "The Drunkenness of Ulster," CúChulainn waited till midnight, consulted with the Druids, and then began his undertaking. And Conchobar became king of Ulster, since his mother was able to delay his birth until night,[393] but she then died.

The description of Etain is associated with the moon. She is white as the snow of the first night... and the bright light of the moon is said to beam from her pleasant face.[394] If one reads Etain's description and then the two Scottish-Gaelic folk prayers on the opposite page,[395] the reverence for the moon is obvious and one is tempted to see the moon in Etain herself.

With the beginning of the conversion of Christianity, the night became generally associated with evil spirits, death, the devil, punishment, and loneliness. A proverb said that the nightly call of the (screech) owl brings misfortune. Today, the idea of the influence of the moon on a woman's life rhythm continues, and there are some advisers for the moon cult, strength, magic, phases, and time.

[392]Cf. chapter "Barrel."
[393]Cf. chapter "Stones."
[394]Cross, 94.
[395]Jackson.

God with wreath of rays

THE NUMBERS THREE AND FOUR: SUN

As stated earlier,[396] sky divinities, including sun gods, are hardly found among Celtic folklore. There are numerous wheel symbols (sun disks) as sun signs primarily in the Hallstatt period (about the 8th–6th century B.C.). They can stand for life or traveling to the Otherworld, especially when they represent the chariot of the sun on, for instance, coins. The wheel, originally a circle ornament or double-circle pattern, is one of the earliest and most predominant sun symbols.[397] In the circle ornaments, the egg has been taken from the sun cult. Later, the sun decor is found in ceramics as a sun with a wreath of rays or in the form of a spoked wheel.

In the sun cult, the eye[398] must also be thought of as a source for the circle ornament through the Indo-European religious metaphor of the sun as the eye of heaven. Since, however, night and day, light and dark are considered two worlds[399] that belong together, the eye could be both the sun in the day sky as well as the moon in the night sky.[400]

Numbers are other symbols that can point to the sun cult. As the number two was assigned to the moon, the number three was assigned to the sun, likewise without numeric content. Symbols of this number are triangles and all shapes can have a triangle as their basic shape.[401] Four is also assigned to the sun. This includes crosses,

[396]Cf. chapter "The Number Two: Moon."
[397]Cf. Lengyel, p. 173.
[398]Cf. chapter "The Number Two: Moon."
[399]Cf. Lengyel, p. 173.
[400]Many statements are not sufficiently documented, but rather assumed.
[401]Cf. chapter "Lyre/Harp."

Feathered god with snakes

including the swastika, which is encountered among the Celts in the form of the "Hakenkreuz" (hooked cross).

Number symbols can encounter interpretative problems. For example, the number four can be seen as two times two to represent a reinforcement of the moon cult. Other times a multiple of three (for example 9) or four can reinforce the sun cult. All numbers from one through nine are either parts of three (1 + 2) or else a multiple of it. As a result, certain interpretations can be interchangeable with it. This leads to confusion, as is shown in the symbols previously described. Numbers in symbolism are not numerically precise data, but a formula for describing various partial views of life or the worldview. Since our knowledge about this in earlier cultures is limited, the meanings are problematical and numbers are not expressive in themselves.

Birds, especially birds of prey such as eagles, vultures, hawks, and falcons, are sun animals.[402] On Celtic coins, the horse can also be associated with the sun. At the same time, however, it was also important for the moon.[403]

The sun cult lists together the meanings life (including healing and fertility), pain, and death, with the emphasis on death. The association with a source of healing, probably together with the warmth of the sun, is represented in Britain (Bath) especially by a female divinity, Sulis, who is a sun goddess according to her name,[404] also Suleviae.

The sun is associated with the holy fire that brought light, warmth, and a new quality of life to the early people, as is known. It has a healing and destructive effect—just think of the hot noonday sun! In extreme cases, the sun can also send lightning, which can cause healing or great disaster.

[402]Cf. chapter "Birds of Prey."
[403]Lengyel, p. 46, Fig. 12.
[404]Cf. Welsh Dydd Sul, "Sunday."

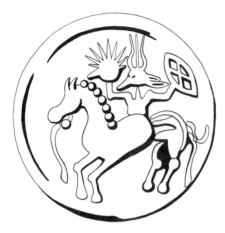

Graves in the Boyne valley are riddles: they are built in such a way that the chambers are in darkness for 51 weeks. On the first morning of the winter solstice, however, sun rays can enter them, if the sky is not cloudy.

There are just as few accounts of the sun cult as there are of the moon cult. The hero CúChulainn can naturally be seen to represent the sun cult. But it is more probable that, as an outstanding hero, he united in himself a whole series of various concepts.[405] The Irish hero Lug(h) is also sometimes associated with the sun, primarily because of being equated with Welsh *lleu* ("light"), as is Finn.[406] The moon has been established in association with light, as it is called *lleuad* in Welsh. Moreover, the characteristics assigned to the sun occasionally appear with Lug,[407] but not when he appears as the companion/father(?) of CúChulainn.[408]

In fact, however, it is CúChulainn and Kai[409] who radiate glowing heat or icy cold:

CúChulainn, when he was only 7 years old, developed an ember into a living coal container that radiated such heat that it threatened to burn others when he came near them. So he often had to be cooled with water, such as from barrels.[410] He also had the ability to stay under water for 9 nights and 9 days without breathing, and he could go without sleeping for the same length of time. A wound from his sword could not be healed; he

[405]Cf. coins in Lengyel, p. 173.
[406]Cf. Low, p. 156.
[407]Cf. "The Fate of the Children of Turenn."
[408]Cf. also Low, pp. 151ff.
[409]Cf. "Cuhwch ac Olwen."
[410]Cf. chapter "Barrel."

himself was the most victorious and could grow as large as a tree. Everything that was in his hand or within a hand's breadth, above or below, dried up, even when it was raining heavily. For strong heat radiated from his head constantly. This was also the reason why frost could not harm him, and his hands served as a source of fire for his companions in the cold.[411]

Kai is the opposite. He is both cold and hot. Thus, he stands for the connection between the sun and water cults.

Fire plays an essential part in its good and destructive roles, particularly in the Irish epics.[412] With the conversion to Christianity, however, fire is increasingly associated with evil. Now Hell is described as a fiery place with the people in it burning in various ways. Does hellfire in early Christianity continue Druidic human sacrifice in a stronger form combined with other functions, especially punishment, whereas fire originally served for prophecy or appeasing the gods? Do Christian moralizing stories such as "The Voyage of the Sons of O'Corra" point in the direction of the Inquisition, which reached its high point in the 12th and 13th centuries?

The idea of a sun goddess continues in Mary when she is called the "sun of women,"[413] and possibly with St. Brigid when she maintains a perpetual fire than can only be tended by women. We also find it further developed with saints, as has already been described for CúChulainn and Kai: light and fire phenomena accompany their birth, they survive burning houses, fiery pillars rise from their heads, their faces are radiant, their bodies can melt snow or warm cold, their fingers can break out into flame, they can travel in fiery chariots, etc.[414]

The sun itself was no longer to be revered as a heavenly body, but only in Jesus Christ—the Christian sun.

[411]Birkhan II 1989, p. 48.
[412]Cf. CúChulainn's biography, "The Radiant Boy," etc.
[413]Cf. Low, pp. 156ff.
[414]Cf. Low, pp. 156ff.

Entwined triangle

TRIANGLE

The number three is important in all early Indo-European cultures, but it is especially important with the Celts. Three denotes the three sides of life: birth–life–death. It is a basic number to which all being can be categorized in three-fold: start–middle–end, past–present–future, front–center–back, above–center–below, time–place–type, heaven–earth–water, and also unity–strength/power–completeness. Since these are all characteristics that exist for many people, there is possibly here a basis for the extensive use of the number three for the division of various characteristics of society into triads.[415]

Three, however, also includes its tensions (1 + 2 = 3 or 3 – 2 = 1, etc.). This in turn invokes arrangements that can also be opposites (for example, Light ↔ Twilight ↔ Darkness, Young ↔ Mature ↔ Old, etc.). It makes, at least sometimes, new entities possible. In any case, there are so many possible meanings for the number three that it, like some other numbers, occurs in Christianity.

Early drawings of humans and animals from the 8th and 9th centuries B.C. were made with clumsy lines or hung from triangles and other surfaces[416] without stories behind them. They were then followed by shaded triangles with possible meaning. Animals appeared as triangles, heads were angled lines (angle hooks). Additional hooks gave specific, even additional, meaning. Also, shelter, tents and houses, could be represented to the fullest extent

[415]Cf. chapter "Triads."
[416]Geometric style of the first finding, Dannheimer, p. 140.

Vessel from the Hallstatt period

by angles. Triangles decorated or formed by themselves body parts, such as mouth and eye. When simplified, they also could be reduced to arrows.

In continuation of the strong tendency to use the number three was the Celts' concept of a triple Mother Goddess, especially in Gaul, which then spread rapidly and widely and was taken over by the Germans.[417] Thus, the above-mentioned elements could be represented pictorially. Just like the elements (water–earth [trees/stones]–heaven [moon/sun][418]), the number three was an integral part of people's lives and was therefore closely associated with them.

[417]Cf. Birkhan 1997, pp. 519ff.
[418]Cf. chapter "Triskele."

Three gift horses:
one stone gray,[419] one pale yellow, one with tired gait
Three main steeds:
one large black-tinted, one with stormy long legs,
one red...[419] with a wolf's gait
Three captured horses:
horse hoof, long tongue, effervescent life[419]
Three lively horses:
one shackled and gray,[419] one brown-spotted,[419]
one pale white with an agile back
Three agile steeds:
one gray, one chestnut brown, one with impetuous
 hooves/
the red with moldy horse feet[419]
Three pack horses:
one black, one enormous and yellow, one with a red
 muzzle[419]
Three horses bearing three horse loads:
the black Moro, black as the sea,[419]
Cornan, the small one with horns,[419] Heith, the spotted
 one[419]

Tri pheth sydd o godi'n fore—
iechyd, cyfoeth a santeiddrwydd

Three things bring early rising—
health, wealth, and holiness.

Tri pheth y dylem eu caru—
aroglau meillion,
blas llaeth a chân adar y coed

Three things we should experience:
the smell of clover, the taste of milk,
and the song of the wild bird.

Tri pheth y dylai Cymro fod
yn debyg i'r Cymro gynt—
bod yn hael, yn wrol ac
yn hawddgar

Three things the Welsh of today
should share with their predecessors—
to be generous, brave, and kind.

TRIADS

In Celtic art, three is often represented as a triplex, such as in a triad, or as three inseparably entwined interlocking views. Everything that constitutes life-knowledge, art, gods, social and cultural relationships, concepts, and courses of action (including St. Patrick's shamrock, which is today one of the national symbols of Ireland, along with the harp)-seems to be imbued with triangular symbolism. This extends from the earliest beginnings of representation as a triangle motif on useful objects, through cultural objects, to literature, where triads are prominent[420] in Ireland and Wales as a genre.[421] The most important knowledge of life, personalities, animals, and other things of significance for society at that time are divided into systems of triads. Thus, for example, there are horse triads (see opposite page, top).

CúChulainn is born three times,[422] many heroes can only be killed three times, sacred things are encircled three times, fathers are kissed three times, etc.

Three or trinity has probably been preserved worldwide as a sign of strength. We too have to be advised three times, tempted three times. Triads were also used, probably already very early on,[423] as a stylistic device in terms of generating excitement and an interesting shape in oral and written tradition. The three triads on the opposite page (bottom) are used purposely by the tourism industry to advertise Wales.

[419]Many translations are unclear or not completely unambiguous.
[420]Cf. "Trioedd Ynys Prydein."
[421]I consider viewing them purely as learning aids (mnemonics) to be too shortsighted.
[422]Thurneysen, p. 268.
[423]Birkhan 1997, p. 492.

Three-headed motif (coin)

TRINITY

The triad and its possible meanings previously described[424] can be applied to the cults of mothers, mother goddesses, and goddesses of war. This application is not used just by the Celts, but it is also found in other places such as India and Egypt. This includes the representation of a god with three heads, but never one with three bodies. Instead there are images with three horns, three breasts, and some with three penises. It is not clear whether this means a strengthening of the most important parts of representations[425] or other functions.[426] This could also imply extensions of their meaning[427] or meanings in one of the directions that are included in the symbol three. Such things must also underlie Morrigán, Macha, and Badb and their multiple functions or appearances.[428] Medb fits into a trinity mainly as a mother-goddess figure: once married, she generates life; she brings in warriors such as Ailill, but also plans and executes death, as with CúChulainn.

With the conversion to Christianity, additional meanings enter: three-headed beings, seldom seen in traditional literature, become especially evil. As a result, the conquering of three-headed dragons is often found in fairy tales. Whereas the Celts trinity is primarily the mother divinity, with Christianity, it is related to the trinity of God as Father, Son, and Holy Ghost (supremacy of the patriarchate).

[424]Cf. chapter "Triangle."
[425]Cf. chapters "Head Cult," "Fertility Magic: Women, Men."
[426]Birkhan 1997, pp. 494f.
[427]Birkhan 1997, pp. 494f.
[428]Cf. chapters "Transformation," "Fertility Magic: Women."

Three spirals

TRISKELE

If the wheel, the circle/ring, and other symbols are to be seen as symbols for the sun, the triskele, like the swastika, is a symbol for the motion of the heavenly bodies—that is, it is a sun wheel with three blades. Both symbols appear in very early European and Asian culture. For the Celts, they are documented at the latest in the La Tène period (3rd/2nd century B.C.). Because of cultural exchanges that obviously also took place at that time, the Celts borrowed from the Greeks winding patterns and other designs, such as tendrils, and developed their own shapes from them. As a result, the distinctiveness of the curves increased, and the triskele developed into a typical Celtic sun wheel, which has today become an emblem of Brittany, the Isle of Man, and partially, along with the harp first and the shamrock second, Ireland. However, not every circle or other geometric figure should immediately be interpreted as religious.[429]

Many also see in triskeles a windmill (could it be a water wheel?), or the elements heaven–water–earth, or else accompanying the elements of water, fire, and air in the earth. The elements that accompany one throughout life are water,[430] stones, and trees (earth), as well as sun and moon (heaven).

The triskele is also mentioned in esoteric literature, in which it stands, greatly simplified, for the spiral of life that embraces the world. In the abstract, and in relation to the number three, it can generate flights of fantasy and the most varied meanings.

Christianity adopted the triskele and used it lavishly in illustrated books.[431] For many people today, it is a purely harmonious, elegant, and fashionable ornament.

[429]Cf. chapter "Triangle."
[430]Cf. chapter "Water."
[431]Cf. *Book of Kells*.

Five spirals

THE NUMBER FIVE

In China, five is one of the most important numbers in numeric mystique. It denotes the five elements, five sky directions, animal types, etc. In Europe, five is viewed as, among other things, a symbol of the connection between sun and moon.[432] It is therefore associated with the following statements: 2 (moon) + 3 (sun) = death–fertility–rebirth + life–pain–death = infinity. Symbols of five are thereby symbols of resurrection (resurrection is only possible after death). They are often depicted before horses on coins: the rider/guide leads the horse to his sign.[433] The best-known five motif would be the pentagram,[434] which is often also hidden in representations of people with extended arms and slightly separated legs.[435]

It is unclear how the doctrine of resurrection/rebirth was really viewed by the Celts. On the one hand, the dead received everything needed for their journey to the Otherworld; on the other hand, they would not need these things if they were reborn into the body of a child. Or did souls repeatedly return to a similar body? According to the epics, they had the ability to enter animals. In this case, the belief in resurrection and rebirth accompanies the notion of changing shape.

A *flock of birds repeatedly came to Conchobar's field and grazed it down to the roots. Angered by this, Conchobar hitched nine chariots in order to drive the birds away. The chariots were led by his daughter Deichtine. The birds, who sang very beautifully, were joined in pairs with silver chains.*

[432]Cf. Lengyel, p. 72.
[433]Cf. chapter "The Number Seven."
[434]Also: pentacle, German *Drudenfuß*.
[435]Leonardo da Vinci.

During the bird hunt, the hunters were overtaken by night and snow. They found a new house in which a married couple lived. They went in and found to their surprise that the house was enormous and filled with food. During the feast, the woman of the house delivered a son, and at the same time a mare gave birth to two foals. These foals were given to the little boy. On the next morning, the house and birds had disappeared, but not the child and foals. The child was raised by Deichtine, but died of a disease.

After returning home from the funeral, Deichtine took a drink that contained an invisible little animal. Lug mac Ethnenn then appeared to her during the night. He told her that they, the bird hunters, had been led to the house and accommodated there, and that the child had been his son. He said the boy had now been transferred to her body (with the little animal) and she was thus pregnant. The Ulster men could not explain the pregnancy and suspected that Conchobar was responsible for it when he was drunk. Thereupon, he promised his daughter to Sauldaim in marriage. She, however, was ashamed to enter his camp in this condition, and she struck her lower body in such a way that she lost the child. But she immediately became pregnant again and finally bore a boy named Sétantae. The smith Caulann took him in as a foster son. But since Sétantae had killed Caulann's dog while playing, the boy offered himself as the smith's dog and was since called Caulann's dog, CúChulainn.

Many people explained CúChulainn as a reincarnation of Lug.

It is interesting that music was originally based on five tones, remnants of which are still found in Irish and Scottish music. It is assumed that this involves the tone system that predominated in early times.[436] Five-fold arrangements are often found later in heraldry, primarily in Africa and Japan, but in the form of flowers. Islam has five pillars: faith, prayer, fasting, alms, and pilgrimage. Christianity knows the five books of Moses.

Today, the symbolism of five appears mainly in the form of the pentagram, which is used in spiritualist ceremonies.[437] Some still see it in this characteristic as a symbol of resurrection, others as a sign of the gathering of the powers of the world. As such, the pentacle is a magical tool accompanying ceremonies of (self-)purification and renewal, connected with old things, or simply something to keep evil away by being a representation of inner mystic energy, which stimulates inner powers. It is also called *Drudenfuß*, *Alpfuß*, or *Mahrfuß* in German. It can be a witchcraft symbol, or simply worn as a form of jewelry.

[436]Birkhan 1997, p. 1096.
[437]Gaia, p. 42.

Seven spirals

THE NUMBER SEVEN

Seven plays a worldwide role in symbolism. The numbers one to nine are important because they contributed to the first and simplest representations of quantity among early peoples. The special position of seven in Eastern literature and among the ancients is easy to comprehend. Seven denotes valuable, important, and necessary things, or things to be avoided, or heroic deeds. In Greece, seven fight against Thebes, there are seven sages, Rome is the city of seven hills, China has seven geniuses (poets), and India seven virgins and a seven-tongued fire god. Finally, the days of the week were named in antiquity after the five known planets and the sun and the moon, which is implemented completely in Welsh: Llun–Luna–Monday (moon day), Mawrth–Mars–Tuesday, Mercher–Mercury–Wednesday, Iau–Jupiter–Thursday, Gwener–Venus–Friday, Sadwrn–Saturn–Saturday, Sul–Sun–Sunday.

Whereas eight and six are often found among the Celts on such items as coins, seven is rare. When it is present, it is usually arranged in the form of a flower or can viewed as a symbol accompanying a horse.[438] There is a great difference in literature that has come down exclusively from the islands: in Mabinogi and Mabinigion,[439] the number seven is relatively rarely used. When it appears, it is mostly in connection with pigs and thereby with the Otherworld.[440] Both in the later Arthurian legends, such as "The Robbing of the Otherworld," and in the Irish tradition, much use is made of the number seven.[441] Could it be a sign of further conversion to Christianity?

[438]Lengyel, pp. 145, 82.
[439]See Appendix.
[440]Cf. "Culhwch ac Olwen"; chapter "Boar."
[441]Cf. chapter "Fertility Magic: Men."

House with seven doors

After the number three, seven is the most important number. This is supported by buildings in the Otherworld, which are characterized by seven—for example, seven doors.[442] In the epic Irish tales seven could be associated with the increasing influence of the conversion to Christianity and with pigs as representatives of the Otherworld (perhaps as a form of punishment). It is thus part of the Christian interpretation of the oldest Celtic literature that has been handed down.

MacDathó's house, which had seven doors that led to seven paths, contained seven cauldrons filled with the meat of oxen and pigs. An enormous pig, which had received the best milk for 7 years, was to be slaughtered.[443]

Culhwch's father took a new wife 7 years after the death of his first wife. Culchwch himself set out with Olwydd, "Track Reader," whose father had been stolen 7 years before by pigs and who had now tracked them down and brought them home in seven herds.

Gwrhyr, the interpreter, transformed into a bird, went to the camp of Twrch with his seven likewise transformed piglets in order to negotiate on behalf of Arthur (Artus).

Medb married Arilill and gave him seven sons. Later, she hunted the pigs of Cruachain. Wherever they were, no grass or leaf grew for 7 years. Wherever they were counted, they did not stay there. Their number was never finally determined: "There are three of them," some said; "More than seven," others said. "There are nine," some claimed; "Eleven," others responded.

After the battle over the two bulls, they reached a pact that led to 7 years of peace between the people of Connacht and the people of Ulster, thus Medb and Conchobar.[444]

[442]MacDathó's house, Medb's house; Thurneysen, p. 455.
[443]See chapter "Boar."
[444]Cf. chapter "Bull."

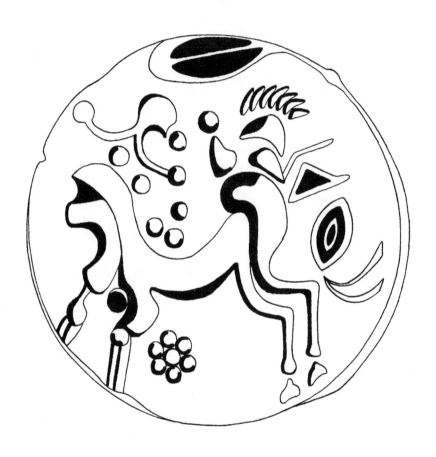

Ride to seven (coin)

CúChulainn starts with 7 years of fighting against Medb. The hero's piece, about which he fights later, consists of a 7-year-old boar fed with milk, hazelnut kernels, wheat, and meat, and a 7-year-old ox fed with milk, fine grass, and grain.[445]

MacConglinnes sees a woman, in his vision, who is wearing a neckband of seven times twenty and seven balls of pig marrow. He also sees a church, the walls of which consist of sides of pork from a 7-year-old boar.

The number seven is often associated with CúChulainn as well: he has seven pupils in each eye, seven fingers on each hand, and seven toes on each foot.[446]

Seven is especially important in the development of Christianity: the world was created in 7 days, there are seven-armed lamps in the temple of Jerusalem, and seven sleepers.

For us, seven is preserved in many formulas—for example, when we talk about the book with seven seals or "seventh heaven." We also know from the Middle Ages the seven deadly sins: pride, greed, lust, envy, gluttony, anger, and sloth. Or we think of the seven wonders of the world.

[445]Cf. chapter "Barrel."
[446]Thurneysen, p. 182.; cf. the two Ferguses in chapter "Fertility Magic: Men."

Sheila-na-Gig

FERTILITY MAGIC: WOMEN

Sex is at the center of fertility magic in the following ways: sexual freedom in the desire for children, sex as an instrument of power to assure succession to sovereignty and conferring the royal dignity coupled with sovereignty over the land,[447] sex with the result of rebirth or rejuvenation, and sex as depravity for selected persons. Changing husbands symbolizes life-creating death, since after the death of one husband, future offspring come with the next husband. The death of men, however, symbolizes the goddess of war and her dominion over life and death.

The stories from the Irish epic cycle of the Red Branch of the Mabinogi[448] illustrate, when added to the "biographies" of the Irish queen Medb (meaning "Intoxicating"), epics that have been woven around Medb:

Medb was a daughter of Eochaid Feidlech mac Finn, the king of Tara (Eastern Ireland) and high king of Ireland. Her beauty robbed every man who saw her of two-thirds of his bravery. Mac Finn gave Medb and his other daughters to the king of Ulster, Conchobar mac Messa, as wives. Medb bore Conchobar a son, but then lost him through pride and returned to her father. Thereupon, Conchobar lay in wait for her and raped her. As a result, Medb's father declared war on Conchobar and was killed by him. Eochaid Data saved Medb from Conchobar and brought her to Connacht. Medb took him as her husband, and he became king over the land. In order not to dishonor her, he was to be neither miserly, apprehensive, nor jealous. Medb herself was generous, fearless, and victorious in battle with a single hand; equality was demanded. She also always had a

[447]Cf. chapter "Horse."
[448]Cf. Appendix.

lover. When Fergus[449] was not present, she needed thirty men to satisfy her. This went well until Medb promoted her nephew Ailill to state warrior and slept with him. Eochaid became jealous. He dueled with Ailill but lost because of Medb. Medb married Ailill under the same three conditions. He became the new king of Connacht and received seven sons from Medb. Later, Medb wanted revenge on her former husband, Conchobar, and prepared for battle. She gained allies by having sex with them, such as CúChulainn, who had just outgrown puberty. As the battle came, he led Medb and her women. They reached an agreement that resulted in 7 years of peace between the Connacht people and Ulster people, thus between Medb and Conchobar.

The motif of rebirth/resurrection is the background for the following story:

Mór Mumhan, queen of Munster, lost her mind one day. Neglected, aged, and ugly, she found work with Fíngin, a king in eastern Munster. Challenged by his wife, the king slept with Mór Mumhan, whose beauty then returned. They married and had a son. After Fíngin's death, Mór Mumhan married Cathal mac Finguine and made him king of Munster.

In the story of Derdriu, every man who gives in to her love dies. Another motif is that men die[450] when they see women wash their clothes or themselves[451] in the river.

The myths presented follow historically documented events in part.

449Cf. chapter "Fertility Magic: Men." 451Cross, p. 47.
450E.g., CúChulainn; Thurneysen, p. 561.

248

Thus the sexual freedom of Irish women was part of the divorce law. According to this, a woman could terminate the marriage, by herself and without the consent of the husband, if the man neglected or ignored the woman sexually or could not satisfy her because of pederasty, homosexuality or bisexuality, impotence, or sterility. The traditional laws had a high respect for women and an equality of rights that has still not been achieved today. The Catholic Church was able to break this law finally only with the support of English colonial power in the 16th century. Accordingly, the image of women and their role in society changed. The patriarchate predominated so that fighting women and/or female Druids were no longer considered heroines but witches. Just compare Medb in the Irish sagas and the female warriors/witches of Gloucestershire in the Welsh romance "Peredur." In the latter, they bring Peredur to the battle and are then killed by him.

Sheila-na-Gigs ("Julia with the Breasts"), however, could not be eliminated completely (not even from all churches), possibly because people believed she protected them from destruction and represented fertility, although this could not have corresponded to the prevailing moral concepts. The first Sheil-na-Gig comes from the 1st century B.C. Some people suspect a resemblance to owls.

In any case, we are often reminded of these representations when reading both Caesar's reports and the Irish epics. To the former, women with bare upper bodies appeared in order to put him in a mild mood. CúChulainn, in contrast, often[452] had naked women sent to him in order to stop his terrific courage in battle and to protect the land from damage.

Also documented is the assurance of succession through a series of marriages (Gormlaith), as are the military deeds of Celtic women.[453]

[452]Thurneysen, pp. 139, 550, and others.
[453]Cartimanduras and Boudicca against Rome, Gráinne Ní Mhaille (Grace O'Malley) and Máire Rua against England.

Phallic stone head

FERTILITY MAGIC: MEN

The Celts were very much concerned with fertility and creative power. Indications of this were thumbs and horsetails that were erected, but most of all phalluses. Thus, like other peoples, the Celts saw their gods with over-sized penises. A statue from the Tongeren Cemetery in Belgium even shows three phalluses: one in the usual place, one on the head, and one instead of the nose. Whole stones had the shape of a phallus,[454] and people gladly wore amulets with pictures of naked women and of men with erect penises.

Some of the menhirs, that is, long stones,[455] for which the Celts are known, were embraced; one slid over them or sat on them like a rider. At sites for burnt offerings, figures are found with erect members or even hermaphrodites.[456] In addition to expressing sexual potency and fertility, the phallus can also mean simple happiness and joy. There are also repeated indications in the epics that sexual appeal is used as a peaceful weapon in order to avoid murder and battles and accordingly assure victory or the upper hand.[457]

In the Irish epics, there are two heroes named Fergus ("Select Man"), about whom wild biographies are reported. It should be taken into consideration that pre-Christian feudal society permitted some sexual behaviors that exist today.

The best-known Fergus is Fergus mac Roich ("Man Power, Son of the Large Horse"), who is presented in the stories about stealing the cattle of Cualinge.[458] This hero has a gigantic build, the strength of

[454]Cf. chapter "Stones."
[455]Cf. chapter "Stones."
[456]Dannheimer 1993, p. 325.
[457]Cf. Brendel, p. 48; Thurneysen, p. 550.
[458]Cf. chapter "Bull."

Chalk picture in open countryside

700 men, and eats for seven—whatever he eats is multiplied by seven: seven pigs, cows, deer, etc. The distance between his eyes is 7 inches, likewise the length of his penis (seven hands), while his scrotum is the size of a flour sack. In Tara, a principal royal seat, the royal coronation stone was called until the 19th century Lía Fáil bod Fearghai, "Fergus's Member."

When his wife Flidias was not with him, Fergus needed seven women. She and Medb[459] were the only ones who could satisfy his wild sexual appetite.

In fact, hunts and feasts and the pleasures associated with women were more dear to him than the title of king, which he lost to Conchobar, the son of his beloved Nessa, because of his love for her. He also permitted himself to be lured to the feast and was thus partly responsible for the death of his son, who was lured into an ambush by false promises. After that, he went to Medb's court as an adviser, where he explained the battle over the two bulls[460] as that of transformed men.

Fergus met his death during games at the lake when he dived under some men in response to Ailill's challenge. Medb tried to soothe him and held him at her breast with her legs around him. He waded with her around the lake in this manner. Ailill, jealous about the driving away of the buck and the doe,[461] had Fergus killed with a spear thrown by Lugaid and ended the life of this fertile man.

The other Furgus, Fergus mac Léite, had a penis as long as the fists of seven men:

[459]Cf. chapter "Fertility Magic: Women."
[460]Cf. chapter "Bull."
[461]Cf. chapter "Deer."

Wooden figure from the Iron Age

*W*hen having sex with the wife of the captured ruler Iubdán, he held his hand on her head, since he was afraid that he would go through it with his member.

Then the husband of the woman entertained the Ulster men with his talk. He didn't understand how women wash and wipe themselves, since Fergus had serviced her lower parts. He also laughed about a man who shook out his wife's cloak, although she had just used it to lie on when having sex with another man.

After Iubdán had spent a year with Fergus, he offered him treasures in exchange for his release, including several that served exclusively for his lust: thus a riding crop that made all women fall in love with its owner, and a pair of scissors that made one who held it in his hand into a sweetheart.

Stone pillar with illustration of transmigration of souls

TRANSFORMATION AND TRANSMIGRATION OF SOULS

Before the conversion to Christianity, animals were probably what people transformed themselves into in order to perform difficult tasks or deeds with new abilities. After the conversion to Christianity, people's transformation was seen as a form of punishment for their sins. This was especially true for women, whose previously permissible activities became sins, such as sexual union with a variety of partners and fertility magic.[462] Generally both aspects of transformation were mentioned in the existing traditional literature. They were written down by monks, the predominant educated class, into a form that served the purposes of a written culture, which was connected with the conversion to Christianity. Thus, Arthur's warrior companions used their ability to change shape to, among other things, defeat Twrch and his (pig-)followers.[463] Twrch himself, however, was a nobleman who had been transformed as punishment.

The three main tasks of metamorphosis are: to obtain other desired or needed abilities,[464] to punish,[465] and to wander (including after death?) through the worlds in order to reach the Otherworld or to lure someone there.[466] Transformation is also important as an aid to escaping or surviving, as a kind of asylum, naturally in the Otherworld.[467] The transformations possibly indicate a lack of strict

[462]Cf. chapter "Fertility Magic: Women, Men."
[463]Cf. "Culhwch ac Olwen."
[464]Cf. chapters "Birds," "Culhwch."
[465]Cf. chapters "Birds" (Blodeuwedd), "Swan" (Children of Lyr), "Ox," "Boar" (Culhwch ac Olwen), "Bull" (Driving away the Cattle of Cuailnge).
[466]Cf. CúChulainn; Thurneysen.
[467]Including eagle in chapters "Owls" (Blodeuwedd), "Swan" (Midir).

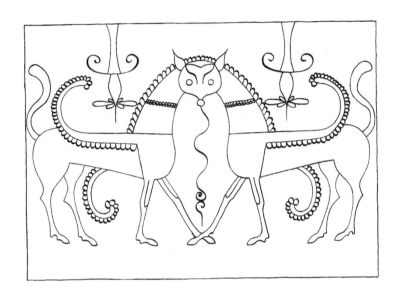

Picture puzzle with horse/owl

boundaries between man and animal in the thinking of the Celts. Preferred animals of transformation are birds, primarily swans,[468] cranes, and owls, as well as pigs and cattle as punishment.

The time of transformations depends on their purpose. Transformations needed rapidly to acquire additional abilities (for example, during hunting and fleeing) occur immediately. If those affected come to the Otherworld, then they are encountered usually at the time of Samhain[469] and then continue.[470] Time conditions are also important in punishment transformation.

Women changing shape with several ways of appearance could be the basis for witch characters in fairy tales, such as Badb, who is mostly in the form of a raven/crow, and Morrigán, who changes

shape according to her purpose. Both are related to Nemhain, who confuses minds, and Macha, who is connected with cranes and horses. The first two wash the clothes of the warriors when they are facing death. Morrigán (war, fertility, matriarchy) and Macha (war, prophesy), and Badb (death, last companion, messenger of death, prophet of death) are sometimes a trinity of divinities.

*B*efore the battle started, Morrigán flew there and warned the brown bull with its fifty heifers and the 150 boys riding on them of the coming attack. The brown bull was himself a transformed swineherd who had added the strength and power of the bull to his human cleverness. He provided protection for a hundred warriors, his musical sound made hearts beat faster, and every day he mounted fifty cows who bore calves the next day.

One day, Morrigán, in the shape of a beautiful maiden, met CúChulainn[471] to mislead him by offering cattle and treasures. CúChulainn spurned her as woman's help, and a duel developed between them. She threatened to cause him injury in the ford by going under his feet as an eel and leading him into a trap. He replied that he wanted to break her ribs with his teeth and that they could only be healed with his blessing. After that, she threatened to become a wolf and drive the cattle into the ford at him. Then he replied that he would shoot out one of her eyes with his sling, whereupon she wanted to go to the ford in the form of a red heifer without him seeing her. As he threatened to break her leg with a stone, she fled.

As the two of them encountered each other, he fell into a trap and was injured by an eel, which wound itself around his leg three times. He stepped on the eel so hard that its ribs broke. The thunder of the weapons

[468]Cf. chapter "Swans."
[469]Cf. chapter "The Year Circle."
[470]Cf. chapter "Swan" (CúChulainn, Aengus).
[471]He also can change shape; Thurneysen, p. 434.

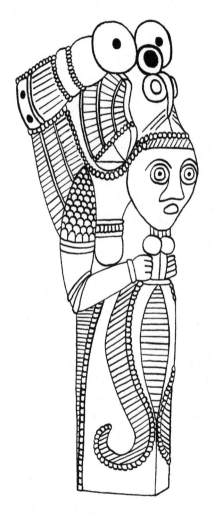

Transforming woman/owl

made the cattle pasturing nearby stampede eastward, but a wolf forced them westward again to CúChulainn. He attacked her by aiming a stone at one of her eyes with a sling. Then she changed her shape into that of a red hornless cow (a white heifer with red ears[472]) in the water, so that he could no longer see the ford. In falling, he threw one more stone at her, with which he broke her leg.

Exhausted, CúChulainn lay down on a stone and complained about being alone in battle. Unrecognized by him, Morrigán joined him in the form an old one-eyed woman, who led a cow with three teats, corresponding to her three injuries, to him. At his request, she gave him healing milk to drink three times, for which he blessed her and she too was healed.

A similar sequence of transformations for victory in battle takes place between Ceridwen and Gwion Bach in the Welsh story of Taliesin,[473] when three drops of brew from Ceridwen's cauldron jump onto Gwion Bach's finger:

N ow, instead of making a brew with magic power for one year for her son, Gwion Bach fled from Ceridwen's revenge. At first, he flew as a rabbit and she as a greyhound. Then he transformed himself into a fish and she into an otter. When he took on the form of a bird, she became a falcon. Finally, he became a grain of wheat, which she as a hen picked up and swallowed. After 9 months, she gave birth to a child. Because of his beauty, he was spared from death, and she transferred his fate to another by giving the child to the sea in a leather bag.

Before a battle, Badb and Nemhain kill three hundred men of Ireland with their cry. Badb, who can take on various shapes,

[472]There are different details in various manuscripts. In another version is Badb, who predicts to CúChulainn that his cattle will be driven away by her calf. As he thereupon readies to attack her, she flies away as a bird.

[473]Cf. Chwedl, Taliesin.

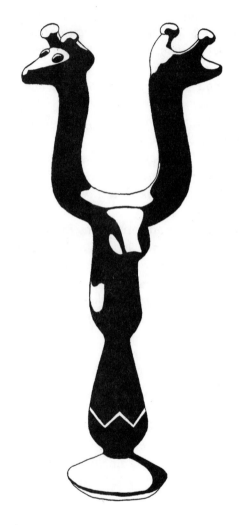

Double bull and crane

accompanies bodies, such as when Conchobar and others are injured or lying dead in the field and CúChulainn goes to heal them. She is a messenger of death when she tells Medb about the death of her son and a prophetess of death when CúChulainn is hurt by her blood and she want to eat his entrails. When she flies around him in the form of a crane and cries out three times, everyone knows that CúChulainn is dead.[474]

Finally, there are the two bulls that are the crux of the story of the driving away of the Cattle of Cuailnge:[475]

The two swineherds of the Otherworld, Friuch (also Runce) and Rucht, were friends. Each went to one region or another to get acorns to feed to the pigs. But a dispute arose between them and each refused to feed the pigs on the other's land. Then both lost their positions as swineherds and were changed into the birds of prey Eite ("claw") and Ingen ("wing"), who cut each other for one year over Munster and one over Connacht. After that, they both became water animals, Blod and Bled, who swam in a river in these same provinces. After a year, they changed rivers. Then they became deer and each gathered the other's herd around him. In order to measure their strength further, they became the warriors Faebur ("Tip") and Rinn ("Cut"), their former masters. After they had yelled at each other so hard that their lungs came out, they changed into the ghosts Sciath ("Shield") and Scáth ("Shadow"). When they were nursed back to health, they took the form of dragons and each threw snow onto the other's land. Then they changed into the worms Tuinniuc and Cruinniuc, which two cows in Ulster and Connacht swallowed in drinks. Thus they were reborn as the two bulls Donn and Finnbennach, which started the great battle between the two provinces.

[474]Thurneysen, pp. 563.
[475]Op. cit., pp. 276ff.

Bathing nymphs

WATER CULT

Water is the origin of life; we encounter it everywhere. Humans are 70% water. It is thus not surprising that in the Irish epics drinking water leads to pregnancy, especially when there are worms (snakes) in it.[476] Accordingly, bodies of water are associated with fertility, primarily with mother goddesses,[477] and are used as places of sacrifice. Water is cleansing, renewing, and healing.

Water is used by CúChulainn to control his excitement, and water is used by the watcher Lludd to keep himself awake.[478] Today there is the myth of the Fountain of Youth, which is described in "The Isle of the Mystic Lake." Water is the homeland of food that grows by itself.[479] But water is also associated with battle and death. Thus CúChulainn fights at fords,[480] there are floods ("The Overflowing of Lough Neagh" and "The Story of Liban the Mermaid"), and women washing clothes or themselves[481] announce death to the warriors, including CúChulainn.[482] Watery graves[483] should also not be forgotten. The three most important aspects of mother goddesses are mentioned. Water accompanies people throughout life like stones, trees, the sun, and the moon. Healing divinities, possibly deriving from sun divinities, are mostly local, thus, for example, Sulis for Bath and Sequana for the Seine.

[476]Cf. Conchobar's Conception, chapter "Stones."
[477]Cf. chapters "Owls," "The Numbers Three and Four," "Triskele."
[478]Cf. chapters "Barrel," "Dragon."
[479]Cf. chapter "Fish."
[480]Cf. chapter "Transformation and Transmigration of Souls."
[481]Cross, p. 38.
[482]Thurneysen, p. 561.
[483]Cf. chapter "Trout."

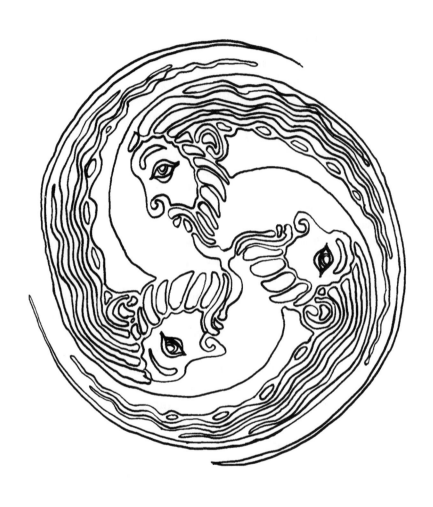

Men's heads forming a whirlpool

Female and male sun divinities (or remnants of them) stand near springs, such as Sulis at Bath.[484] Also, there is a sea god in the insular Celtic tradition named Manannán mac Lyr ("Manannán [from the Isle of Man?], Son of the Sea"), Welsh Manawydan mah Llyr.[485]

Water also belongs to places that lead to the Otherworld[486] or appear in association with it, whether directly or indirectly, via birds. Numerous references to water are found especially in "The Voyage of Maildun." A final meaning of water is wisdom; in the Bible there is a fountain of wisdom.

Conall Cernach, another hero who is mentioned often, is conceived with the aid of water:

Finnchaem, daughter of Cathbad, had no children. A Druid promised to help her have a child if she would pay him well. She promised to do so, and he led her to a spring, sang proverbs, and told her to wash herself. After doing this, she also drank some water and swallowed a worm. It developed into a boy in her body, with a worm through his hand. At his baptism, the Druids prophesied that he would turn against Connacht and thus against his mother. The mother's brother Cet mag Mágach tore the child out of the arms of Finnchaem and stepped on his neck. But his spine remained intact and Conall Cernach only received a crooked neck.

The significance of purification and healing is continued by Christianity in baptism, keeping the elements of cleansing, transformation, and rebirth. The fertility well is also one of the things created by god at the beginning of the world.[487] Today we still find monsters in bodies of water, such as Nessie in Scotland. The water of life in Scotland is whiskey—at least according to the whiskey industry.

[484]Cf. Birkhan 1997, pp. 580ff.
[485]CF. Birkhan 1997, pp. 681ff.
[486]Cf. chapter "The Otherworld" (The Pursuit of the Gilla Dacker).
[487]Low, p. 66.

Two-headed monster entwined with humans

HEAD CULT

Head representations are found in stone, metal, wood, bone, and other materials as pictures, or in relief form on objects, or as free-standing statues. Representations of the heads of dead persons with closed eyes and painted skulls, starting from the 3rd century B.C., are found. Some of the heads and skulls document head-hunting and a skull cult. Both were probably very widespread among early peoples and go back to the mystery of the head. Thus, scalping among Native Americans and their human sacrifices belong to the same field. These cults are known in Siberia, Southeast Asia, West Africa, and especially in Scythia.[488] They drank the blood of the first enemies killed, set up the head of the king to demand payment of their share of tribute, used scalps as napkins, sewed clothing onto them, if they had enough, and decorated the skull.[489] Did the sewing of clothing have a parallel in the Arthurian tradition, where giants or fiends make cloaks out of the beards of defeated kings?

In head-hunting, heads are probably trophies of war, as are animal heads on the walls of hunters today, or establish the right to a share of the bag of whatever is caught. Skull cults viewed the head as containing the immortal divine inspiration. By acquiring the head, the person would receive the beheaded's abilities and life essence as protection and to ward off evil. Thus heads were hung on horse's manes or embalmed and cut into amulets,[490] impressed on coins[491] and weapons, and made into decorations at the entrance façades to places of worship and temples, especially when they were valuable heads.

[488]7th through 3rd centuries B.C., settlement region: North Italy.
[489]Birkhan 1997, pp. 826f.
[490]Dannheimer, p. 172.
[491]Birkhan 1997, p. 823.

When the Celt Boier killed Roman ruler Lucius Postumius during their participation under Hannibal in the second Punic War, his head was cleaned, covered with gold, set up, and used as a religious vessel for libations to the gods.[492] Skull cups have been found at places of sacrifice[493]—the skull cult is obviously part of the sacrifice ceremony. The ceremonies might have involved human sacrifice. This would also be indicated by Merlin (Myrddin),[494] who wanted to ensure the construction of Vortigern's fortress with his blood. Skulls were also used in consecration and sacrifice offerings.

Hunting and cults are interrelated. The Celts hunted for heads for an entire day before they took the city of Rome on the third day of the siege of 387 B.C.[495] Heads were stuck to lances or tied to saddles, and CúChulainn impaled them on forks of branches, piled them into heaps, then slept on them or packed them under his knees, as did his foster brother Conall Cernach.[496] Goreu cut off the head of a giant,[497] placed it on a pole in the front courtyard, and took over the giant's kingdom and fortress. Head-hunting continued in Ireland as late as the 13th century, according to the annals.

[492]Birkhan 1997, p. 123.
[493]Op. cit., p. 123.
[494]Cf. chapter "Dragon."
[495]Birkhan 1997, p. 102.
[496]Thurneysen, pp. 565ff, etc.
[497]Culhwch, in Birkhan II 1989, p. 91.

It is not certain whether many Celtic warriors used half-cleaned skulls as drinking cups or even drank the blood of their enemies. However, certain women were mentioned who drank the blood of their dead lovers: CúChulainn's wife[498] and Deirdriu.[499] Morrigán extends to the people of Dagda a handful of the blood of a killed enemy. Rubbing blood onto a person is also known.[500] And the head of a mortally wounded friend was also cut off in order that it not fall to the enemy.

Skulls are associated with fertility by bringing back strength to a man who drinks milk from them. This is probably a type of cauldron and symbol of renewal.

The head represents the entire body when presented in head statues, busts, or masks. Heads were also set up simply in memory of the dear dead person and as protection from enemies. This is also witnessed in the story of Branwen[501]:

A fter Bendigeidvran had been mortally injured in the battle to free his sister, Branwen, he ordered his friends to cut off his head and take it with them to Gwynfryn ("White Mountain")[502] in London. There, it was to be buried with his face turned toward France. Their journey took a long time. The head was cut off and the seven who survived the massacre went on their way with Branwen. In Aber, Branwen's heart broke, since she thought the men had lost their lives because of her and destroyed two islands. The seven then went alone and celebrated in Harddlech for 7 years, during which the head was good company for them, as if Bendigeidvran were with them, and Rhiannon's bird sang to them. Then they stayed 80 years in Gwales. Those were their best years, and they did not notice that

[498]Thurneysen, p. 565.
[499]Op. cit., p. 334.
[500]Birkhan 1997, p. 123.
[501]Second branch of the Mabinogi (see Appendix); cf. chapter "Cauldron."
[502]Probably the oldest part of the tower.

Portal with embedded skulls

they had grown older. They were called "the Guardians of the Noble Head." Then, however, one of them opened the door to Cornwall, and they again became aware of their loss and set off on their difficult journey to London to bury the head. This was now one of Britain's three fortunate concealments[503]; *as long as the head remained there, no plague would visit the island from the east.*

The Irish epic of the death of Mess-Gegra and Conchobar[504] represents other aspects of the head cult. They include the transfer of the desirable characteristics of another, taking out the brain before using it further, and possibly the belief in healing:

Conall Cernach went to seek revenge on Mess-Gegra, king of Leinster, who had killed his brother and beheaded him. Conall found Mess-Gegra and defeated him in a duel. Knowing that Conall Cernach wanted his head, Mess-Gegra suggested to Conall Cernach that he put his head on his own and thereby add dignity to dignity. Conall Cernach cut Mess-Gegra's head off and carried it to a high stone on the bank of a ford. At that time, there were three brave warriors in Ulster, each with an affliction: CúChulainn was one-eyed, Cuscrid stuttered, and Conall had a crooked neck. As he had been advised, Conall Cernach now placed the head of Mess-Gegra on his and let it roll over his back, and from that time on his hunchback disappeared.

Later, Conall Cernach found Mess-Gegra's wife and told her that she now belonged to him. Mess-Gegra's wife demanded proof and Conall Cernach presented her husband's head. The head was sometimes red, sometimes white. Conall Cernach asked Mess-Gegra's wife

[503]The other two are the dragon of Lludd in Snowdonia (cf. chapter "Dragons") and the bones of Gwerthefyr the Blessed, which were scattered over all the main ports of the island of Britain. Thus the land was protected from enemies, until the three disclosures came and, among other things, Arthur recovered the head of Bendigeidvran, since he thought that it was fitting for him alone to protect the island.

[504]Brendel 1984.

why this happened. She answered that her husband doubted whether a single Ulster man could take her away. Conall Cernach then ordered her to get into the chariot. She, however, said she needed to grieve. He allowed her. She started to wail, threw herself backward to the ground, and was dead.

Conall's charioteer did not want to take Mess-Gegra's head with him because it was too heavy. Conall took the brain out, cut it with his sword, mixed chalk with it, and formed a ball from it. The skull remained with the dead wife. Later on, when the Ulster men were drunk and the three heroes Conall, Cúchulainn, and Laegire were riding off to battle, Conall asked for Mess-Gegra's brain. It was the custom to hold balls of the enemies' brains, mixed with chalk, when fighting. When everything was over, the brain was then put back.

The next day, they went to play. Ket mac Matas, a monster of a man, went through Ireland, looking for adventures. He learned about Mess-Gegra's brain and took it with him, for he knew that it had been prophesied that Mess-Gegra would take revenge for his death. Now every time there was a dispute between the Ulster people and the Connacht people, he carried it in his belt, assuming that it could bring about a decisive death blow to the Ulster people. Ket moved eastward and drove the Ulster men's cattle that had followed him away. On the other side, the Connacht men came to help him, and a battle started between them in which Conchobar participated.

On Ket's advice, the women of Connacht asked to see Conchobar, as there was no one on earth to compare with him in beauty, form, clothing, size, build, eyes, skin, hair, wisdom, eloquence, radiance, luster and dignity, weapons and wealth, conviviality, and bravery. He put himself in the right position and Ket was able to mix with the women, place Mess-Gegra's brain in his sling, and shoot. Conchobar was struck and fell to the ground, and two-thirds of the brain stuck to his head. The Connacht men fled, and the Ulster men carried Conchobar away. His physician sewed his head with golden thread, the color of his hair, and with complete abstinence from riding, sports, women, excitement, and agitation, he lived another 7 years.

We should not judge these ceremonies, which were based on early concepts about the function of life. Killing people as a display for the pleasure of others, as in the Roman gladiator fights, or for punishment and scaring people, as is documented with Caesar and throughout human history, are unequally gruesome.

A continuation of head-hunting is today's ball game, for example, soccer. Here, our ancestors chased heads or simply played with them without any military battle.[505] Head-hunting was also a part of the Arthurian tradition.[506] There is also an Irish proverb today that goes back to head-hunting:

Go mbainidh an diabhal an ceann díot agus obair lae ded mhuinéal.

May the devil cut your head off and struggle with your neck for a whole day.

[505]See Mess-Gegra's Brain; Thurneysen, p. 565.
[506]Cf. Peredur, the Old French Grail romance of Percival.

The goddess of the sea

THE OTHERWORLD[507]

The idea of the Otherworld arises from the concepts of the Celts on the fate of people after death or life beyond the environment of their own experience. As already established, death for the Celts is the beginning of a new life rather than its end, for which reason the Otherworld represents the changed human world of the reborn (a soul that has awakened from the dead becoming flesh again = reincarnation).

There are a great number of names to denote the Otherworld: Ir. Tír Tairngire ("Land of Promise"), Ir. Tír na n-óg ("Land of Youth"), Tír na mban ("Land of Women"), Tír na mbéo ("Land of Life"), Tír fa tonn ("Land under the Waves"), Tír sorcha ("Land of Bliss"), Mag mell ("Pleasant Realm"), Moy mell ("Pleasant Plain"), and síd "seat (of residence, mostly represented as an elf home in a hill or under the ground). Versions of these words are in many languages: Welsh Cae Siddi ("sídh"), Welsh Annw(f)n ("very deep" or "not deep"), and German Nicht-Weld ("Non-world"). Motifs include: Welsh Cae Wydyr ("Glass fortress"), Ynys wydrin ("Glass Island"), Caer Vedwit ("Fortress of Drunkenness")[508] and Avalon ("Apple Island"). In many epics, Avalon is the last resting place of Arthur; in Welsh epics, it lies underground or in a cave.[509]

The concept of the Otherworld, in terms of the other side, is an innovation of Christianity and the mythologies.[510] The widespread representation of this world in the Celtic epics, already influenced by Christianity, therefore gives only fragmentary glimpses into possible concepts of the world of the reborn.

[507]German *Andere-Welt*, also *Anderswelt, Anderland.*
[508]Birkhan II 1989, p. 246.
[509]Cf. "King Arthur in the Cave."
[510]Birkhan 1997, p. 838.

The Isle of Avalon

Concepts of an Otherworld are found among all peoples that believe in the transmigration of souls. This is reflected in the various fairy-tale motifs of places under water and in the earth. The Otherworld can therefore be located in all kinds of mysterious natural formations, such as caves, forests, swamps, mountains, hills, valleys, and cliffs, and in inaccessible regions, such as in heaven, in the ocean, and on islands, as well as in structures built by people, namely towers and wells. Manannán is a god of the Otherworld, and this is the case with him on the Isle of Man. The entrance—a cave, a tent, a tree, a cliff, or a crack in the ground—is often found only once.[511] One goes there on horses,[512] ships, in the form of a bird, and many other ways.

Other possibilities for coming into contact with the Otherworld are dreams and states of trance. Numerous clans and many kinds of groups sought conditions that could also be called an "intermediate world" in order to enter into a connection with the Otherworld.

The theme of the Otherworld forms one of the essential elements of insular Celtic literature. The Otherworld seems omnipresent; it mixes into reality, especially at Samhain.[513] The most important heroes, Oisin, CúChulainn, Pwyll, Arthur, etc., can wander between the worlds. The distinctions are flexible so that a strict classification of heroes as humans, gods (residents of the Otherworld), or demigods is impossible. Mixed in with the Otherworld is also the representation of people who simply came from somewhere else—another place or country.

Features of the Otherworld include fruits,[514] animals,[515] and colors. Red, often in combination with white, is the color of the Otherworld. It is interesting that the first colors seen in archeologi-

[511] Cf. Giraldus Cambrensis, pp. 133ff.
[512] Cf. Oisín in Tírnanog, Arthurian heroes.
[513] Cf. chapter "The Year Circle."
[514] Cf. chapter "Apple Tree."
[515] Cf. chapter "Birds."

Entrance to the Otherworld

cal findings are likewise red and white. Do they stand for male and female fertility, semen and menstrual fluid? Or moon and sun? Is there a connection? We encounter animals with red ears and white bodies—for example, Arawn's dogs,[516] cows,[517] a red tent,[518] the red pigs from Cruachain, red horses. The heroes Conall Cernach and CúChulainn are sometimes described as having white and red faces,[519] as is the cut-off head of the defeated Mess-Gegras.[520]

The description of the Otherworld as a type of land of milk and honey is found in Mac Conglinne's vision.[521] Another emphasizes love[522]:

*O*ne day, Condla the Red (also Connla the Golden-haired), son of the Hundred-Fighter, was traveling with his father when a woman in beautiful robes approached them. In response to Condla's question, she explained that she came from Síde, where there was neither death nor sin, people ate without stopping, and there was always friendly company and never a dispute. The father could not see the woman and asked Condla whom he was talking to. But the beautiful woman answered instead:

He is talking to a beautiful woman,
young and of a noble race,
neither death nor age threaten her.
I love Condla the Red!
I call him to the Field of Bliss,
where King Boadag rules forever;
his land knows neither need nor misery.

[516]Mabinogi, see Appendix.
[517]Brendel; but there really are such things, cf. chapter "Cow."
[518]Cf. Gereint.
[519]Brendel, p. 46; cf. chapter "Cart."
[520]Op. cit., p. 72; cf. chapter "Head Cult."
[521]Brendel 1987.
[522]Brendel 1989.

The father called his Druid, Coran, since everyone heard the woman, but no one except Condla saw her. The Druid sang so loudly that no one could hear the woman anymore. She disappeared, but not before giving Condla an apple. For a month, Condla ate and drank nothing except the apple. The apple did not get smaller, while his yearning for the beautiful woman grew. When he was traveling with his father again, he saw the woman and she spoke to him. Again the father called the Druid. But the woman questioned the Druids' art and soon saw their power disappear. Condla hesitated, and the woman sang:

Joy always fills the mind
of all who wander therein,
No gender has been seen
as women and girls...

But your mind hesitates for a long time
about going over the sea to there.
Let us travel to Boadag's Síd
come to me in the glass ship...

After she ended her song, Condla jumped into the ship. They went away, and no one ever saw them again.

In Christianity, the Otherworld is simplified as Hell[523] and Paradise;[524] going to one or the other depends on one's behavior. In contrast, the old insular Celtic epics do not recognize behavior as a role for the being after death. It seems, rather, that one can choose between various possible pleasant lives or encounter them by chance. Only with the conversion to Christianity are there names for inhabitants of the Otherworld. There are, in addition to birds, fairies and elves.

In the early Irish tradition, the Otherworld was not seen as an unpleasant place. Only gradually did it develop into a Christian means of education. An example is the Welsh epic of the robbing of the Otherworld by Arthur:[525]

According to the report of Pwyll and Pryderi, the jailers of Gweir, everything was magnificent in the castle of the elves, Caer Siddi. Arthur went with three full ships to the square and rotating fortress, but none of the seven men came back. From the elves' castle, the fortress of drunkenness, Arthur brought the cauldron, from which nine spinsters heated and cooked only for the brave. Lamps burned before the door of Hell. In the square fortress of the island of the mighty gate, noonday was pitch black. Its drink was clearer. There was a spotted ox. The battle was frightful, and the memory of the fortress was frightful. It was also called the "Fortress of the Entrails,"[526] Caer Rigor, Caer Vandwy, Caer Ochren.

Have the colors red and white now been replaced by black and white? There are some indications of this, which are consistent with other assessments, such as day = good and night = bad.

[523]Red birds, burning people.
[524]Cf. "The Voyage of the Sons of O'Corra," Joyce 1996.
[525]Birkhan II 1989.
[526]Probably because of its shape as a labyrinth.

The year circle with directions

THE YEAR CIRCLE: SAMHAIN/ HALLOWEEN, BELTENE

Closely associated with the conceptions of the Otherworld is the calendar of agricultural festivals, with four divisions, which is known primarily from Ireland. This involves a sun calendar. It is unclear here whether this is exclusive to the Irish or if it existed on the continent alongside the calendar of Coligny.

The year circle was divided by four important festivals: Imbolc/Oimlec on February 1, Beltaine/Cétsamuin on May 1, Lugnásad on August 1, and Samuin/Samhain on October 31 and November 1.[527] At that time, neither solstices nor equinoxes played a role. At the times mentioned, there was a special cheese. These were also the days on which political meetings and markets were held.

Imbolc, later the feast day of St. Brigid, was a purification festival or the festival when sheep gave milk.[528] This shepherds' festival was a festival of rebirth and fertility.

Beltaine, or Cétsamuin, "First of Summer," opened the warm, bright season. It was also celebrated on the continent and came from the old Celtic cycle of festivals. On this day, large fires were ignited: old ones were extinguished, and new ones were struck with flint. Cattle were driven between the fires to drive out diseases and bring purification. There are also indications of fire as a fertility cult and support for the sun.[529] On these feast days there were four festivities;

[527]The spelling differs according to the Irish form chosen or its reproductions in other languages.
[528]Oilec—cf. Birkhan 1997, pp. 791.
[529]Green, p. 42.

Circle dance as a knot picture

one of them was Oenach, which is described in "The Childbirth of Ulster." Beltaine could also have been a slaughter festival. It was celebrated with a maypole, May queen, and many other customs.

Lugnásad was celebrated to honor the god Lug. What the festival had to do with him—for instance, Lug's death and/or marriage—has not been clarified.[530] It was celebrated from the middle of July to the middle of August with great festivities, such as the annual market, games, horse races, and engagements. It was the day on which male and female romantic partners were chosen for a year, namely until the next festival. Children conceived on this night were born in the warm half of the year and had good chances of survival.

Samhain probably appears as the name of a month in the Coligny calendar and could thus have been one of the Old Celtic festivals.[531] In Ireland, it was the day on which the bloody sacrifice to the king's idol was made.[532] As in Rome, the entrance to the Under/Otherworld stood open on this day[533] so that an understanding could be reached with its inhabitants. Naturally, not everything that came out of the Otherworld was desirable—much less so with increasing conversion to Christianity. As a result, precautions were taken against disaster. At Samhain, fires were ignited on which people placed a log for their own herds. Finally, since this took place in the dark time of the year, also called the "year night," protection and warmth were necessary. The night before November 1 is called in Welsh Nos Calan ("Night of the Start of Winter") and it was one of the "three ghost nights," in Welsh *teir nos ysbrydnos*. Prophesies were made with stones and nuts. Depending on how the fire people were healed in the fire, the new year would be good or bad, the expressed wish would be fulfilled or not, and the result hoped for would happen or not.[534] In general, on

[530]Cf. Birkhan 1997, pp. 535ff.
[531]See Birkhan 1997, pp. 786ff. for problems with this.
[532]Op. cit., pp. 575f.
[533]Thurneysen, p. 315.
[534]Rees, p. 109.

Circle ornament with human figures

this night the ghosts helped in making decisions. Piles of stones were erected.[535]

According to the text of the epics, battles were fought and heroes died at Beltaine and Samhain.[536] There was a cease-fire during festivals and a taboo at Samhain against many other activities, such as marriages, trade, and ship travel.[537]

The combining of the Otherworld with Samhain is shown in "CúChulainn's Sick Bed":

*E*very year, the Ulster people held a festival for 3 days before Samhain, on Samhain itself, and for 3 days afterward. At this time there were only games, festival meetings, eating and drinking, and all the Samhain ceremonies Ireland started.

Once, everything was ready, but Conall Cernach, stepbrother of CúChulainn, and Fergus, his stepfather, were absent. As a result, the start of the festival was delayed. People played and sang while waiting. Then a mighty flock of birds came down onto the nearby lake. Immediately, the women were overcome with desire for these birds, the most beautiful in Ireland, and each one thought her husband could catch them. Conchobar's wife wanted one for each of her shoulders. So the other women wanted this too. But CúChulainn's wife said that the birds had to be caught mainly for her. CúChulainn was angry, however, at being asked to go at this time to hunt for birds for the women. He was reprimanded for this, since he was responsible for putting out one eye of every woman in Ulster who fell in love with him. Those who fell in love with Conall Cernach became hunchbacked, and those who fell in love with Cuscrid the Stammerer started to stutter. So CúChulainn entered the chariot and performed his bird-catching trick, jumping in a circle in the air and then striking

[535]Cf. chapter "Head Cult."
[536]Birkhan 1997, pp. 501f; Thurneysen, p. 198.
[537]Birkhan 1997, pp. 792ff.

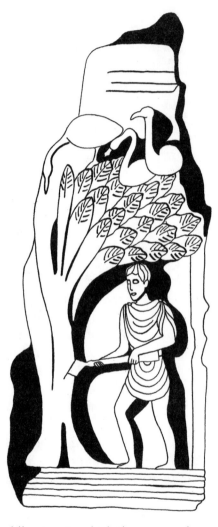

Esus fells a tree in which three cranes have alighted

the birds so that they could be caught by their feet and wings. The men distributed two birds to each woman, but one for CúChulainn's wife was left out. He promised her then that next time he would catch the two most beautiful birds just for her. And soon they saw two birds on the lake that were tied together with a chain. They sang a song that put them all to sleep. His wife warned him about these birds. CúChulainn was insulted by this, and he shot a stone in the direction of the birds with this sling and missed them. This confused CúChulainn, who then threw a spear. This hit one of the birds, and both disappeared. Angry, CúChulainn fell asleep on a cliff.

Then he saw a woman in a green cloak and one in a purple mantle approach him and beat him until he was near death. The Ulster people did not dare to wake CúChulainn from his dream, but just carried him away from there. He lay silent for a year. One day before the next Samhain, they all gathered around him and Aengus entered, sang a song about the hero's sickbed, and disappeared again. CúChulainn could speak again. He told about his dream and was sent back by Conchobar to the cliff. There, he met the woman with the green cloak, who told him about the love of Fann, the sister of Aengus, for him. Fann would be given to him if he would fight against three warriors. He agreed and followed her to Fann's home. But he took his charioteer, Laeg, along, who then told CúChulainn's wife, at his request, that Síde women had visited him and made him ill. They were outraged that the Ulster men and even Laeg did not come to CúChulainn's aid. So they tried to help him and shake him awake. At the same time, the Síde women tried to take him to Fann. When he was reminded of the battle he had agreed to, he went with Laeg and his chariot to the land of Síde and met Fann there. CúChulainne struck the enemies into the river and shared the camp with Fann for a month. They arranged a new meeting at a yew tree. CúChulainn's wife learned about this and went there to kill Fann. She knew everything red was beautiful and everything new was

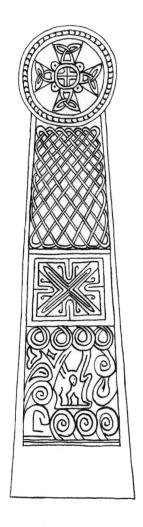

Celtic wheel cross

white and preferred by acquaintances. Thus CúChulainn stood between two women, and even before he had made a final decision, Fann went back to her husband. Then CúChulainn made three high jumps to the south, lived for a long time in the mountains, without eating and drinking, and slept nights on the road. The Druids and Fili were sent to him. Their magic spells turned away his threatened death, and a drink of forgetfulness brought him back to his wife.

The Welsh story "Lludd a Llefelys"[538] testifies clearly to the division of the year into two parts:

L lludd, son of the great Beli,[539] ruled successfully over Britain, including London. And every year, on the eve of the first of May, the cry of two fighting dragons frightened everyone. All supplies of food and drink disappeared that had not been eaten in one night.

Christianity has become a part of these days so that November 1 is dedicated to All Saints and November 2 to All Souls. Also, Halloween is still celebrated in Ireland and Great Britain. Often a hollowed pumpkin resembling a human skull is carried around. Children go from house to house and collect treats, which are to bring happiness to the giver. In Wales, people also bob for apples. In large parts of Great Britain, this festival is still celebrated like the change of year at Sylvester (New Year's Eve).

[538]Cf. chapters "Dragon," "Basket," "Barrel."
[539]Connection with Beltane is doubtful.

APPENDIX

EXPLANATIONS

Mabinogi: The four branches = epics from Wales that are relatively closely associated or defined as such.

Mabinogion: Mabinogi + four independent epics + three romances: "The Dream of Maxen Wledig," "Lludd and Llefelys," "Culhwch and Olwen," "The Dream of Rhonabwy" (Jones 1986); three romances: "The Duchess of the Well," "Peredur, Son of Efrawg," "Gereint, Son of Erbin" (Birkhan I 1989).

Colors: Red, often in combination with white, is the color of the Otherworld. It is interesting that red and white are some of the first colors that can be seen in Celtic findings.

Ap < map/mab: "Son" in the British Celtic languages such as Welsh (also Cumric), Breton, and Cornish. "Ap," "mab," etc. identify the father's name, as also occurs, for example, in Peder*son* or *Mac*Donald (Mac/Mc = "son" in Irish and Scottish).

TITLES OF EPICS MENTIONED

Adventures of Connla the Fair (Cross, 1936)

The Ancients (Jones, 1978)

Asterix the Gaul (Goscinny, 1969)

Asterix and the Cauldron (Goscinny, 1969)

Baranor, the Son of the King of Erin, and the Daughter of the King of the Kingdom under the Waves (Hermann, 1975)

The Blazing Spear of the King of Persia (Joyce, 1996)

The Boyhood Deeds of Finn (Cross, 1936)

Branwen, Daughter of Llyr (second branch of the Mabinogi—Jones, 1986)

Breuddwyd Rhonabwy (Birkhan II, 1989)

Bricriu's Banquet (Thurneysen, 1921)
Canu Aneirin (Rockel, 1989)
Canu Taliesin (Rockel, 1989)
The Childbirth of Ulster (Brendel, 1984)
Chwedl Taliesin (Thomas, 1992)
Conchobar's Conception (Thurneysen, 1921)
Coroni Arthur (Jarman, 1957)
CúChulainn's Sickbed (Thurneysen, 1921)
CúChulainn's Conception (Thurneysen, 1921)
Culhwch ac Olwen (Birkhan II, 1989)
Cyfranc Lludd a Llefelys (Roberts, 1975)
The Death of CúRoi (Thurneysen, 1921)
The Death of Mess-Gegra and Conchobar (Brendel, 1984)
The Demon Cat (Booss, 1986)
Derbriu's Pigs
The Destruction of Da Derga's Hostel (Cross, 1936)
Die weiße Forelle (Booss, 1986)
The Dispute over the Hero's Piece (Brendel, 1984)
The Driving Away of the Cattle of Cuailnge (Thurneysen, 1921)
The Driving Away of the Cattle of Regamna (Thurneysen, 1921)
The Driving Away of the Fraech's Cattle (Thurneysen, 1921)
The Gallic War (Woyte, 1945)
The Great Traps of Mag Mitheimne (Thurneysen, 1921)
The Red Onslaught of Conall Cernach (Thurneysen, 1921)
The Robbing of the Otherworld (Birkhan II, 1989)
The Story of the Duchess of the Well (Birkhan I, 1989)
The Story of Gereint, Son of Erbin (Birkhan II, 1989)
The Story of Percival, Son of Evrog (Birkhan II, 1989)
The Twelfth Foal (Hetman, 1975)
The Twelfth Goose (Booss, 1986)
The Destruction of the Hall of Da-Derga (Thurneysen, 1921)
Conception of Conall Cernach (Thurneysen, 1921)

The Fairy Harp (Jones, 1978)

The Fairy Palace of the Quicken Trees (Joyce, 1996)

The Fate of the Children of Lir (Joyce, 1996)

The Fate of the Children of Turenn (Joyce, 1996)

Field of Pig Counting (Thurneysen, 1921)

Gelert (Jones, 1978)

Geoffrey of Monmouth: The History of the Kings of Britain (Thorpe, 1983)

Giraldus Cambrensis: The Journey through Wales (Thorpe, 1978)

How Fionn MacCumhal Was Born (Agricola, 1988)

Hügel der Jagd (Thurneysen, 1921)

An Island That Was Dyed Black and White (Joyce, 1996)

The Isle of the Mystic Lake (Joyce, 1996)

King Arthur in the Cave (Rees, 1996)

King O'Toole and His Goose (Booss, 1986)

Liban the Mermaid (Joyce, 1996)

Llywelyn and His Dog (Jones, 1978)

Mac Conglinne's Vision (Brendel, 1984)

The Magic Pigs of Cruacha (Jackson, 1971)

Manawydan, Son of Llyr (third branch of the Mabinogi—Jones, 1986)

Math, Son of Mathonwy (fourth branch of the Mabinogi—Jones, 1986)

Merlin (Jones, 1978)

Oisin in Tirnanoge (Joyce, 1996)

On the Birth of Arthur and How He Became King (Birkhan II, 1989)

On the Dispute between the Two Swineherds (Thurneysen, 1921)

The Overflowing of Lough Neagh and the Story of Liban the Mermaid (Joyce, 1996)

Peder Keinc y Mabinogi (Jarman, 1979)

Percival, Son of Efrawg (Birkhan, 1989)

The Physicians of Myddfai (Jones, 1978)

The Poems of Taliesin (Williams, 1975)
The Prophecies of Merlin in Monmouth: The History of the Kings of
 Britain (Thorpe, 1966)
The Pursuit of Dermat and Grania (Joyce, 1996)
The Pursuit of the Gilla Dacker and His Horse (Joyce, 1996)
Pwyll, Prince of Dyfed (first branch of the Mabinogi—Jones, 1986)
The Radiant Boy (Booss, 1986)
Scél Mucce MacDathó (Thurneysen, 1921)
The Second Battle of Mag Tured (Moytura) (Cross, 1936)
Sharvan the Surly Giant and the Fairy Quicken Tree of Dooros
 (Joyce, 1996)
Tales of the Ultonian Cycle (Rolleston, 1995)
Tales of the Tuatha de Danann (Cross, 1936)
Tourigheacht Diarmuda agus Grainne (Joyce, 1996)
Trioedd Ynys Prydein (Bromwich, 1978)
The Twelve White Geese (Booss, 1986)
The Voyage of Maildun (Joyce, 1996)
The Voyage of Bran, Son of Febal (Cross, 1936)
The Voyage of the Sons of O'Corra (Joyce, 1996)
The Wandering of Tuath Luchra and Fergus's Death (Thurneysen, 1921)
The White Trout (Booss, 1986)
Why Individual Types Were Named (Brendel, 1984)
The Witch Hare (Booss, 1986)
The Wooing of Etain (Cross, 1936)

BIBLIOGRAPHY

Agricola, Christiane. *Volkssagen aus Schottland* [Folk Epics from
 Scotland]. Leipzig, 1988.
Birkahn, Helmut. *Keltische Erzählungen vom Kaiser Artus I* [Celtic Tales
 of King Arthur, I]. Essen, 1989.
Birkahn, Helmut. *Keltische Erzählungen vom Kaiser Artus II* [Celtic
 Tales of King Arthur, II]. Essen, 1989.

Birkahn, Helmut. *Kelten* [Celts]. Vienna, 1997.

Booss, Claire (ed.), Yeats, W. B., and Lady Gregory. *A Treasury of Irish Myth, Legend, and Folklore.* Avenel, 1986.

Botheroyd, Silvia. *Irland—Mythologie in der Landschaft* [Ireland: Mythology in the Landscape]. Darmstadt, 1997.

Botheroyd, Silvia and Paul. *Lexicon der keltishen Mythologie* [Lexicon of Celtic Mythology]. Munich, 1992.

Brendel, Renate. *Der Streit um das Heldenstück* [The Dispute over the Hero's Piece]. Leipzig, 1984.

Bromwich. *Trioedd Ynys Prydein. The Welsh Triads.* Cardiff, 1978.

Bromwich, et al. *The Arthur of the Welsh.* Cardiff, 1991.

Cross, Tom Peete and Slover, Clark Harris. *Ancient Irish Tales.* New York, 1936.

Cunliffe, Barry. *Die Kelten* [The Celts]. Bergisch Gladbach, 1992.

Dannheimer, Hermann and Gebhard, Rupert. *Das Keltische Jahrtausend* [The Celtic Millenium]. Mainz, 1993.

Davies, Walford. *Saunders Lewis.* Llandysul, 1996.

Dillon, Miles. *Early Irish Literature.* Dublin, 1994.

Duval, Anjela. *Traoñ an Dour.* Brest, 1982.

Filig, Jan. *Die keltische Zivilisation & ihr Erbe* [The Celtic Civilization and Its Legacy]. Prague, 1961.

Elser, M, et al. *Enzyklopädie der Religionen* [Encyclopedia of Religions]. Augsburg, 1990.

Geoffrey of Monmouth: The History of the Kings of Britain. Harmondsworth, 1983.

Goscinny, R. and Uderzo, A. *Asterix and the Cauldron.* 1969; *Asterix der Gallier* [Asterix the Gaul]. 1969.

Green, Miranda. *Dictionary of Celtic Myth and Legend.* London, 1992.

Grenham, John. *The Little Book of Irish Clans.* Dublin, 1994.

Heinz, Sabine. *Ausgewählte Probleme der literarischen Übersetzung dargestellt anhand der Übersetzung mittelwalisischer Texte ins Deutsche* [Selected Problems of Literary Translation, Presented by Means of

the Translation of Middle Welsh Texts into German]. Lewiston, 1996.

Hermann, Joachim. *Lexikon früher Kulturen* [Lexicon of Early Cultures]. Leipzig, 1987.

Hetmann, Frederik. *Keltische Märchen* [Celtic Fairy Tales]. Darmstadt, 1975.

Jackson, Kenneth. *A Celtic Miscellany.* New York, 1982.

Jarman, A. O. H. *Chwedlau Cymraeg Canol.* Caerdydd, 1957.

Jones, Angharad. *Y Dylluan Wen.* Llandysul, 1995.

Jones, Eirwen. *Folk Tales of Wales.* Llandysul, 1978.

Jones, Gwyn and Thomos. *The Mabigoni.* London, 1986.

Joyce, P. W. *Old Celtic Romances.* Dublin 1996.

Lengyel, Lancelot. *Das geheime Wissen der Kelten* [The Secret Knowledge of the Celts]. Freiburg i.Br., 1981.

Le Roux, F. and Guyonvarc'h, Ch. *Die Druiden* [The Druids]. Rennes, 1996.

Lofmark, Carl. *Bards and Heroes.* Liarwerch, 1989.

Low, Mary. *Celtic Christianity and Nature.* Belfast, 1996.

Mackenzie, D. A. *Tales from the Moors and the Mountains.* Glasgow, 1931.

Mackworth-Pread, Ben. *The Book of Kells.* London, 1993.

Maier, Bernhard. *Dictionary of Celtic Religion and Culture.* Woodbridge, 1997.

Meyer, Kuno. *Ancient Irish Poetry.* London, 1911.

Morpurgo, Michael. *Arthur. High King of Britain.* London, 1996.

Murphy, G. *Early Irish Lyrics.* Oxford, 1956.

Norton-Taylor, Duncan. *The Celts.* London, 1980.

Osborne, Ken. *Stonehenge und benachbarte Denkmäler* [Stonehenge and Neighboring Features]. London, 1995.

Parry, Thomas. *Dafydd ap Gwilym.* Caerdydd, 1979.

Rees, Anthony. *The Celtic Legends of Glamorgan.* Felinfach, 1996.

Roberts, Brynley F. *Cyfranc Lludd a Llefelys.* Dublin, 1975.

Rockel, Martin. *Taliesin. Aneirin. Altwalisische Heldendichtung* [Taliesein. Aneirin. Old Welsh Heroic Poetry]. Leipzig, 1989.

Rolleston, T. W. *Celtic.* London, 1995.

Rothery, Guy Cadogan. *Concise Encyclopedia of Heraldry.* London, 1994.

Ross, Ann. *Pagan Celtic Britain.* London, 1974.

Seulette, Freidrich. *Die Kelten zwischen Alesin & Pergamon* [The Celts between Alesin and Pergamon]. Leipzig, 1984.

Sharkey, John. *Celtic Mysteries.* Singapore, 1979.

Symbols of the Cultures. Celts. London, 1995.

Szabo, Miklos. *Auf den Spuren der Kelten in Ungarn* [On the Trail of the Celts in Hungary]. Budapest, 1971.

Thomas, Gwyn. *Chwedl Taliesin.* Caerdydd, 1992.

Thomos, R. S. *No Truce with the Furies.* Newcastle upon Tyne, 1995.

Thorpe, Lewis. *Giraldus Cambrensis: The Journey through Wales.* Harmondsworth, 1978.

Tomos, Angharad. *Yma o Hyd.* Talybont, 1992.

Welch, Robert. *The Oxford Companion to Irish Literature.* Oxford, 1996.

Williams, Ifor. *The Poems of Taliesin.* Dublin, 1975.

Woyte, Curt. *Caesar: Der Gallische Krieg.* [Caesar: The Gallic War]. Leipzig, 1945.

INDEX

A

Animals
 Characteristics, 17, 19, 21
 Frieze, 16
 Symbols, 18, 19
Apple tree, 142, 143, 154–155
Ash, 142, 152–153
Avalon, 278

B

Barrel, 172, 173
Basket, 170, 171
Beltaine, 33, 285–286
Bird, 74, 82, 83–135, 84, 106, 126, 258
Blackbird, 85, 96–97, 105
Boar/Pig, 39, 62, 63–69, 64, 66, 68, 77, 172, 175
Book of Kells, 14, 105
Bull, 21, 123, 149, 175, 243, 259, 262
Bull, Pictic, 56
Bull-head handles on pot, 54
See also Steer

C

Cart, 146, 182, 183–185
Cattle, 61, 258, 261
See also Cow;
 Steer/bull; Ox
Cattle-oath, 57
Cauldron, 60, 87, 162, 163–169, 166, 182, 243, 271, 283
 Gundestrup, 13–14, 47, 49, 130, 131, 164

Cernunnos, deer god, 46
Chalk picture, 252
Christianity, 14, 15, 19, 27, 29, 61, 85, 93, 99, 109, 117, 135, 140–141, 168–169, 171, 211, 227, 233, 235, 239, 243, 257, 267, 277, 282, 293
Circle, 201–203, 226, 288
Circle dance, 286
Coin, 42, 44, 50, 68, 123, 131, 132, 134, 179, 206, 209, 210, 212, 216, 223, 232, 244, 269
Conifer, 140
Cow, 60, 61, 65, 67, 263, 281
Crane, 21, 53, 83, 93, 111, 113, 122, 123, 258, 259, 262, 263, 290,
Cross, 201, 202, 203, 223, 292
 Wheel, 201
Crow, 83, 85, 124, 125, 127, 128, 129
Crucifix, 200

D

Deer, 21, 47–51, 50, 55–57, 63, 67, 169, 263
Deer god Cernunnos, 46
Dog, 65, 67, 70, 71–73, 72, 181, 215, 281
Dove, 98, 99–101, 140, 145
Dragon, 13, 27, 31–35, 75, 162,174, 263
 Four-legged, 30

 Three-headed, 233
 Two-footed, 34
Dragons, two fighting, 32,173, 283, 293
Duck, 110,113, 145

E

Eagle, 67, 77, 85, 89, 102, 103, 104, 105, 108, 223
Egg, 25, 204, 206, 221
See also One
Elements of life, 235
Epona, horse goddess, 20, 37–39
Eye, 62, 210, 216, 221
See also Two

F

Falcon, 25, 223
Fertility magic
 Men, 251
 Women, 247–249
Fire, 224–226, 285
Fish, 41, 131–137, 132, 134, 136, 261
Five, 159, 238, 239
Forty days and nights, 155
Fountain of Youth, 265
Four. See Three

G

God figure, 80, 60, 220, 222
Goddess, 118
Goddess, sea, 276
Goose, 41, 93, 113, 118, 119–121, 120
Gray, 185, 230

H

Halloween. See Samhain

Hallstatt culture, 13
 Period, 47, 175, 179,
 183, 187, 228
Harp, 67, 158
 See also Lyre
Hawk/falcon, 107–109,
 223
Hazel, 142
Head cult, 269–275
Head-hunting, 271–275
Heat/cold, 224–225
Heraldry, 19, 73, 77, 85,
 89, 93, 95, 117, 143
Holy Grail, 165, 171,
 193
Horn, drinking, 174
Horned helmet, 176
Horns, 175–177, 208
Horse, 36, 37–45,
 39–41, 45, 126, 148,
 169, 223, 224, 230,
 231, 258, 259, 281
 Goddess Epona, 20
Human figure, 288
Human head, 134, 190,
 212, 232, 250, 266,
 268, 270
 See also Head cult

I
Imbolc, 21

K
Knots, 286

L
Lamp, 283
Lamp of God, 213
La Tène period, 179,
 183, 187, 189
Leopard, 77
Linden, 157
Lion, 74, 75–77, 76,
 105, 169
Lugnasad, 285, 287
Lyre/harp, 159–161,
 160

M
Menhir ("long stone"),
 195, 197–199, 251
Mistletoe, 148, 149
Moon, 214, 218, 265
 Cult, 144, 209,
 211–213, 215, 216
 God, 208
 See also Two
Moon–Sun connection,
 239

N
Nine days and nights,
 69
Nymphs, 264

O
Oak, 63, 105, 142,
 146–147, 151
Ogham alphabet, 142,
 196
Ogham Stone, 117, 201
One, 189–193
One/egg, 205–207
One-eyed, 209, 273
Otherworld, 49, 61, 69,
 71, 83, 85, 103, 111,
 113, 131, 147, 151,
 154, 163, 165, 193,
 221, 237, 239, 267,
 277–283, 280, 287,
 289
Owl, 17, 19, 67, 85, 86,
 87–91, 88, 89, 90,
 105, 215, 219, 249,
 258, 260
Ox, 59–60, 65, 172, 283
 Winged, 58

P
Peacock, 21, 94, 95
Pegasus, 42, 44
Phallus, 250, 254
Pig, 65, 67, 147, 243,
 258, 281
 See also Boar

R
Rabbit, 79–81, 78, 80,
 93, 215, 261
Raven, 41–43, 125, 127,
 129
Rays, 220
Red, 13–14, 32, 33, 35,
 184, 230, 261, 273,
 279, 281, 283, 295
Resurrection/rebirth,
 237
Rooster, 92, 93

S
Salmon, 67, 105, 131,
 133, 135, 155, 219
Samhain, 197, 215, 279,
 285, 287, 289, 291,
 293
Seven, 65, 67, 147, 155,
 159, 172, 241–245,
 242, 244
Shape changing, 63, 123,
 237, 257–264, 263
Sheila-na-Gig, 246, 248,
 249
Skull, 272, 274, 293
 Cult, 270
Snake, 18, 22, 23–29,
 27, 63, 68, 75, 169,
 175, 187, 193, 205,
 215, 222
 Knots, 26
 With Egg, 24
 With Undivided
 Progenitor, 24
 With ram's head, 28
Spiral, 234, 236, 240
Spotted, 59, 61, 184,
 230, 283
Steer/bull, 52, 53–57
Stones, 195, 199
Sun, 265
 Cult, 93, 144, 159,
 221, 223
 Goddess, 225

See also Three/Four

Swan, 112, 113, 115–117, 116, 258

Swastika, 201, 235

Sword, 187–188, 190, 283
 Family of, 189
 In stone, 190–191
 Sheaths, 192
 Sword dance, 186

T

Three, 155, 159, 161, 197, 198, 217, 219, 221–225, 229, 261, 291

Three and four/sun, 221–225

Toad, 17, 105

Torque, 14, 62, 87, 178, 179, 180, 181, 215–216

Transformation, 131, 243, 258
 See also Shape changing

Transmigration, 59, 63, 256
 Of souls, 257–263

Tree, 105, 138, 169, 197, 265, 290
 of Life, 84, 144–145
 of Ross, 150

Trees, 139–157
 Holy, 142

Triads, 231

Triangle, 226, 227–230

Trinity, 233

Triskele, 159, 235

Trout, 137

Two, 209

Two/eye and moon, 209–219

U

Underworld. *See* Otherworld

W

Water birds, 114

Water cult, 23, 37, 265–268

Wheel, 201, 221, 235

White, 13–14, 32, 33, 59, 113, 230, 273, 279, 281, 283, 295

Woman, 260

Women with deer, 48

Worship place, 194

Y

Year circle, 284

Yellow, 32, 33, 35, 59, 230

Yew, 142, 151